MAYA LIN

Recent Titles in Greenwood Biographies

George W. Bush: A Biography
Clarke Rountree

Che Guevara: A Biography
Richard L. Harris

Sarah Palin: A Biography
Carolyn K. Cooper

David Petraeus: A Biography
Bradley T. Gericke

Paris Hilton: A Biography
Sandra Gurvis

Frederick Douglass: A Biography
C. James Trotman

Sojourner Truth: A Biography
Larry G. Murphy

Harriet Tubman: A Biography
James A. McGowan and William C. Kashatus

George Washington Carver: A Biography
Gary R. Kremer

Lance Armstrong: A Biography
Paula Johanson

Prince William: A Biography
Joann F. Price

Oprah Winfrey: A Biography
Helen S. Garson

John F. Kennedy: A Biography
Michael Meagher and Larry D. Gragg

MAYA LIN

A Biography

Donald Langmead

GREENWOOD BIOGRAPHIES

 GREENWOOD

AN IMPRINT OF ABC-CLIO, LLC
Santa Barbara, California • Denver, Colorado • Oxford, England

Library of Congress Cataloging-in-Publication Data

Langmead, Donald.
 Maya Lin : a biography / Donald Langmead.
 p. cm. — (Greenwood biographies)
 Includes index.
 ISBN 978-0-313-37853-9 (hardback) — ISBN 978-0-313-37854-6
(ebook) 1. Lin, Maya Ying. 2. Architects—United States—Biography.
3. Chinese American architects—Biography. I. Title.
 NA737.L48L36 2011
 720.92—dc22
 [B] 2011009788

ISBN: 978-0-313-37853-9
EISBN: 978-0-313-37854-6

15 14 13 12 11 1 2 3 4 5

This book is also available on the World Wide Web as an eBook.
Visit www.abc-clio.com for details.

Greenwood
An Imprint of ABC-CLIO, LLC

ABC-CLIO, LLC
130 Cremona Drive, P.O. Box 1911
Santa Barbara, California 93116-1911

This book is printed on acid-free paper ∞

Manufactured in the United States of America

CONTENTS

Series Foreword vii

Introduction and Acknowledgments ix

Timeline: Events in the Life of Maya Lin xiii

Chapter 1 "Where Are You *Really* From?": Chinese Ancestry 1

Chapter 2 A Tradition in Architecture: Lin Huiyin and
 Liang Sicheng 15

Chapter 3 Escaping China: Maya Lin's Parents 27

Chapter 4 "People Here Are Nice": Athens, Ohio 39

Chapter 5 Outside, Looking In: Childhood and Youth 49

Chapter 6 Almost for "a Lark": An Undergraduate at Yale 63

Chapter 7 Design in Mashed Potato: The Vietnam Veterans
 Memorial Competition 75

Chapter 8 Annus Horribilis: Building the Vietnam
 Veterans Memorial 89

Chapter 9 Accretions and Aggravations: Continuing
 Conflicts in Washington 105

CONTENTS

Chapter 10 New Haven, New York: New Beginnings 117

Chapter 11 Out of the Wings: The Architect as Artist 131

Chapter 12 A Hectic Decade: The 1990s 145

Chapter 13 A New Millennium 159

Further Reading 173

Index 181

SERIES FOREWORD

In response to high school and public library needs, Greenwood developed this distinguished series of full-length biographies specifically for student use. Prepared by field experts and professionals, these engaging biographies are tailored for high school students who need challenging yet accessible biographies. Ideal for secondary school assignments, the length, format and subject areas are designed to meet educators' requirements and students' interests.

Greenwood offers an extensive selection of biographies spanning all curriculum-related subject areas including social studies, the sciences, literature and the arts, history and politics, as well as popular culture, covering public figures and famous personalities from all time periods and backgrounds, both historic and contemporary, who have made an impact on American and/or world culture. Greenwood biographies were chosen based on comprehensive feedback from librarians and educators. Consideration was given to both curriculum relevance and inherent interest. The result is an intriguing mix of the well known and the unexpected, the saints and sinners from long-ago history and contemporary pop culture. Readers will find a wide array of subject choices from fascinating crime figures like Al Capone to inspiring pioneers like Margaret

Mead, from the greatest minds of our time like Stephen Hawking to the most amazing success stories of our day like J.K. Rowling.

While the emphasis is on fact, not glorification, the books are meant to be fun to read. Each volume provides in-depth information about the subject's life from birth through childhood, the teen years, and adulthood. A thorough account relates family background and education, traces personal and professional influences, and explores struggles, accomplishments, and contributions. A timeline highlights the most significant life events against a historical perspective. Bibliographies supplement the reference value of each volume.

INTRODUCTION AND ACKNOWLEDGMENTS

The Vietnam Veterans Memorial—The Wall—in Washington, D.C., stirs deep feelings—none of the four million people who visit it each year leaves unmoved. I first saw it on a crisp November morning 20 years ago. Its emotional power was emphasized by the sight of a middle-aged man, wearing a business suit and carrying a topcoat and overnight bag, walking toward me; sobbing uncontrollably, he was oblivious to all around him. Years later, when Greenwood invited me to write a biography of The Wall's creator, Maya Lin, the vivid memory of that encounter constrained me to eagerly accept.

Maya Ying Lin was born in Athens, Ohio, the daughter of political refugees who had fled China shortly before Mao Zedong declared the foundation of the People's Republic. Her father, Huan (Henry) Lin, studied ceramics at the University of Washington, and, as the culmination of a series of academic appointments, he became dean of the College of Fine Arts at Ohio University. Her mother, Ming-hui (Julia) Chang, later became a professor of literature there. In 1977, having graduated from high school as co-valedictorian, Lin won a place at Yale, where she intended to study veterinary science. Soon, for ethical reasons, she changed her major to architecture and was awarded a bachelor of arts degree cum laude in 1981.

In that year, at the age of 21 and while still an undergraduate, she won a national design competition for the memorial. Her entry was selected by a jury of eminent artists from among 1,420 other anonymous submissions. She proposed a 500-foot-long V-shaped wall of polished black granite, half-buried in the earth and incised, row upon row, with the names of more than 58,000 young Americans who were killed or declared missing in action in the Vietnam War. It was dedicated on November 13, 1982. Lin's design was like a supernova—a stellar explosion that outshines an entire galaxy; it changed attitudes to and set a standard for monument design for decades to come, possibly forever. But the analogy fails, because supernovae fade, while Lin's "protean design talents" (to borrow the words of Shaila Dewan) "have defined her as one of the most gifted creative geniuses of the age." Because the memorial brought her instant fame and laid the foundation of her career, it looms large in the following pages.

It was realized in the face of vigorous—even vicious—resistance from some influential quarters. Worse, Lin was besmirched with slurs on her youth, gender, and ethnicity. Her antagonists tried to "improve" the work with traditional sculptural trappings, and the Controversy, as it was termed, continued for about a year, involving veterans, writers, artists, and politicians, until, ignoring Lin's wishes, a compromise was agreed. Angered, hurt, and disillusioned, she withdrew to the "safe haven" of academia, completing a master of architecture degree at Yale in 1986.

Upon graduating, she established the Maya Lin Studio in the SoHo neighborhood of New York, where she worked on experimental sculpture while preparing for the state's architect's licensing exam (which she has never taken). A number of large, critically well-received commissions—sculpture, earthworks, landscape, kinetic art, and later, architecture—more or less reluctantly accepted in the years around 1990 heralded a resurgence in her career and brought her once more into the public eye. Demand for her work has never abated. A lifetime champion of conservation, most recently she has almost exclusively taken up the cause of saving the Earth, leading in 2010 to the launch of *What Is Missing?*, her cyber art magnum opus.

Lin has been rewarded with many honorary degrees and other tributes at home and abroad, including election to the American Academy

of Arts and Letters, the American Academy of Arts and Sciences, and the National Women's Hall of Fame. In February 2010, President Barack Obama presented her with the country's highest distinction for artistic virtuosity, the National Medal of Arts, bearing the citation "for her profound work as an architect, artist, and environmentalist." She now lives in upper Manhattan (and sometimes in Ridgway, Colorado) with her husband, Daniel Wolf, and their two daughters, India and Rachel.

Despite having celebrity thrust upon her, Lin continues to jealously guard her personal privacy. This biography therefore depends largely upon published material. Among it are transcripts of (or at least citations from) a number of face-to-face and telephone interviews. Lin has been frugal with them, granting only about 20 over her 30-year career; most were given after 2000. The information they provide is the closest to primary sources.

Heartfelt thanks are offered to the following people (listed alphabetically) who willingly assisted in my research: Noa Ain; Tony Baldwin; Sharon Ball, College of Fine Arts, Ohio University (OU); Hilary Blecher; John Bolcer, Archivist, Special Collections, University of Washington Libraries; Andrus Burr, FAIA; Pam Callahan, University Planner, OU; Jacqueline H. Chen; Robert W. Doubek; Peter Forbes, FAIA; Lauren Georger, Archivist, Manhattanville College Library; Jean P. Greer, Vice-President of Public Art and Creative Individuals, ASC, Charlotte, NC; Linda L. Hall, Archives Assistant, Williams College; Daniel Hartwig, Records Services Archivist, Yale University; Dick Hay; Rob Hudson, Associate Archivist, Carnegie Hall; Professor Edward Kamens, sometime Master of Saybrook College, Yale; Ray A. Killian Jr.; William Kimok, University Records Manager, OU; Gayle D. Lynch, Senior Library Specialist for Archives, Brown University; Professor Alina Macneal, Drexel University; President Emeritus Robert W. Neff, Juniata College; David Reiser, architect, of Athens, OH; Tim Teng, Fuzhou, Peoples Republic of China (PRC); Professor Emeritus James Y. Tong, OU; the late Professor Yang Guo Qing, Fuzhou, PRC; Wendy Yang of Sydney; and Nanci A. Young, Archivist, Smith College Archives. There are many others who have helped much. Despite my urging that they be named, they prefer to remain anonymous. They know who they are and how deeply their cooperation is appreciated.

Particular thanks go to Janice Hartman, College Archivist, Juniata College, for the interest she has shown in the project and to my good friend of many years, Chen Faipeng, who opened windows onto the Chinese side of the story. Rachel Griffin edited the manuscript and made many helpful suggestions.

Once again, my deepest gratitude is reserved for my wife, Coby. Almost daily, she has tolerated non sequiturs and borne intrusions upon her own routine to listen to my speculations. Moreover, she has frequently offered valuable insights and perspectives that left me asking, "Why didn't I think of that?" Over nearly two years—and for much longer—she has nursed me through periods of ill health and put up with my melancholia. Who else would?

I also sincerely thank the publisher's editorial staff, especially Debra Adams, who offered me this enviable task in the first place, and the rather long line of her successors at Greenwood and ABC-CLIO.

The University of South Australia, at which I hold an adjunct professorship, provided valuable logistical support, which is gratefully acknowledged.

TIMELINE: EVENTS IN THE LIFE OF MAYA LIN

1945 Huan (Henry) Lin (Maya's father) emigrates to the United States from Fuzhou, China, on scholarship from University of Washington (UW).

1949 Ming-hui (Julia) Chang (Maya's mother) emigrates to the United States from Shanghai, China; takes up scholarship at Smith College, Northampton, MA.
Henry enrolls in master of fine arts program, UW.

1951 June: Julia awarded bachelor of arts in English.
September: Henry appointed darkroom technician, College of Education, UW.
October: Julia moves to UW, enrolls in master of arts program.
December 28: Henry and Julia marry.

1952 December: Julia awarded master of arts degree.

1955 February: Henry begins teaching at UW.

1956 Tan Lin (Maya's brother) is born.
Julia begins teaching, Far Eastern and Russian Institute, UW; commences study for doctorate.

1957 July: Henry begins one-year appointment teaching ceramics, University of Wisconsin.

1958 Henry appointed assistant professor of art, Ohio University (OU) (full professor, 1966; Director, School of Art, 1968; Dean, College of Fine Arts, 1972–1984).

1959 October 5: Maya Ying Lin is born, Sheltering Arms Hospital, Athens, OH.

1963–1977 Maya at nursery/elementary school, OU Department of Education Laboratory School (aka Putnam School) through 6th grade; Athens Middle School through 8th grade; Athens High School, through 12th grade.

1965 Julia returns to UW with Tan and Maya to complete doctorate, awarded August. Begins teaching at OU (assistant professor of English, September 1967; full professor, 1972–1988).

1977 June: ML graduates from high school as co-valedictorian.
 September: Enters Saybrook College, Yale, planning a career in field zoology.

1978 [?] ML switches to architecture major.

1979 Fall semester in Copenhagen, Denmark; summer: travels in Europe.

1981 May: Wins Vietnam Veterans Memorial competition; relocates to Washington, D.C. Until early 1982, design consultant, Cooper-Lecky Architects.
 October: Graduates cum laude, bachelor of arts, Yale College.

1982 Drafter, Cooper-Lecky Architects.
 Summer: instructor, Phillips Academy, Exeter, NH.
 Fall: Enrolls in master of architecture program, Harvard Graduate School of Design.

1983 **Events** Withdraws from Harvard. For most of year, works in the architectural office of Peter Forbes and Associates, Boston.
 September: Enrolls in master of architecture program, Yale.
 Exhibitions Museum of Modern Art, San Francisco.

1984 **Events** February: Receives AIA's Henry Bacon Medal for memorial architecture.

Works July: Designs stage sets for *Trio* (opera by Noa Ain), Philadelphia College of Art; Arts at St. Ann's, New York; Carnegie Hall.

Exhibitions February–March: "American Women Artists—The Younger Generation," Sidney Janis Gallery, New York.

October–November: "Sites and Solutions: Recent Public Art," Albright College, Reading, PA, and Gallery 400, University of Illinois at Chicago (1985).

1985 **Events** January: Receives Presidential Award for Design Excellence.

Spring: Teaching assistant for Vincent Scully, Yale School of Architecture.

Summer: Visits People's Republic of China with Julia and Tan. Guest lecturer, Qinghua University School of Architecture, Beijing.

Works *Aligning Reeds*, Mill River, New Haven, CT.

1986 **Events** May: Awarded master of architecture degree.

Summer: Study in Kyoto, Japan, with Fumihiko Maki.

Summer: Visiting professor, *Exploration of Controversies in Public Art* seminar, Yale College.

October: Establishes Maya Lin Studio, New York; begins internship, Peter Forbes, New York.

1987 **Events** May: Awarded honorary doctorate in fine arts, Yale.

Exhibitions April–July: "Avant-Garde in the 80s," County Museum of Art, Los Angeles.

1988–1989 **Works** Civil Rights Memorial, Southern Poverty Law Center, Montgomery, Alabama (with Robert Cole architect).

Peace Chapel, Juniata College, Huntingdon, PA.

1988 **Events** Awarded National Endowment for the Arts Visual Artists Fellowship (Sculpture).

Spring: Visiting lecturer, School of Landscape Design, Harvard.

Exhibitions February–March: "60s to 80s Sculpture Parallels," Sidney Janis Gallery, New York.

1989 **Events** Receives honorary doctorate, Juniata College.

1989–1991 **Works** *Topo*, Charlotte, NC (with Henry Arnold, landscape architect).

1989–1993 **Works** *Women's Table*, Yale.

1989–1995 **Works** *Eclipsed Time*, Pennsylvania Station, New York.

1990 **Events** April: Guest lecturer, Metropolitan Museum of Art, New York.

April: Receives award, "Design 100—Elements of Style" (*Metropolitan Home Magazine*).

June: Inducted into Ohio Women's Hall of Fame.

Works Rosa Esman Gallery, New York (with William Bialosky, architect).

1991 **Events** January: Visiting lecturer, Walker Arts Center, Minneapolis.

October: Visiting lecturer, Ontario College of Art.

Exhibitions May–June: "Working with Wax: Ten Contemporary Artists," Tibor de Nagy Gallery, New York.

September–October: "Social Sculpture," Vrej Baghoomian Gallery, New York.

1992 **Events** Named Board Member, Energy Foundation, San Francisco. Visiting artist, Sculpture Department, Yale University.

Exhibitions "Culture Bites," Cummings Art Center, Connecticut College, New London; Sonoma State University, CA.

"Ho Hum, All Ye Faithful," John Post Lee Gallery, New York.

1992–1993 **Events** Artist in residence, Wexner Center for the Arts, Ohio State University, Columbus.

Works *Groundswell*, Wexner Center.

Museum for African Art, New York (with architect David Hotson).

1992–1994 **Events** Member, National Advisory Board to the Presidio Council, San Francisco.

1993 **Events** Awarded honorary doctorate in fine arts, Smith College;

honorary doctorate in fine arts, Williams College.

Visiting lecturer, School of Art, University of Washington.

Works Weber Residence, Williamstown, MA (with architect William Bialosky).

Exhibitions "Presence," Ramnarine Gallery, Long Island City, NY.

1993–1994 **Exhibitions** "Public/Private," Wexner Center (solo).

1993–1995 **Works** *Wave Field*, FXB Aerospace Building, University of Michigan, Ann Arbor.

1993–1996 **Works** *10 Degrees North*, Rockefeller Foundation Headquarters, New York.

1994 **Events** Receives New York Women's Agenda Star Award.

Named board member, *Teaching Tolerance*, Southern Poverty Law Center.

Summer: residency, Pilchuk Glass School.

Named among *Time* magazine's "50 for the Future."

Works Mock/Sanders Residence, Santa Monica, CA.

Exhibitions December: "Critical Mass," School of Art, Yale; McKinney Avenue Contemporary, Dallas (1995).

1995 **Events** Joins advisory board, Studio in a School, New York.

January: included in *Utne Reader, 100 Visionaries*.

Awarded honorary doctorate, Brown University.

Assumes Avenali Professorship, Townsend Center for the Humanities, University of California, Berkeley.

Maya Lin: A Strong Clear Vision, Academy Award, Best Documentary.

1995–1997 **Works** *A Shift in the Stream*, Principal Financial Group HQ, Des Moines.

1996 **Events** December: Marries Daniel Wolf, New York.

Receives honorary doctor of arts, Harvard.

Receives American Academy of Arts and Letters Award in Architecture.

Science pour l'Art Award.

Visiting lecturer, Whitney Museum of Modern Art.

Works *Sounding Stones,* Federal Courthouse New York.

Exhibitions "Extended Minimalism," Max Protetch Gallery, New York.

1996–1998 **Works** Norton apartment, New York (with Hotson).

Reading a Garden, Cleveland Public Library (with Tan Lin; Malcolm Holzman, architect; Olin Partnership, landscape architect).

1997 **Events** October: Birth of daughter India.

Receives John P. McGovern Arts and Humanities Award.

Receives honorary degree, New York University.

April: Visiting Lecturer Portland, OR, Arts and Lectures.

Works *Untitled* (Topographic Landscape).

Crater Series.

10° North, Rockefeller Foundation, New York.

Asia/Pacific/American Studies Institute, New York University (with Hotson).

Exhibitions January–October: "The Private Eye in Public Art." LaSalle Gallery, Charlotte, NC.

Fall: "Stung by Splendor," Cooper Union School of Art, New York.

December–February 1998: "The Bronx Community Paper Company: Designing Industrial Ecology," Urban Center of the Municipal Art Society, New York (solo).

1998 **Events** William A. Bernoudy Resident in Architecture, American Academy in Rome.

Named board member, Natural Resources Defense Council, New York (continuing).

Works *Phases of the Moon.*

Avalanche.

Furniture for Knoll.

Exhibitions "Maya Lin," American Academy in Rome (solo).

"Maya Lin: Topologies," Southeastern Center for Contemporary Art, Winston-Salem, NC; Cleveland

Center for Contemporary Art, 1998; Grey Art Gallery, New York University, 1998; Des Moines Art Center, 1999; Contemporary Arts Museum, Houston, TX, 1999 (solo).

1999 **Events** July: birth of daughter Rachel.

February: Visiting lecturer, Technology, Entertainment Design Conference.

Lectures: Museum of Art Philadelphia, PA; Art Museum, Denver, CO; Duke University, Durham, NC.

Receives Excellence Award, Industrial Designers Society of America.

Receives Rachel Carson Leadership Award, Chatham University, Pittsburgh.

Works Langston Hughes Library, Childrens' Defense Fund, Clinton, TN (with Martella Associates).

Exhibitions April–September: "Urban Mythologies: The Bronx Represented Since the 1960's" Bronx Museum of the Arts.

October–November: "Maya Lin: Recent Work," Gagosian Gallery, Beverly Hills (solo).

November–March 2000: "Designing the Future: Three Directions for the New Millennium" Museum of Art, Philadelphia.

November–February 2000: "Tomorrow Land." Alan Koppel Gallery, Chicago.

December–April 2000: "Capturing Time: *The New York Times* Capsule," American Museum of Natural History, New York.

"Powder," Aspen Art Museum, Colorado.

2000 **Events** Publishes *Boundaries*.

Receives Frank Annunzio Award, Christopher Columbus Foundation.

Fall: Robert Gwathmey Chair in Art and Architecture, Cooper Union.

Visiting Lecturer: 92 Street Y, New York; Ball State University, Muncie, IN; City Arts and Lectures, San Francisco; Portland Arts and Lectures, Portland, OR;

Rochester Arts and Lectures Series, NY; Smithsonian Institution, Washington, D.C.; Walker Art Center, Minneapolis; Washington University, Seattle.

Works *Time Table*, Iris & B. Gerald Cantor Center for Visual Arts, Stanford University, Palo Alto, CA.

The Character of a Hill, Under Glass, American Express Client Services Center, Minneapolis (completed 2001).

Confluence Project, Washington State and Oregon (ongoing).

Exhibitions February–April: "Illusions of Eden: Visions of the American Heartland," Columbus Museum of Art; moved to Museum of Modern Art, Vienna (2000); Ludwig Museum, Budapest; Madison Art Center, Wisconsin (2001); Washington Pavilion, Sioux Falls (2001).

March–April: "Nature: Contemporary Art and the Natural World," Marywood University, Scranton, PA.

August: "Precious Metals—Sculptures in Gold and Silver," Baldwin Gallery, Aspen, CO ; Elaine Baker Gallery, Boca Raton, FL (2001); Galerie Simonne Stern, New Orleans (2001); Nohra Haime Gallery, New York (2001).

Fall: "Between Art and Architecture," Houghton Gallery, Cooper Union School of Art (solo).

November 2000–February 2001: "Women Designers in the USA, 1900–2000: Diversity and Difference," Bard Graduate Center, New York.

2001 **Events** December: William C. Devane lecture, Yale.

Works Aveda Headquarters, New York.

Ecliptic, Frey Foundation, Grand Rapids.

Sculpture Center renovation and expansion, Long Island City (completed 2002).

Exhibitions January–February: "White Light," Illinois State University, Normal. September–October: "New Blue: Recent Work of Graduates of the Yale School of Architecture, 1978–1998," Yale.

2002 **Events** Judging panel, Chrysler Design Awards.

October: Receives Cultural Leadership Award, American Federation of Arts.

Becomes member of Yale Corporation (tenure until 2008).

Exhibitions May–April 2003: "Images of Nature," Museum of Fine Arts, Boston, MA.

2003 **Events** May: Receives Finn Juhl Architecture Award, Copenhagen, Denmark.

October: Serves as visiting lecturer, New Yorker Festival.

Named Juror, World Trade Center Site Memorial Competition.

Works Greyston Bakery, Yonkers, NY.

Sundials, U.S. Embassy, Istanbul, Turkey (dedicated in June).

Exhibitions March–May: "U.S. Design: 1975–2000," Denver Art Museum; Museum of Contemporary Art and Design New York; Memphis Brooks Museum of Art (2003–2004); Contemporary Arts Museum Houston (2004).

May: "Maya Lin/ Finn Juhl," Danish Museum of Decorative Art, Copenhagen (solo).

2004 **Events** Named member, judging panel, Volvo for Life Awards, New York.

November: Receives Pearl S. Buck Award, Randolph College, Lynchburg, VA.

Anderson Ranch Artist Award, CO.

Works Riggio-Lynch Chapel Children's Defense Fund, Clinton, TN (with Bialosky).

Input (with Tan Lin) Ohio University, Athens.

11 Minute Line, Knislinge, Sweden.

Museum of Chinese in America, New York (with Bialosky) (completed 2009).

Exhibitions "Maya Lin and Jenny Holzer: Out of Athens and in Public," Kennedy Museum of Art, OU, Athens.

"Maya Lin," Wanås Foundation, Knislinge, Sweden (solo).

August–September: "Maya Lin's Designs for East Tennessee," Knoxville (solo).

2005 **Events** Inducted into American Academy of Arts and Letters, American Academy of Arts and Sciences, National Women's Hall of Fame.
Works Box House, Telluride, CO (with Bialosky).
Flutter, Wilkie D. Ferguson Jr. Federal Courthouse, Miami, FL.
Garden of Perception, School of the Arts, University of California at Irvine.
Manhattanville College, Manhattanville, NY (with Hotson) (completed 2006).
Exhibitions "Linear Photograph," Bernard Toale Gallery, Boston.

2006 **Events** May: Receives honorary doctorate in humane letters, Columbia University.
Receives Good Design Award, Chicago Athenaeum.
Works *By Definition*, New Jersey City University (with Tan Lin).
Michael and Laura Koch apartment, New York City.
Exhibitions April–December: "Glass—Material Matters," Los Angeles County Museum of Art.
July–August: "Sculpture," Gagosian Gallery, Beverly Hills, CA.
July–August: "ECO-LUX Art in the Light of Ecology," Lightbox, Los Angeles. "Systematic Landscapes," Henry Art Gallery, University of Washington, Seattle; Contemporary Art Museum, St. Louis (2007); Museum of Contemporary Art, San Diego (2008); De Young Museum, San Francisco (2008–2009); Corcoran Gallery of Art, Washington, D.C., 2009 (solo).

2007 **Events** Awarded honorary doctorate in humane letters, Manhattanville College.
Receives AIA 25-Year Award.
March: Sculpture residency, Museum of Glass, Tacoma.
April: Gives introductory address, "China and Energy," 16th Conference of Committee of 100, New York City.

Participates in symposium "Balancing Two Cultures: Eastern and Western Identity in Design," Museum of Modern Art, New York.

Works Storm King Wavefield, Mountainville, NY (completed 2008).

Pin River, Contemporary Art Museum St. Louis (commissioned 2007).

Exhibitions "Not For Sale," P.S.1 Contemporary Art Center, Long Island

2008 **Events** Receives New York Prize Senior Fellowship, Van Alen Institute.

Distinguished Visiting Scholar, Liberal Studies, University of Louisville, KY.

Works Christine Nichols House, Venice, CA (with Bialosky) (completed 2010).

Cast-silver model of the Colorado River, CityCenter Fine Art Program, Las Vegas, NV (completed 2009).

Exhibitions "Tara Donovan, Maya Lin, David Opdyke and Margaret Wertheim," David Weinberg Gallery, Chicago.

"Time Is of the Essence: Contemporary Landscape Art," Asheville Art Museum, NC.

2009 **Events** Serves on President's Committee on White House Fellowships.

August: Keynote Speaker, National Association of Asian American Professionals, Denver, CO.

Exhibitions May–November: "Maya Lin: Bodies of Water," Storm King Art Center, NY (solo).

September–October: "Three Ways of Looking at the Earth," PaceWildenstein, New York (solo).

September–November: "Maya Lin: Recycled Landscapes," Salon 94, New York (solo).

September–April 2010: "12+7: Artists and Architects of CityCenter," Bellagio Gallery of Fine Art, Las Vegas, NV.

Works *The Last Memorial.*

2010 **Events** January: MoCA Taipei's "Visual Attract and Attack," Taiwan.

February: Receives National Medal of Arts.

March: Lecture, Academy of Visual Arts, Hong Kong.

Exhibitions February–April: "Maya Lin" Arts Club of Chicago (solo).

June: "13 Pieces by Maya Lin," at Telluride Gallery of Fine Art (solo).

Chapter 1

"WHERE ARE YOU *REALLY* FROM?": CHINESE ANCESTRY

This is an age when people are identified by numbers. Reacting against social security numbers, credit card numbers, and the ones and zeros that define them on electronic databases, more and more individuals are seeking to discover their origins by compiling family trees and writing family histories. In March 2010, NBC-TV launched a series, *Who Do You Think You Are?*, in which public figures are helped to uncover their ancestry, for at least a few generations. Almost all public libraries have special genealogy departments, and Googling the term "geneal**" yields 420 million websites. The question Who am I? has been asked for millennia, even among preliterate cultures.

Until she was 21, Maya Lin had no inkling of her origins. Apart from her parents and her brother, Tan, she knew nothing of family connections—nothing beyond Athens, Ohio. In a 2003 interview, she said, "I will...get into a cab sometime and the cab driver will turn around and say, 'Where are you from?' And I'll say, 'Ohio.' And they'll say, 'No, no, where are you really from?'"[1] A couple of years earlier, she had admitted:

> I didn't find out more about my family's history until [my father told me about it] on my 21st birthday, after we were in Washington.

There was a party at the Chinese embassy, and my father was going on and on with the Chinese ambassador; they were just talking and talking. And afterwards I said, "What were you talking about?" and he said, "We were talking about my father." It turns out my grandfather, on my father's side ... was a fairly well-known scholar.[2]

Her forebears, both by blood and by marriage, included many who made major contributions to the creation of modern China. The extended Lin family, concentrated in the Chinese southeastern coastal province of Fujian, can trace its origins to the reign of Emperor Zhou Wu Wang, founder of the Zhou Dynasty (1134 B.C.). To discover how they were woven into the intricate tapestry of 20th-century Chinese politics—indeed, why Lin's parents emigrated to the United States—it is necessary to outline a little of China's tumultuous history.

At the end of the 19th century, the Qing dynasty—the Manchus—ruled China. Some 250 years earlier, the seminomadic Manchus had come from the area northeast of the Great Wall, overrunning the disintegrating Ming state and superimposing their "barbarian" ways on Han cultural traditions. Toward the end of the 1700s, the Qing armies themselves had weakened, bureaucratic corruption was prevalent, and self-interested, ultraconservative mandarins were resisting modernization. The resulting popular unrest was made worse by natural disasters and famine. For the next 100 years, China, defeated in successive conflicts—the Opium Wars of the midcentury, the first Sino-Japanese War (1894–1895), and the Boxer Rebellion (1900–1901)—was forced to accept unfavorable treaties with Western powers. Historian Amanda Ryder explains that, by the 1890s, as resentment of the Manchus festered, reformist and revolutionary secret societies were established, intent on ousting the interlopers, whose interest they equated with those of the European imperialists, and restoring a Han Chinese dynasty.[3]

Through her aunt's marriage to his son (more of whom later) and for other reasons, Maya Lin's family was linked to Liang Qichao (1873–1929), "the greatest personality in the history of Chinese journalism," whose writings shaped emerging democratic ideals in China. Although Qichao, a farmer's son, passed the provincial civil service examination at the age of just 11 and held the equivalent of a master's degree at 16, he never reached the highest rank of *jinshi*. From 1891, his mentor was

the classical scholar Kang Youwei. Eager to adapt the political, economic, and social institutions of the West to render China competitive in the modern world, Kang established a school in Guangzhou; Liang became an instructor.

In 1895, Kang and Liang mobilized 1,300 civil service examination candidates in Beijing to protest the terms of the Treaty of Shimonoseki, under which much Chinese territory had been ceded to Japan following its victory in the Sino-Japanese War. The two men also demanded urgent modernization of government and helped found the Society for the Study of National Strengthening; the first of many reform groups, it was banned within a year. Liang, a constitutional monarchist, was unhappy with Qing governance, and, with Kang and others, he persuaded the progressive emperor Guangxu (reigned 1875–1908) to implement reforms. But the so-called Hundred Days' Reform of the summer of 1898 had little practical political, legal, or social effect.

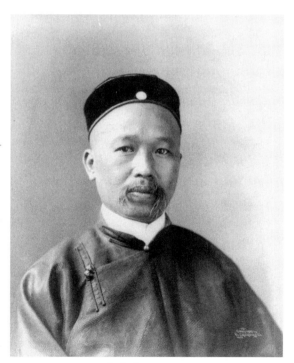

Yu Wei Kang, 1905. (Library of Congress.)

The Empress Dowager Ci Xi (1835–1908) was the power behind the throne. Afraid that reforms would undermine her and supported by General Yüan Shikai, commander of the modernized Newly Created Army, she executed a coup d'état and made herself regent. On September 21, 1898, Guangxu was placed under house arrest. A week later, six reformist leaders were executed. Kang and Liang, also sentenced to death, fled to Tokyo, but the Japanese, at the urging of the Qing court, deported Kang. He settled in Singapore, where he founded the Chinese Reform Association (later renamed the Protect the Emperor Society).

Liang Qichao was not to return to his homeland for 14 years. As Kang's deputy, from 1899 he visited Chinese communities in Hawaii, Hong Kong, Singapore, Ceylon (now Sri Lanka), Australia, and North America, championing democratic reform. When the finances he sought were not forthcoming, he returned to Yokohama in May 1901 to resume his career as a journalist. Within eight months, he launched his most influential propaganda publication, the *New People's Miscellany*. Consumed by Chinese expatriates in Japan, each edition ran to 14,000 copies; many were smuggled into China. As he observed the progress of Japanese modernization and interpreted Western Enlightenment literature, Liang came to believe that Confucianism was impeding China's progress. He began to diverge ideologically from Kang and, under the influence of Sun Yat-sen, briefly embraced the idea of a Chinese republic.

Educated in his native Guangdong Province and in Honolulu, the reformer Sun Yat-sen had studied medicine in Canton (now Guangzhou) before receiving his degree in Hong Kong in 1892. Around then, he converted to Christianity. Incensed by its corruption and impotence, he resolved to bring down the Qing dynasty through democratic revolution. Early in 1894, he had proposed to the governor-general of Zhili that China should model her reforms on the West. When he was ignored, he had gone to Hawaii to organize the Revive China Society, aimed at establishing a republic. With other revolutionary groups, he had launched the abortive first Guangzhou Uprising in October 1895; nine subsequent attempts also failed.

Arguing that revolution and monarchism were mutually exclusive, Sun rejected Liang's path to reform. But, despite their philosophical differences, the two cooperated, agreeing that, once their goal was

achieved, Sun would become China's president and Liang its vice president. Liang went to the Chinese diaspora in Hawaii to raise funds for an armed uprising, planned for August 1900. On his return to Shanghai, he found that the insurrection had been thwarted and most of its leaders executed. He escaped to Singapore, only to face the wrath of Kang for choosing revolution over constitutional reform.

In 1903, Liang traveled through the United States. He concluded that its systems—he thought them unjust—were unsuited to Chinese cultural nuances and unlikely to effect the reforms that China needed. He believed that his people, uneducated and inadequately trained, were unready for American-style democracy; China first needed to be united. As a result of his tour, he turned his back on Sun's radicalism (albeit again temporarily) and reconnected with Kang, committed to establishing a constitutional monarchy. After 1905, the younger generation, impatient with gradual change, chose Sun's approach. In August, in Tokyo, he united several organizations to form the bourgeois Chinese Revolutionary League. Its goals were, of course, consonant with those of the Revive China Society. In November, the League launched its propaganda publication, *The People's Report*; the first edition included a summary of Sun's program, incorporating the so-called Three People's Principles: Nationalism, Democracy, and the People's Livelihood.

The Lin family had another link with these momentous events.[4] Maya's grandfather's cousin Lin Juemin (in China, perhaps her most famous relative) has been passed over in the English literature. The grandson of Lin Zhen Gao, a prominent Fuzhou scholar, Juemin was influenced by Western thought from his youth. In 1907, he went to study at Tokyo's Keio University, and, in 1909, he joined Sun's Chinese Revolutionary League. Two years later, he was sent home to organize an anti-Qing uprising in Guangdong—the 10th one engineered by Sun. After several postponements, on April 27, 1911, the rebels—about 100 young men from all walks of life—attacked, only to meet overwhelming resistance. Wounded, arrested, and sentenced to death, Juemin was immortalized as one of the 72 Martyrs of the Hill of the Yellow Flowers. He was 24 years old. His poignant *A Letter to My Wife*, written on the eve of battle, is a modern Chinese literary masterpiece that is still widely read.

On October 10, two groups—the Literary Association and the March Together League—mounted yet another armed uprising, in Hubei

Province. Capturing three cities, they established the Hubei Military Government. Within weeks, 17 provinces had declared against the Qing. To save the dynasty, Zaifeng, the regent, recalled General Yüan Shikai out of retirement. He was too late; revolutionary forces had taken a huge toll upon the imperial army, and Zaifeng was toppled. On January 1, 1912, a provisional republican government was established in Nanjing, and Sun Yat-sen, having returned from the United States, was installed as its president. He drafted a provisional constitution, together with several decrees intended to promote democracy and capitalism, but his envisioned republic took form slowly. In August, his associate Song Jiaoren organized an alliance of smaller groups into the Nationalist Party, known as the *Kuomintang* (KMT).

Now able to return to China, Liang Qichao took a key role in forming another coalition, the *Jinbudang* (Democrat Party); he advocated a strong executive, in contrast to the KMT, which favored a two-house parliament. However, real power was already in the hands of Yüan Shikai, who commanded the Beiyang Army. To avoid civil war, Sun agreed to Yüan's demand to unite China under a Beijing-based government. In March 1913, Yüan replaced him as provisional president. What had happened until then was merely the beginning of sorrows. Many parties contended for political control, but, in the December 1912 National Assembly elections, the KMT secured a large majority in both houses. However, Yüan was already plotting against the republicans. His agents assassinated Song, then acting director of the KMT, and, the following June, supported by foreign capital and resolved to exterminate the KMT, he attacked Jiangxi and Nanjing provinces. In September, Liang Qichao's disciple Li Liejun declared Jiangxi independent and launched a punitive expedition against Yüan. Several other provinces—Anhui, Fujian, Guangdong, Nanjing, Hunan, and Shanghai—declared their autonomy.

Taking advantage of laxity within the KMT and discord in the leadership of his opponents, in October 1913, Yüan unconstitutionally seized the presidency and aborted the adoption of a constitution. Early in November, despite Liang's vehement objections, Yüan expelled 438 KMT parliamentarians. Having fled to Japan, Sun prepared the Chinese Revolutionary Party in July 1914 for an armed campaign, launching a couple of futile attacks. Late in 1915, Yüan convinced his puppet legislature to proclaim him emperor; again ignoring the provisional

constitution, he refused to reconvene parliament. The republican parties, organized by Liang and supported by military leaders, declared a "War to Protect the Nation," and, in March 1916, Yüan was forced to resign. From his death three months later until Chiang Kai-shek unified China, control was in the hands of generals and "warlords"–provincial military governors—who for a decade formed alliances or fought among themselves, according to their whims.

Sun Yat-sen and his second wife, the American-educated, politically radical Soong Ching-ling, returned to China, continually relocating between Shanghai and Guangzhou. In July 1917, Sun launched a movement to protect the constitution, and, a month later, parliament elected him Generalissimo of the Military Government of the Republic of China. About a month later, China declared war on Germany. China's part in the Great War was relatively minor: it invaded German and Austro-Hungarian settlements in Tientsin and Hankow and confiscated the Deutsche Asiatische Bank and 14 German ships in Chinese ports. In addition, thousands of Chinese laborers were sent to Europe to work for the Allies. Meanwhile, the southwestern warlords, contemptuous of constitutional issues, exploited Sun's prestige to inflate their own power before joining with their northern counterparts to oust him. He resigned in May 1918.

After a brief term in the cabinet of the Beiyang "warlord" government, in 1917, Liang Qichao retired from politics to return to scholarship. In 1919, he was a member of China's unofficial delegation at the Paris Peace Conference, a disappointing experience that convinced him of the "cultural and moral bankruptcy" of the West. In 1920, he became a history professor at the newly established Nankai University, in Tientsin. Later, he taught at Shanghai's Tung-nan University and the Tsinghua Research Institute in Beijing. He continued to write about Chinese cultural and literary history until his death, in January 1929, producing a body of work that would inspire later reformers.

To return to more immediate Lin family connections, although a lesser light than Liang Qichao, her paternal grandfather, Lin Changmin, was also a significant player in the genesis of modern China. Maya Lin's nonchalant remark, already noted, that he "helped to draft one of the first constitutions of China. He was a fairly well-known scholar" needs some expansion, because he did (and was) much more than that.

Changmin was the last in a line of competent mandarins, a gifted diplomat as well as a scholar, poet, and calligrapher. His powerful and distinguished father, Xiao Xun, had studied at the Qing Dynasty's Imperial Academy and been mayor of several counties of Zhejiang Province.[5] Having first attended the family's own school in Hangzhou, Changmin graduated from Waseda University in Japan in 1909. Returning to China, he was appointed General Secretary of Fujian Consultative Council and director of the Fuzhou Law School. Later, he established his own law school. When Sun's Nanjing Provisional Government was created, in 1912, Changmin held the position of Interior Counselor and Code Commissioner, and he helped to write its constitution. The following year, he was appointed General Secretary of the National Council Senate, and from 1914 he held several senior appointments: counselor of the Northern Government State Department; Director of the Legal Department; Chief Justice of Duan Qi Rui's Cabinet (for only three months); Director of the Foreign Affairs Committee; and member of National Council League.

Changmin knew Liang Qichao before their cabinet days—certainly they corresponded as early as 1910, when the latter was still in exile. Eventually, that friendship would lead to an arranged marriage between Lin's daughter and Liang's son. That romantic story and more of Changmin's family life is related in the next chapter. In relation to contributing to the making of modern China, he served as a catalyst for the crucial protest known as the May Fourth Movement.

Despite the failure of the 1911 insurrection, China's so-called new culture phenomenon would culminate, eight years later, in an expression of nationalism that united all social classes. The Beiyang government had cut deals with foreign powers and was exploiting the people, increasing already intolerable taxes. The consequent unrest, fueled by conflicts among the warlords, was brought to a head by the unfair terms imposed upon China by other nations in the Treaty of Versailles. The victors of World War I convened a Peace Conference in Paris early in 1919. Chinese delegates asked for the expulsion of foreign powers from China—notably, Germany from Shandong Province—and the annulment of the so-called 21 Demands made by Japan in January 1915. However, the Japanese, British, and French governments agreed to transfer Shandong to Japan. Lin Changmin was first to report the

outrageous decision; published in *Chenbao* (*Morning Paper*) on May 2, 1919, his article "Diplomatic Warning to the Nation" triggered the May Fourth Movement.

On that day, more than 3,000 students and staff from 13 Beijing universities joined in clamorous protest, condemning Japanese imperialism and the Chinese government's corrupt bureaucrats, and demanding the sacking of the three ministers whom they blamed for the loss of Shandong. When the house of one of the politicians was burned, many demonstrators were arrested and beaten; one died from his injuries. The next day, there was a general student strike in Beijing, which spread to other cities, ending with a general strike in Shanghai that paralyzed the national economy. The government was forced to dismiss the ministers, release the arrested students, and (at least symbolically) rescind its acceptance of the Versailles Treaty. The success of the Movement, as far as it went, demonstrated that China's different social classes could work together. Because it is celebrated in the revolutionary mythologies of both contenders for control of the country—the Nationalist Party and the (yet-to-be-formed) Communist Party—it is unsurprising that, more than 60 years later, Maya Lin's father, a former Nationalist, and Chai Zemin, Communist China's first ambassador to the United States, could amicably discuss Lin Changmin's part in modern Chinese history. Anyway,

> The outpouring of popular outrage through the May Fourth Movement coalesced in a new nationalism with repeated cries for a "new culture" that would reinstate China to its former international position. The way out of China's problems, many believed, was to adopt Western notions of equality and democracy.... Science and democracy became the catchwords of the day.[6]

Lin Changmin died tragically, in 1925, when his son Huan—Maya Lin's father—was just seven years old. The circumstances were these: Changmin advocated the idea of provincial, as opposed to national, government. In 1925, the Manchurian warlord Zuo-lin Zhang attacked Beijing, pronouncing himself head of a Central Government. In November, General Guo Song-ling of the Feng Army, after yet another uprising, invited Changmin to be Provincial Governor of Fujian. On

the last day of the month, the two left Beijing, but their car was ambushed at Xinmin Tun by a Japanese-sponsored wing of the Feng Army bent on assassinating Guo. As Lin tried to escape, he was killed by a stray bullet. His death seems to have left his family in financial difficulties, and his future son-in-law Sicheng (Qichao's son) was made executor of his estate. More details of the Lin family are set out in the following chapter.

By 1923, with military support, Sun Yat-sen had convened a government consisting largely of members of the former democratically elected parliament. Confident that a Nationalist-Communist coalition—the Chinese Communist Party (CCP) was founded in July 1921—could mobilize China's industrial workers and peasants, he admitted Communists to KMT membership. He believed that, with a large enough army he could unseat the warlords and create a reunified China. The Soviet Union, itself established only in 1922, furnished him with military advice, technology, and weapons. When Sun died, in March 1925, the KMT leadership was divided between the left-wing Wangh Ching-wei and the right-wing Hu Han-min. But the real power belonged to Chiang Kai-shek.

After training at Tokyo's Military Preparatory Academy, Chiang had returned to China in 1911. He joined the KMT to overthrow the Qing. He knew little about the West and would become increasingly attached to Confucianism and to Chinese identity, culture, and traditions. Nevertheless, he had embraced Sun's Three Principles—especially Nationalism. Under his leadership, the KMT established a government in the southeast provinces. China was burdened with warlord factionalism; as commander-in-chief of the National Revolutionary Army (and with Soviet assistance), Chiang launched the 1926–1927 Northern Expedition to crush three warlords and two independent armies. His forces took Beijing and Shanghai, and, within a year, he had subjugated the southern half of China. Then, in the "White Terror" of 1927, he turned the KMT against the Communists; those who survived were purged from the erstwhile alliance.

Dismissed by the Wuhan-based Nationalist government, Chiang set up an alternative administration in Nanking, and, when the Wuhan regime disintegrated, in February 1928, his group alone survived. With Chiang at its head, the Nanking Nationalist Party was China's nominal

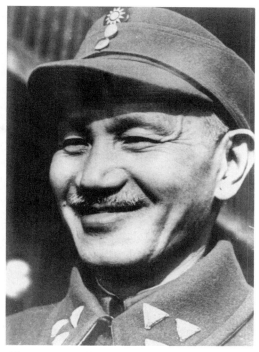

Chiang Kai-Shek, 1945. (Library of Congress.)

government until 1937. It attempted to unify the vast, culturally diverse country in the face of partisan divisions, mutinies by warlords, Communist threats in the south, as well as Japanese aggression in Manchuria, Beijing, northern China, and the coastal provinces. Despite achieving a handful of social and economic reforms, the Nanking party's failure to diminish poverty and establish democracy led to its eventual downfall. Moreover, those at the highest levels of the KMT, corrupted by aid from the West, were growing complacent. Chiang, trying to strengthen his party by liaisons with wealthy landlords, estranged the peasants, who formed the majority of the population. Aggravated in turn by the Great Depression and, later, by World War II and the incipient Cold War, China eventually would erupt into civil war.

When the Japanese invaded Shanghai in January 1932, the Nanking government moved inland. After July 1937, as an undeclared war broke out between China and Japan, the KMT and the CCP forged a second tenuous coalition, naturally fraught with mutual distrust.

Within 18 months, the alliance began to falter, and, after 1940, civil conflicts escalated in those regions that the Japanese had not occupied. The populace blamed the KMT, which it perceived as more concerned with anti-Communist purges than with resisting foreign aggression. Eventually, Chiang's Nationalist state was brought down by Japanese imperialism from without and by Communism from within.

The famous (or notorious) Mao Zedong played a preeminent role in the rise of Chinese Communism. He had embraced Marxism in 1918, and, as a labor organizer, he was one of the 12 Chinese at the CCP's first meeting, in Shanghai, in 1921, under the auspices of the Communist International. When Sun's First United Front subsumed the CCP, Mao moved to Shanghai as a KMT executive. He, too, broadly accepted Sun's Three Principles, especially that describing socioeconomic equality. A victim of Chiang Kai-shek's purge, Mao considered marshalling a revolution of the peasantry. (By contrast, Communist orthodoxy called for a revolution of the urban proletariat.) Working with Zhu De and Zhou Enlai, he coordinated peasant protests in Hunan Province; without the sanction of the CCP Politbureau, he mustered a guerrilla force in Hunan and Jiangxi, and, by winter 1927, his army of "peasants and workers" numbered 10,000.

Mao's prestige grew after the CCP's urban uprisings failed. Late in 1931, he proclaimed the Chinese Soviet Republic in Ruijin, under his chairmanship. Despite the Politbureau's disapproval and regardless of Chiang's military successes against him, he increased his control of the Communist movement. Then, in the fall of 1932, a half-million-strong Nationalist army surrounded his Red Army, based in South China. Within 12 months, the Communists had lost half their territory, and 60,000 of their soldiers were dead. Mao initially planned to break out and attack the KMT from the rear; instead, his army retreated, planning a push to the Communists' Second Army in Hunan. The legendary Long March began in October 1934. About 90,000 soldiers, party leaders, and bureaucrats took 40 days to get through the Nationalist positions, only to be attacked at Xiang, where they lost another 45,000 men. Instead of heading for Hunan, the remainder struck out for Shaanxi province—a 370-day, 8,000-mile march across swampy grasslands and some of the highest mountains in the world. Hundreds perished. Fewer than 10,000 reached their destination, where, with others, they eventually built a redoubtable force of 80,000.

Before the Long March, the CCP had suffered ideological and practical internal conflicts; after it, Mao assumed sole command and adapted Marxist-Leninist and Stalinist ideas to the Chinese psyche and traditions. Encouraging his leaders to integrate with the rural masses, he created an image of the Red Army as a guerrilla force prosecuting warfare in defense of the people—the People's Liberation Army (PLA). Beginning to plan a new China, by 1940, he had developed a program for attaining unchallenged political power. His teachings, later famously spread through *The Little Red Book,* became the nucleus of CCP thought, and, by 1945, Party membership would grow to 1.2 million. Chinese Communism became, in effect, Maoism.

When the United States declared war on Japan, in December 1941, the Sino-Japanese conflict became part of World War II. America immediately began to lavish massive financial and military aid upon the KMT, buying the right to station troops in China; besides enlisting a strong ally, the United States looked to exercise a stabilizing postwar influence in Asia. But, by the war's end, China was "economically prostrate" due to several causes—the costs of civil discord and a foreign war; rising inflation; and Nationalist Party profiteering and hoarding. As it often does, famine dogged the footsteps of war. And floods had dispossessed millions of people. To make matters worse, in February 1945, the Yalta Conference licensed Soviet troops to enter Manchuria.

Later that year, China's Nationalist and Communist leaders agreed on the form of postwar government—democracy, equality for political parties, and a unified military. But the antagonists soon engaged in civil war. Through American mediation, a cease-fire was agreed in January 1946, but, because neither side would compromise its ideology or yield territory regained from the Japanese, attempts at a truce foundered within months. Despite continuing negotiations, the peace completely collapsed in spring 1946. Although the Americans continued to support the Nationalists with substantial loans, they withdrew less than a year later, when it became clear that the tension could be ended only by armed intervention.

The Nationalists attempted to regain popular backing by undertaking reforms, but years of unrestrained corruption and poor government had eroded their standing. Although they enjoyed some advantages—international support, more personnel, more territory—over the PLA, their demoralized forces, exhausted by the war with Japan, were outstripped.

The PLA was well ensconced in the north, and in January 1949 it took Beijing unchallenged. By November, having first secured its hinterland, it seized other major cities, again meeting little resistance. In that final year of the civil war, the KMT suffered more than one-and-a-half-million military casualties before toppling completely. On October 1, Mao declared the establishment of the People's Republic of China (PRC), bringing to a climax a political upheaval that had begun in 1911. Chiang Kai-shek had added Taiwan (Formosa) and the Pescadores archipelago to China's territory in 1945. The Nationalists, anticipating defeat, had been seeking a secure location for a government-in-exile. They fled to Chungking and, on December 8, 1949, retreated to Taiwan.

Not all their supporters followed. Among the many young people who fled to America were Maya Lin's father, Huan (Henry) Lin, and her mother, Ming-hui (Julia) Chang. But, before discovering how they made a new life 7,500 miles from home, other significant members of the Lin family bear mentioning.

NOTES

1. Bill Moyers, "Becoming American," interview with Maya Lin, Public Affairs Television, 2003, http://www.pbs.org/becomingamerican/ap_pjourneys_transcript5_print.html.

2. American Academy of Achievement, "Maya Lin, Artist and Architect," Scottsdale, AZ, June 16, 2000, http://www.achievement.org/autodoc/page/lin0int-1.

3. Amanda Ryder, "Barbarian Emperors," *China Now* (December 1990), 30.

4. I am indebted to Wendy Yang and to the late Professor Yang Guo Qing of Fuzhou, People's Republic of China (PRC), for information about the Lin family before 1949.

5. Biographical information about Lin Changmin (drawn from Lin Changmin's ancestral home located at Nanhou Street) *Fuzhou Evening News*, April 26, 2008, 22. My thanks for the article are due to Tim Teng of Fuzhou, PRC, and Linda Liu for their translation from Mandarin.

6. "Chen Duxiu and the May Fourth Movement," *China: A Teaching Workbook*, Columbia University, East Asian Curriculum Project, n.d., http://afe.easia.columbia.edu/china/modern/read2.htm#May%20Fourth.

Chapter 2

A TRADITION IN ARCHITECTURE: LIN HUIYIN AND LIANG SICHENG

For almost 20 years after first learning of her extended family, Maya Lin seems not to have been eager to discover more. Her knowledge of her family remained fragmented and imprecise. Yet—and it was quite coincidental—within a couple of years of her father's disclosures, the significant roles that his half-sister, Lin Huiyin, and her husband, Liang Sicheng, played in Chinese architecture were published in America. Their work was recognized in two books: Jonathan Spence's *The Gate of Heavenly Peace: The Chinese and their Revolution, 1895–1980*, of 1981 and *Liang and Lin: Partners in Exploring China's Architectural Past*, written by their friend Wilma Fairbank and first published in 1984. Also in 1984, Liang Sicheng's own comprehensive English-language *A Pictorial History of Chinese Architecture* was released.[1]

In September 2002, when Lin was asked if she had learned more about her roots, she enigmatically replied, "I have and I haven't," and expanded:

Wilma Fairbanks [*sic*] just wrote a book on my uncle and aunt.... They are quite well known in China; a [TV] soap opera in Hong Kong is based on them. They were the pre-eminent architectural

historians. They studied architecture at the University of Pennsylvania and at Yale and brought Modernism to China. They were architects in love with an ideal. My aunt died young. My uncle at first was for progress and hence the design of Tiananmen Square [sic]; later in life, he realized the importance of preserving the old China. Then he was at odds with the regime that wanted to wipe away the old.... They traveled throughout China and documented the old temple styles in an amazing, beautiful book; it was a lost volume. Wilma and John Fairbanks [sic] found the volume and published it many, many years later.[2]

That response was replete with approximations and plain factual errors. That raises the question whether there is really a link between Lin's family heritage and her oeuvre, as some writers have asserted—indeed, as she herself has hinted. Certainly, it casts doubts upon the assertion that she is an "astonishing example of the power of genetics in shaping human creativity. She knew nothing, growing up, about a Chinese uncle and aunt.... *She came to regard the life of* [Lin Huiyin] *as a source of strength for herself.*"[3]

While there can be no doubting the "Chineseness" (Lin claims "Japaneseness," too) in some of her work, such categorizations are very broad. The means by which hints of oriental thought may have found expression in her modern Western art—and the degree to which they did so—deserve closer scrutiny. Is there a whiff of myth? Lin writes in *Boundaries*, published in 2000, that she "kind of" absorbed her Asian heritage without realizing it:

When I was twenty-one or twenty-two, a reporter was going: "Oh, but the [Vietnam Veterans] Memorial is so Asian." And I said, "Well, you're a Taoist; you're reading your Taoist thoughts into it." It took me another ten years to realize how much my work is as much about Asian or Eastern thought processes. I'm not learned [in Asian philosophy]. I almost did not want to go in and learn it.[4]

To examine the allegation of "the power of genetics," it is necessary to return to Lin Changmin and his unconventional—at least to

Western eyes—domestic arrangements. Because his first wife, one Miss Wang, bore no children, he took a concubine—euphemistically known as a second wife—named He Xue-yuan, who was uneducated and very conservative. She gave birth to Huiyin in 1904; a son died in infancy, and a second daughter died in childhood. Changmin's parents were concerned that he would have no more sons to continue the family name. Perhaps because Changmin was often away from the family home in Fuzhou, busy with politics, they did not arrange another marriage for him for many years. Returning to China from Japan in 1909, he moved with Xue-yuan and Huiyin to Shanghai. Three years later, they moved again, this time to Beijing. Around 1917, he took a second concubine—a Fukien woman, Cheng Gui-lin. She was by all accounts a sweet person but also uneducated. Because she produced a daughter and four sons—the eldest, Lin Huan, would become Maya Lin's father—Changmin favored her above the increasingly embittered Xue-yuan, who was consigned with her daughter to a small house in the family compound.[5] According to her son Liang Congjie, Huiyin loved her father but hated him for neglecting her mother, and she loved her mother but hated her for not resisting that neglect. He also asserts that she loved her stepbrothers; other sources, including Lin herself, claim that her father "adored" his half-sister.

Yet, Huiyin and Huan hardly could have known each other. She was age 14 when he was born. The whole family (including both wives), fragmented though its structure may have been, then lived in separate households in the same compound in Beijing. Huan was only two years old when Huiyin went to study in England and four she when returned to China. A couple of years, later she left to study in the United States for five years. In 1925, when she was there, Changmin fell to an assassin's bullet, and his untimely death further disintegrated the family. When Huiyin returned from America, in 1928, it was to teach at the Northeastern University in Shenyang—nearly 3,000 miles from Fuzhou, where Huan and his brothers were at school. He remained there through his university years, while his half-sister lived almost 1,500 miles away in Beijing until 1937. Then she and her family fled from the Japanese invaders, living in remote Lizhuang until the end of World War II; in 1941, Huan also moved 250 miles inland to Shaowu. In 1946, the siblings returned to Fuzhou and Beijing, respectively;

two years later, Huan went to the United States, never to return—and never to see Huiyin again.

Changmin was sent to London in the summer of 1920 as director of China's League of Nations Association. Possibly because neither of his wives would fit in diplomatic circles, the intelligent and beautiful 16-year-old Huiyin went him to host his social functions. In England, she enrolled at St. Mary's College at Richmond and took the English name Phyllis. A school friend—an architect's daughter—first made her aware of the notion of "architect." It may seem strange to modern Westerners that, even by the early 1900s, the profession was unknown in China; public and religious buildings were designed by mandarins or monks, while the form of less significant structures depended upon long-standing traditions, transmitted by building craftsmen. Architecture, unlike, say, painting and calligraphy, was not considered a fine art. Soon after the fall of the Qing, increasing numbers of young Chinese began studying architecture and civil engineering at American and European universities.

At the London International Union, Xu Zhimo, later a leader in China's modern poetry movement, met and fell in love with Huiyin, who was seven years his junior. In 1922, he abandoned, then divorced his wife, Zhang You Yi. But Huiyin was already engaged to Sicheng, Liang Qichao's eldest son, so Changmin took his daughter back to China. The separation (it has been said) broke Xu's heart—at least, for a while. Soon he began a tempestuous affair with Lu Xiaoman, who divorced her husband to marry the poet in 1926; it didn't last. Some authors insist that Xu never stopped loving Huiyin—incidentally, she said that she had never loved him—and dedicated much of his work to her. Xu's love affairs still capture the popular imagination in China; fact has become entangled with fiction, providing the plot for *April Rhapsody*, a TV soap opera produced in Taiwan in 1999. That, however, is another story.

Qichao instructed his nine children in classical Chinese culture. Eager for Sicheng to study political science, he also introduced him to organizations that promoted Western knowledge. But Huiyin, recognizing her fiancé's aesthetic sensibilities, planted another idea in his mind. Although he had no art training, Sicheng had been arts editor of a student newspaper at an English-language school, Tsinghua College.

So why not study social sciences or even architecture? Serious injuries sustained in a 1923 motorcycle accident delayed his plans for pursuing graduate studies in the United States, but, as soon as he recovered, he and Huiyin, supported by the Boxer Rebellion Indemnity Scholarship Program, went to America. They had been forbidden to marry until after graduation. First taking a summer program at Cornell, they later enrolled at the University of Pennsylvania. There, the French-born professor Paul Philippe Cret oversaw an architecture curriculum that was to train them in the Beaux Arts principles then dominating the American profession. An intensive study of architectural history lay at its core.

In the 1920s, women were barred from Penn State's architecture program, as they were at many universities, because it was widely believed that architecture was "no career for a woman." So, while Sicheng undertook studies for a master of architecture degree—he graduated with distinction in June 1927—Huiyin enrolled in the School of Fine Arts. But she was allowed to take architecture courses, and, in three years, she completed a four-year bachelor's degree with honors. She then became a part-time teaching assistant in—architecture! For a while after graduating, the couple worked as Cret's assistants, and later in 1927 Huiyin went alone to Yale to pursue graduate studies in stage design. Sicheng spent a year at Harvard, studying the history of Chinese architecture.

They were married in the following March 1928, in Ottawa, Canada. On the way home to China, they took a grand motor tour of Europe, along a route prescribed by Liang Qichao—England, France, Spain, Italy, Switzerland, and Germany—and then through Siberia. Their return in the fall, along with 10 foreign-trained compatriots, brought Western architectural thought to China. This group pioneered a revival of traditional architecture adapted to modern China's changing needs. Until then, many public and commercial buildings had been designed by foreigners, chiefly in the European historical revival styles found in treaty ports like Shanghai, Guangzhou, and Fuzhou. In 1928, the Society for the Study of Chinese Architecture (SSCA) was founded.

In September, Liang Qichao pulled strings so that Sicheng would be invited to establish and head an architecture department—the second in China—at the recently founded Northeastern University, in

Shenyang, then under Japanese control. With Huiyin and three other Penn graduates (Chen Zhi, Cai Fangyin, and Long Jun) forming the core of the faculty, he initiated a "Cret-style" curriculum. As well, the Liangs, in partnership with the latter two professors, produced the master plan and buildings for Jilin University, in Changchun.

When the Japanese invaded Manchuria, in September 1931, Sicheng had to close the architecture program at the National Tsinghua University (his alma mater), where he and Huiyin were then teaching. He became the SSCA's Director of Technical Studies, and, into the early 1940s, he was to lead a team that conducted a meticulous field study of China's historical buildings. Despite the Sino-Japanese war, World War II, civil conflicts, and the depredations of warlords and brigands, it would record more than 2,000 buildings in the northern provinces. It produced illustrated articles in the *Bulletin of the Society for Research in Chinese Architecture*. Sicheng's 18 field reports were published in 1982.

By 1937, when the Japanese occupied Beijing, the Liangs had two children—a daughter, Tsai Ping, eight, and a son, Tsung-chieh (Congjie), five. Intellectuals were highly esteemed and well paid in China, and the family had enjoyed a comfortable lifestyle in a simply furnished house with a large landscaped courtyard. They owned a Chevrolet and employed seven servants. But, early in September, unwilling to cooperate with the invaders, they abandoned their home. Taking with them with Huiyin's mother, a family friend, and two Tsinghua professors and carrying only what could fit in two suitcases, they left Beijing on a six-week odyssey to relative safety.

They traveled by boat and rail to Changsha, the capital of Hunan province. That proved a poor choice of sanctuary, because it was the target of the first Japanese air raids, and their house was destroyed. A few weeks later, they moved with other fleeing academics southwest to Kunming; the bus trip took a month. When the Japanese bombed Kunming, they moved on to Lizhuang, in Sichuan Province. Lizhuang, once a village, became one of China's major cultural centers, sheltering more than 12,000 refugee academics, writers, and students, as well as priceless national artifacts. The SSCA was made an Institute of the national *Academia Sinica*, and Sicheng was given charge of the architectural survey of Hunan and Sichuan provinces.

Until 1944, forced to survive on Sicheng's inadequate pay and without enough funds to support his work, the Liang household occupied a peasant's house with neither running water or heating. The family returned to Beijing in July 1946. As noted, China, its economy in ruins, was teetering on the brink of civil war. Liang was asked to re-establish an architecture department at Tsinghua University. The old family home was gone, and they moved into a house on campus. The long journeys had exhausted Huiyin, who had tuberculosis; denied medication and an adequate diet for almost 10 years, her health rapidly deteriorated. When American friends suggested that the Liangs might emigrate to the United States, they declined.

Sicheng was honored internationally after World War II. In February 1947, he was a member of the team of architects chosen to design the headquarters of the United Nations, in New York City. He was also appointed visiting professor at Yale for the 1947 spring term; later in the year, the university awarded him an honorary doctorate. Princeton followed suit, noting his pioneer research in Chinese architecture and planning. But, when he returned to China in 1948, the country was in the throes of civil war. He resumed his position at Tsinghua, where, perhaps influenced by the Modernists he had met on the U.N. project, he began experimenting with the fashionable Bauhaus-type curriculum. Around 1952, the Communist government, influenced by Russian revisions to the curricula of all Chinese universities, would put a stop to that.

At first, Sicheng and his wife kept in step with the regime. On September 30, 1949, the first session of the Chinese People's Political Consultative Conference (PCC) commissioned the Monument to the People's Heroes, in Beijing's Tiananmen Square. Chairman Mao laid its foundation stone even before design ideas were canvassed from all over China. A construction committee, formed from 17 organizations, appointed Sicheng as project manager. From 140 competition entries, 3 finalists were selected by October 1951; a hybridized final scheme—a bit of this one, a bit of that one—was presented for public comment at the PCC. The 125-foot-high granite pedestal, begun in August 1952, took almost six years to complete—not without continual revisions, some minor, some major—and it was dedicated on May Day 1958. Sicheng did not design it and should not carry the blame. But he and

Huiyin *were* responsible, with a team of six Tsinghua University staff, for the design of the National Emblem of the People's Republic. The result of another competition, it was officially adopted by the government on September 20, 1950.

The Liangs fell out with the Party leaders over redevelopment plans for Beijing. In June 1949, just before the Eighth Route Army occupied the city, senior Communist officers had asked Sicheng to identify significant cultural sites, to avoid damage in the imminent battle. The promises were hollow, and, once in power, Mao initiated a "program of ruthless reinvention" to make Beijing the national capital. Sicheng was then vice director of the city's planning commission, so the government naturally turned to him for advice. He urged Mao to build the proposed new administrative complex in the suburbs west of the Forbidden City, thus preserving old Beijing as a cultural center—a "living museum." The broad Ming dynasty walls, with their gates and moats, could be transformed, Sicheng suggested, into a public park. But his vision was rejected. British Sinologist Isabel Hilton writes that, tragically, "Mao began to destroy Beijing... [building the vast] Avenue of Heavenly Peace, and creating the world's largest and bleakest urban

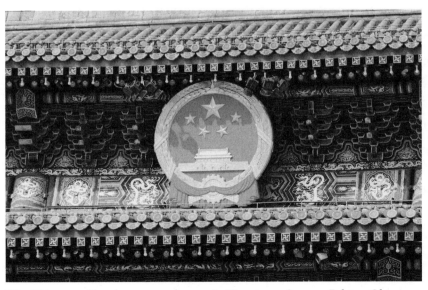

The Chinese emblem hangs over the gate in Tiananmen Square, Peking, China. (iStockphoto/Dariusz Kopestynski.)

open space, Tiananmen Square. In the sixties came the greatest cultural crime, the destruction of the 800-year-old wall."[6]

Although Liang Sicheng was universally esteemed, his relationship with his political masters was increasingly strained, because of his allegedly "formalist and reactionary" views about the future of Beijing. Becoming the Communists' target of choice, he was remorselessly attacked as a protagonist of architectural revivalism and accused of anti-Party "capitalistic idealism." In 1956, he was forced to "self-criticize" in a number of essays—the alternative was execution. His "misled" students were forced to denounce him, and, obliged to wear a sign labeling him a "reactionary academic authority," he was subjected to public humiliation. The Party dubbed him (according to his son's account) a "contemptible pile of dogsh*t."[7]

Huiyin—"particularly compelling,...charming, whimsical, poetic, witty, sensitive and capable of suffering in silence"—had lost her fight with tuberculosis in the previous year. She was only 51. Today she is feted for her critical writings about architecture, arts, literature, and philosophy; she also wrote poetry, essays, and fictional works. Maya Lin's father commented upon his daughter's resemblance to her: "Maya is very emotional, very sensitive. She was always been interested in the arts but at the same time all the female Lins are very strong, very independent: all very talented and very determined. Maya and my sister are very similar in personality."[8]

Seven years after Huiyin's death, Sicheng married a family friend, Lin Zhu, an archivist in the Tsinghua architecture department. The authorities unsuccessfully tried to persuade her to divorce him. They also evicted him from his small house, compelling him to move to a single room. He was forced to dispose of most of his books and was denied contact with "outsiders"—even his son. After 1966, he became very ill, and, in January 1972, he died in a Beijing hospital, a lonely man complaining, "I regret that I took up architecture. It would have been better if I had studied mechanics or radio."

Some of Liang's English-language essays on Chinese architecture appeared in *Encyclopedia Americana, Asia Magazine* and in *Pencil Points* in the 1930s and 1940s, but he never saw his magnum opus in print. As noted, written in English and originally intended for publication in the late 1940s, the scholarly, profusely illustrated *Pictorial History of Chinese*

Architecture remains the most comprehensive analysis of China's architectural development. It records ancient buildings in photographs and detailed drawings, annotated in both Mandarin and English. Because her English was better than his, Huiyin wrote and edited parts of the text. A Chinese version, *Zhongguo jian zhu shi*, was "unofficially" produced at Tsinghua University in the 1950s, but it was not published until 30 years later.

Despite an opportunity to discover them, Maya Lin seems to have been unaware of her aunt's and uncle's achievements. She protested, "I had studied architecture for four years [sic] in undergrad and it never comes out that there's this background on this amazing woman [Lin Huiyin]"[9] It raises questions about why her father didn't tell her about these significant connections earlier than he did—especially when she decided that she wanted to study architecture. His reticence does not sit well with Lin's claim that her father "adored" his half-sister. She recalled, "[I would] say, 'Oh, you didn't tell us much about your family history,' and my mother [would] say, 'Oh, you never asked.'...[I] guess that they didn't speak much about it because...it might have been painful for them because they had to leave all their family, all their friends. And because they weren't going to be offering it up, we didn't ask."[10]

So is there some kind of hereditary connection between Lin and the famous aunt whom she never knew—indeed, whom she never knew *about?* Is there in her work, as Robert Campbell contends, an "astonishing example of the power of genetics in shaping human creativity"? Louis Menand asks, "Was her own passion for monuments influenced by her family?" and answers himself, "Not at all. In fact, this connection was news to Lin." Yet, he contradicts himself: "There is, so to speak, monument-making in her genes."[11]

As for Campbell's poetic statement that Lin "came to regard the life of [Lin Huiyin] as a source of strength for herself," one need only read the verbatim transcript of an interview given in 2000:

> I think I'm—I'm following in the footsteps of my aunt's, my half-sister on my father's side, where essentially—I mean, I have a funny legacy. [Lin Huiyin and Liang Sicheng] were, like, sort of the strong art historians of China. They catalogued most of the architectural works—historical works of China. They also helped

to bring modernism. They studied at University of Pennsylvania, went back to China in the Communist Revolution, and they designed Tiananmen Square.[12]

NOTES

1. For later editions, see Wilma Fairbank, *Liang and Lin: Partners in Exploring China's Architectural Past* (Philadelphia: University of Pennsylvania Press, 2009), and Liang Sicheng, *A Pictorial History of Chinese Architecture* (Cambridge, MA: MIT Press, 1984).

2. Jan Garden Castro, "One Who Sees Space: A Conversation with Maya Lin," *Sculpture* 21 (September 2002): 36–43, http://www.sculpture.org/documents/scmag02/sept02/lin/lin.shtml.

3. Robert Campbell, "Rock, Paper, Vision," *Boston Globe*, November 30, 2000. Emphasis added.

4. Michael Krasny, "Thinking with Her Hands" (interview), *Whole Earth* (Winter 2000), http://www.wholeearth.com/issue/2103/article/125/thinking.with.her.hands.

5. I am indebted to Wendy Yang and to the late Professor Yang Guo Qing of Fuzhou, People's Republic of China (PRC), for information about the Lin family before 1949. Further biographical information about Lin Changmin is drawn from ["Lin Changmin's Ancestral House Is Located at Nanhou Street"] *Fuzhou Evening News*, April 26, 2008, 22. Thanks for the article are due to Tim Teng of Fuzhou, PRC, and Linda Liu for their translation.

6. Isabel Hilton, "The Lost City," *Granta* 73 (Spring 2001), http://www.granta.com/Magazine/73/The-Lost-City/2.

7. "The 2000 Ramon Magsaysay Award for Public Service," August 31, 2000, Manila, Philippines, http://www.rmaf.org.ph/Awardees/Biography/BiographyLiangCon.html.

8. Phil McCombs, "Maya Lin and the Great Call of China," *Washington Post*, January 3, 1982, F1.

9. Bill Moyers, "Becoming American," interview with Maya Lin, Public Affairs Television, 2003, http://www.pbs.org/becomingamerican/ap_pjourneys_transcript5.html.

10. American Academy of Achievement, "Maya Lin, Artist and Architect," Scottsdale, AZ, June 16, 2000, http://www.achievement.org/autodoc/page/lin0int-1.

11. Louis Menand, "The Reluctant Memorialist," *New Yorker,* July 8, 2002, 54–65.

12. Maya Lin, "Boundaries," *Booknotes*, November 19, 2000, http://www.booknotes.org/Transcript/?ProgramID=1589. Tiananmen Square was laid out in 1651 and was enlarged to four times its original area in 1958.

Chapter 3

ESCAPING CHINA: MAYA LIN'S PARENTS

Many accusations were directed at Maya Lin's winning design for the Vietnam Veterans Memorial in Washington, D.C. Among the wildest came from one Ted Sampley, a notorious extremist. After regurgitating a few ill-digested scraps of knowledge, he concluded that her proposal was underpinned by an "un-American" philosophy. He asserted, "*It is obvious* that Maya Lin was born into a family whose culture and values are rooted in Confucianism and that its influence has played, either consciously or subconsciously, a pivotal role in her creative expressions."[1] Wrong and—dare it be said?—wronger! The truth is that for several generations Lin's forebears on both sides were Christian—Methodist, to be exact.

Christianity reached China in the seventh century. Twelve hundred years later, Western powers used the first Opium War and subsequent unfair treaties to open China to economic exploitation; Protestant missionaries followed. In September 1847, American Episcopal Methodists arrived, and, within 10 years, they were well established in Fuzhou. Soon there were 60 mission stations in six regions of Fujian Province: the denomination founded a college and extended its work for 300 miles along the Yangtze; churches, schools, and hospitals were

built in Beijing and other centers. When the Communists took power, in 1949, there were more than 50 churches of various traditions in the Fuzhou area; today, about one in seven of Fujian's 35 million people is Christian.

There is often a common pattern in a family's religious allegiance. The fervor of converts is diminished in their children, who "take it for granted," and conviction is dulled as generations pass. Although Maya Lin's mother described her own father as "devout," it seems that she and her husband (a third- or fourth-generation Christian) had no active church connections apart from a church wedding. Describing her personal spirituality, Lin says that she embraces no formal creed but follows her own ethical values.[2] Her husband, Daniel Wolf, is Jewish.

Lin's father, Huan, saw little of his own father, Changmin, who was often away from home on government business, sometimes for years at a time. As noted, he was murdered when the boy was only seven. Lin once described her father's upbringing as "fairly [strict] upper-crust," but there is no objective evidence that he underwent traditional Chinese schooling. What *is* documented is that, because his father's family was both Christian and progressive, Huan had a Westernized education. He graduated from Fujian College High School in Fuzhou in 1937, then enrolled in a bachelor of arts program at Fujian Christian University (FCU), taking a major in education and a minor in agricultural economics. The selective policies of China's central government made such private universities necessary in the emergent modern nation. Flourishing cosmopolitan areas like Shanghai, Beijing, and Guangzhou attracted most of the government's investment in tertiary education. Elsewhere, the responsibility was left to provincial governments, which often could not afford to meet it, or to private interests. So, before 1931, Fujian had no national or provincial government university. But, because the city was the Methodists' first beachhead in the Far East and because missions established colleges that fit their regional programs, the two Christian colleges in Fuzhou and the private Xiamen University were crucial to the province's education system.[3]

The second Sino-Japanese War began in earnest with the full-scale invasion of China early in July 1937. As Britain, France, and, later, the United States joined China in resisting Japan and its Nazi/Fascist allies, the local conflict was subsumed by World War II. When Japanese

forces overran most of China's eastern seaboard, several universities fled, lock, stock, and barrel, from the coastal cities, and, for about 10 years, FCU established a "refugee campus" at Shaowu, 250 miles inland in the northwest part of Fujian. From 1941, it shared accommodation there with Hangchow Christian University.

After completing his degree, in 1942, Maya's father, Lin Huan, taught Principles of Education at FCU until 1944. During that period, he also worked as assistant secretary to the university's president, Lin Ching-jun. In 1944–1945, the U.S. Navy Air Force employed him as an interpreter on an annual salary of $250 (an apprentice American seaman was paid $50 a month) and posted him to the former Chinese Nationalist airfield at Kienow, in Fujian. He returned to Fuzhou in April 1946 when, in great financial difficulties, FCU returned to its badly bombed campus. Huan resumed teaching and was also made secretary to acting president Theodore Hsi-en Chen. He also served as registrar and director of the university's publications office until 1948, when he left his beloved China, never to return.

The People's Liberation Army occupied Fuzhou on August 17, 1949. The Communist government realized that many existing academic institutions could serve its purposes. Consequently, FCU, specializing in agriculture programs and teacher training, was allowed to continue relatively unchanged—at least, for the time being. But, in 1951, guided by Russian advisers, there were major reforms in the national curricula and a restructuring of China's education system. Most Christian colleges and universities soon were abolished or, like FCU in 1953, absorbed into public institutions.

By then, Huan had been in the United States for five years. According to one writer, he escaped from Red China "fairly easily," on a scholarship to study education at the University of Washington (UW). But his career path soon diverged into the field of art ceramics. Like that of many young Chinese then in America ostensibly to study, his heartbreaking decision not to return to China was probably political. His father and most of his extended family were Nationalists. Nothing is documented of his personal convictions. Explaining that neither of her parents spoke much of their past, Lin guessed that Huan had emigrated because, as the eldest son of a wealthy family, he was in danger. However, it is uncertain how much of the family's wealth remained

after World War II or how much the cash-strapped FCU could afford to pay its staff. Perhaps he was just seeking a better life. Lin believed that her father "was a bit of a rebel [who] wasn't allowed to go into art in China." She asked rhetorically, "Why did he like pottery so much? Because his father had an amazing collection of Chinese ceramics and porcelain so he had an appreciation for it. And then he was finally able to do what he wanted to do in America." But when Huan began to study pottery, his father, whom he had hardly known, had been dead for about 25 years. And, it might be asked, against what or whom does a 30-year-old rebel?

In China, Huan Lin had been a senior university administrator. In America, despite his fluency in English, it was impossible to take up where he had left off. In 1949, he enrolled in a master of fine arts degree program, taking a major in ceramics under the Swiss-born potter Paul A. Bonifas. For anyone intending to become a ceramicist, there hardly could have been a better move. Huan registered at the university as Huang Ling—an alternative English spelling that he used until 1957. He would complete his degree in 1956, with a thesis titled "Ceramic Art in Modern Living."

The Fine Arts School at UW was Modernist. After 1919, its faculty began to produce art that reflected contemporary international ideas, and, in 1923, Walter F. Isaacs was appointed dean and initiated a curriculum that led to the birth of modern art in Seattle.[4] Bonifas, a "modernist giant," had worked as a subeditor of Amédée Ozenfant's and Le Corbusier's radical Purist art journal, *L'Ésprit Nouveau*. His association with Ozenfant was revived during the Great Depression, when they both were drawn temporarily into H. Th. Wijdeveld's *Academie Européenne "Méditerranée"* on the French Riviera. When that venture failed, in 1934, Bonifas migrated to the United States and began teaching ceramics at UW.

At the end of his second year of study, Huan met Ming-hui Chang— she had taken the English name Julia—a pretty woman, some 12 years his junior, who had fled China in 1949. After completing a bachelor of arts degree at Smith College in Northampton, Massachusetts, in mid-1951 she moved to UW to pursue graduate studies. As noted, the couple came from Christian backgrounds (in 1956 Huan cited Methodism as his "preferred religion") and, following what must have been a

whirlwind courtship, they married in Seattle's Christ Episcopal Church on December 28, 1951. They rented an apartment on N.E. 40th Street, on the edge of Seattle's University District. Huan was obliged to find employment. From September 1951 until January 1955, he worked as a darkroom technician in the College of Education. Then he was appointed a teaching assistant in Art Education—his first academic post in America. For 18 months, from February 1955, he was Bonifas's research assistant, until he became an acting instructor in September 1956. Having chosen a career in a new discipline, he needed to build it from the bottom up.

Chang Ming-hui had dramatically escaped from her hometown, Shanghai, in 1949. She has told the moving story in UW's alumni magazine, *Columns*: here, a summary must suffice.[5] Her father, Chang Fu Xing, was a successful ophthalmologist, an alumnus of Pennsylvania State University. Her mother died when Ming-hui was only seven, and Fu Xing remarried. Both her grandmothers were physicians; one had trained at Johns Hopkins University. Many influential Chinese organizations had existed for some time in America; among other functions, they found employment and housing for immigrants, and acted as advocates before the U.S. and Chinese governments on behalf of regional groups. Fu Xing used his American connections to secure admission to Smith College for his daughter, then a junior at St. John's University in Shanghai. She "dreamed of studying English literature at an American university, then returning to teach in Shanghai, introducing to [her] students the great literary traditions of the West."[6] On May 24, 1949—the very day that Communist forces entered Shanghai—a telegram arrived from the college, offering her a scholarship.

The imminent Communist victory threatened to shatter her dreams. Her father, like most upper- and middle-class citizens, supported the Nationalist Party, which by then was almost on its knees. Fearing that China's borders would soon be closed to the West, Fu Xing urged Ming-hui to leave. To secure her safety, he made the agonizing and costly decision never to see his daughter again—that is a paradox of parental love. Although plans were discussed for her younger brothers, Yong and Heng, to follow her to America as soon as they reached the "right age," the family knew that the chances of achieving this were slight.

Ming-hui was to be smuggled out of Shanghai with a friend, Shirley Wang, on a junk belonging to one of Fu Xing's patients. It regularly sailed to the Zhoushan Islands, which were still held by the Nationalists. From there the girls could take passage to Hong Kong or Taiwan and on to America. But there was little chance of safe departure through the early summer of 1949, as Nationalist aircraft continued to bomb Shanghai, Nanjing, and other coastal towns. The young refugees finally embarked before dawn one August morning. Lin's mother recalls

> I felt I was abandoning [my brothers]. I felt even more guilty about leaving my father and my maternal grandmother, Hao Po—two people I loved the most. Although I did not know it at the time, it would be three decades before I would see my brothers again, and my dear [nanny] Liu Ma. And I would never again lay eyes on my father or my grandmother.[7]

Like many professionals in China, her father was forced to forsake his practice during Mao's notorious Cultural Revolution. He died in 1975.

Besides her suitcase, Ming-hui carried just a few indispensable documents and a small amount of U.S. currency sewn into her clothing. Even aboard the junk, she was not nearly safe. Bombing recommenced at first light and intensified during the morning, but the vessel was able to weigh anchor during a lull before noon. When gold was found hidden in the galley, customs officers delayed their departure while the captain was taken ashore "to clear the matter up." It may be suspected that money changed hands before they were allowed to sail. The four available berths were occupied by other passengers, so Ming-hui and Shirley were forced to sleep on the floor. Their three-day voyage was fraught with incident: to add to the appalling below-deck conditions, part of the cargo was vermin-infested; there was a violent monsoon; and they were attacked by machine-gun-brandishing pirates. Even after they reached the relative sanctuary of the Zhoushan Islands, the girls remained aboard for another night while the captain obtained permission for them to disembark. No doubt more palms were greased.

Two prearranged contacts failed to materialize, and Ming-hui and Shirley stayed with the boat owner's family for more than month, until an introduction was arranged to the Nationalist's Chief of Secret Police. He organized their passage to Xiaman, on the south coast of Fujian, and from there finally, via Hong Kong, to America. Safely in the United States, the girls parted company. Shirley enrolled at Flora MacDonald College in Red Springs, North Carolina, for only a semester, before moving to Peabody Conservatory. Ming-hui arrived at her destination in October 1949. Forty years later, having distinguished herself in the New World, she poignantly wrote:

> Have there been any regrets? The answer is yes and no. I regret with great sadness that I never got to see my father and grandmother again....However, I have no regret at all in making the choice of leaving China and later in making my home...in the States. I must confess that at times I still feel homesick for China but I've mellowed enough to realize that the China I used to know and love no longer exists, except in my memory.

In June 1951, Smith College awarded her a bachelor of arts degree, with a major in English. While at Smith, she was regarded as the unofficial Asian studies department, teaching Chinese, Japanese, and Indian literature "in translation." Then, as noted, in October, she moved to Seattle to enroll in UW's master of arts program. She graduated in December 1952 with a thesis titled "Yeats and Indian Philosophy."

In 1954, Huan Lin—by then he was calling himself Henry— co-founded Northwest Designer Craftsmen, a guild-type collective that aimed to encourage high standards of design and craftsmanship in the region and to generate public interest in the crafts. His colleagues worked in widely diverse fields: stained glass artist Russell Day; jewelry designers Coralynn Pence and Ruth Pennington; weaver Hella Skowronski; portraitist and enamelist Lisel Salzer; woodworker Evert Sodergren; lighting designer Irene McGowan; and another ceramicist, Robert Sperry.

Henry and Julia's son, Tan—Maya's only sibling—was born in 1956. By then, Julia had joined the faculty of the Far Eastern and Russian Institute at UW as a teaching assistant and had started to work on a

doctoral degree. Meanwhile, Henry was enjoying a expanding national reputation as an art potter, winning awards in exhibitions not only in the Northwest but also in California, Minnesota, Kansas, and as far away as Florida. In July 1957, he was given a one-year appointment as an art education instructor in the University of Wisconsin's Pottery and Advanced Ceramics program. For a number of reasons—not least the move to Madison—Julia deferred her doctoral research. In 1965, she would return to Seattle for several months in order to complete her thesis. In August, she was awarded a doctor of philosophy degree in Far Eastern and Slavic Languages and Literature for a dissertation titled "Tradition and Innovation in Modern Chinese Poetry."

The Lins moved to Athens, Ohio, in 1958, when Henry was appointed an associate professor in the School of Art at Ohio University (OU). In May 1966, he was promoted to full professor, and two years later he became director of the school. In 1972, when Anthony Trisolini, Dean of the College of Fine Arts, died unexpectedly just a week after being appointed, Henry replaced him. He held that position until his retirement in June 1984. Lin has spoken gratefully of her father's decision to forfeit his art practice and return to academic management in order to pay for his children's education: "That was a very tough sacrifice for him. It's sort of sad. By the time he retired and went back to ceramics, arthritis had kicked in."[8] Henry was also an excellent teacher—that was attested by his students—and joyful about the medium that he knew so intimately.

Henry Lin, like his daughter, was an intensely private person, and there is little about him on the public record. One of his former students observed that he was uncommunicative, although never unpleasant. He published hardly anything (then again, few senior university administrators have time to research and write), and he diligently avoided social events and the public eye. Little of his pottery has been published, and there are only a couple of portrait photographs in the public domain. But there are glimpses of a modest man. Professor Ursula Belden of OU tells of his exchange with a cardiac surgeon who addressed him as Dr. Lin: "When Henry protested that he wasn't a Dr., just an MFA, the surgeon replied, 'Yes, you are a doctor. I have seen your work and it is beautiful. I am a Dr. because I heal the body. You are a Dr. because you heal the spirit.'"[9]

His sense of humor is illustrated by an anecdote published in an Athens, OH, newspaper almost two decades after his death.

> In the 1970s, then [university] President Claude Sowle decided to hold public meetings at which college deans would argue for money for their departments.... [At one] Lin began his remarks by saying, "*Ni hao, Dr. Sowle.*" Of course, he was speaking Mandarin, and he continued to speak Mandarin—which Dr. Sowle did *not* understand—for the rest of his remarks, occasionally using a Chinese abacus to emphasize a financial point. At the end of Lin's remarks, President Sowle told him, "Henry, you know I don't understand Chinese, but I've never understood you more clearly than right now—you need big bucks!"[10]

The article did not reveal whether the ploy was successful.

He made his mark upon the College and the wider OU community. University President Claude Sowle succinctly observed that he brought sobriety (whatever that meant) and a sense of mission to the deanship. During his tenure, new programs were created in art therapy and film history and criticism. In 1967, he suggested that the college's so-called teaching gallery should become a public art museum and a venue for social gatherings; after seven years of determined effort on Lin's part, the Anthony G. Trisolini Gallery was established. In 1978, he initiated the Trisolini Print Project, and, for more than 30 years, contemporary artists—some with no printmaking experience—have taken up residencies to work in print media, building up an important body of work. The Contemporary American Print Collection is now housed in OU's Kennedy Museum, located in Lin Hall—named, of course, in Henry's honor.

It has been difficult to gain further insights into the man whom Lin credits with being, through the closeness of their relationship, the "single biggest" contribution to her achieving her goals. Asserting that she and Henry bonded from "the day she was born," she reflected, "My brother formed a unit with my mother, and my father and I formed our own.... I got the same attention from him that would in those days have been given to a boy. I was completely aware that it was unusual. And that made all the difference to me."[11]

By the time he retired, Henry had developed chronic cardiovascular problems. In August 1989, following a heart attack, he passed away at Cottage Hospital, in Santa Barbara, where the Lin family had a second home. His body was cremated in California, and several weeks later a private memorial service was held in Athens. There was no publicity, no fuss. In 1990, the University's art gallery held a retrospective exhibition of his work.

Julia Lin began teaching at OU in 1965, and she was appointed assistant professor of English in September 1967. Later rising to full professor, she was granted tenure in 1972. In the 1968–1969 academic year, while Henry was undertaking independent studies in ceramics on sabbatical leave at Berkeley, she was supported by the American Council of Learned Societies as she completed a treatise on modern Chinese poetry, the first English-language book-length study of its kind. Based upon her doctoral dissertation, it was published in 1972 as *Modern Chinese Poetry: An Introduction*. In 2008, she wrote, with justifiable pride, "my father wrote me a most loving letter, telling me he felt blessed to have a daughter who through determination and effort had produced such a splendid work." She added,

> When I began teaching Chinese literature he sent another letter, saying how pleased he was that instead of introducing great Western works to students in China, I was introducing magnificent Chinese culture to students in the West. Though he never said it outright, I have always felt that these were his ways of letting me know how happy he was to have gotten his beloved daughter out of China—even at such a great and permanent cost—and to see her fulfilling her dreams in a new life, on a new continent.[12]

Julia's *Essays on Contemporary Chinese Poetry* was published by Ohio University Press in 1985, and, in 1992, she translated *Women of the Red Plain*, an anthology of contemporary poetry by Chinese women. She retired in 1998, with emeritus status. The following year, she was named as one of 30 high achievers among Smith College alumni at a gala event marking the school's 125th anniversary. In retirement, she continues to be productive: in 2009, she translated and edited *Twentieth-Century*

Chinese Women's Poetry: An Anthology. After living in Athens, Ohio, for so long, in 2003 Julia Lin moved to an apartment in Newtown, Pennsylvania, to be closer to her children and grandchildren.

On occasion, Maya Lin has explained her parentage quite simply:

> Sometimes a total stranger ... will ask me where I am from. I mutter "Here it goes again" or I will respond, "Ohio," and the stranger will say, "No, no, where are you *really* from?" ... I used to practically get into brawls with the person, insisting I was really from Ohio. ... Now, practiced at avoiding conflict, I say, "Ohio ... but my mother is from Shanghai and my father is from Beijing."[13]

NOTES

1. Ted Sampley, "Have You Ever Wondered Why the United States and POW/MIA Flags Are Not Allowed to Fly over the National Vietnam Veterans Memorial Wall?," *U.S. Veteran Dispatch* (March–May 1997), revised 2005, http://www.usvetdsp.com/maya_lin_wall.htm (emphasis added).

2. Bill Moyers, "Becoming American," interview with Maya Lin, Public Affairs Television, 2003, http://www.pbs.org/becomingamerican/ap_pjourneys_transcript5.html.

3. Ryan Dunch, "Reflections on Missionary Education in Modern China," www.library.yale.edu/div/colleges/dunch.doc.

4. Matthew Kangas, "How the UW Art Teachers Brought Modern Art to Seattle," *Art Guide Northwest* (Spring 2009), www.artguidenw.com/UniversityModerns.htm.

5. Julia Lin, "My Escape from Shanghai," *Columns* (December 2008), 24–36.

6. Ibid.

7. Julia Lin, *Class of 1951, 50th Reunion Book* (Northampton, MA: Smith College, 2001), 63.

8. Moyers, "Becoming American."

9. Ursula Belden, "Keynote Address at the 24th Annual Ohio University Honors Convocation on September 22, 2001," http://www.ohio.edu/reflections/insight.html.

10. http://www.athensnews.com/news/sports/2007/feb/12/wise_up_
money/.

11. Nancy Hass, "Hey Dads, Thanks for the Love and Support…,"
New York Times, June 16, 2002.

12. Lin, "My Escape."

13. Moyers, "Becoming American."

Chapter 4

"PEOPLE HERE ARE NICE": ATHENS, OHIO

During a visit to Fuzhou in the summer of 1985, Maya Lin joked that her father had been content to remain in Athens, Ohio, because its uncomfortable humidity reminded him of his home in China.

Athens stands on the Hocking River in southeastern Ohio, surrounded on three sides by the wooded foothills of the Allegheny Plateau. Not far away, even-topped ridges rise to 1,000 feet above sea level; steep valleys, their sides covered with lush forests, cut between them. In the fall, dense stands of native pine and hemlock contrast with the oranges, russets, deep reds, and brilliant yellows of maple, beech, hickory, oak, and tulip trees. In spring, the forest explodes with the colors of flowering dogwood, red-bud, and wildflowers. Athens's central business district—locally named "uptown" rather than "downtown" because, from most parts of the hilly town, it is *literally* "up"—and the sprawling Ohio University campus are encircled on the north, east, and west by grids of residential lots. The outermost northern and western neighborhoods push their winding, wooded fingers into the precipitous hills of Wayne National Forest.

A year after the U.S. Congress adopted the Land Ordinance of 1785, Rufus Putnam and Benjamin Tupper, with an entrepreneurial group of Revolutionary War veterans from Massachusetts, established the Ohio

Company of Associates, to acquire land in the Northwest Territory.
The Northwest Ordinance of 1787 proposed the creation of a number
of new states, and, because "religion, morality, and knowledge [were]
necessary to good government and the happiness of mankind," educa-
tional institutions were prescribed as essential to settlement. The Ohio
Associates bought 1.5 million acres for just eight-and-one-half cents
each. To create a buffer between them and the Native Americans and
to expedite settlement, Congress gave the Company another 100,000
acres—the so-called Donation Tract.

In April 1788, Putnam led a party to establish the Territory's first per-
manent community, Adelphia, at the junction of the Muskingum and
Ohio Rivers; later it was renamed Marietta. But nine years would pass
before flatboats carrying Athens County's first 11 white settlers came
down the Ohio. They chose an "attractive bluff"—the present location
of Athens—above a tributary, the Hockhocking , as a convenient site for
a university between Marietta and Chillicothe. At first, the pioneers were
content simply to clear and farm their land, but, as others arrived toward
the end of the 18th century, a township was laid out. Ohio became a state
of the Union in 1803, and two years later the new town (such as it was)
became the county seat. Athens was incorporated as a village in 1811
and achieved city status in 1812, when the population reached 5,000.

Salt was the nucleus of the county's economy, and communities flour-
ished around its extraction until after the Civil War, when the industry
waned in the face of market competition. Completed in 1845, the 56-mile
Hocking Canal connected Athens to the Ohio and Erie Canal; it was
closed in 1890, about 30 years after the Cincinnati and Marietta Rail-
road reached Athens. By then, almost all of the county had been cleared
for farming. After 1870, coal mining had replaced salt as the major in-
dustry; like brick making, it was an essential part of the region's iron
production. By 1920, Athens County's annual coal output exceeded
6.5 million tons, but the boom was short-lived. As gas and oil became
more popular fuels for home heating in the early 1940s, most of the
mines shut down. After World War II, the coal companies strip-mined
parts of the county, but those operations ceased around the mid-1960s.[1]

However, the town of Athens had a different reason for being—
not industry but Ohio University (OU), founded by Putnam, Tupper,
Winthrop Sargeant, and Manasseh Cutler and incorporated in 1802.

It received its charter from the state legislature on February 18, 1804, and opened in June 1809 with only three students. Its first undergraduate degrees were awarded in 1815. The earliest faculty had only a basic (albeit wide-ranging) education, and courses were of little more than modern high school standard; only after 1822 did specialist academics offer a traditional college program.

The West, East, and South Greens—clusters of student housing around landscaped open spaces—make up much of the university's picturesque 1,700-acre campus. The pragmatic names approximately describe their location. Another group of buildings, known as The Ridges, formerly a large state-run psychiatric hospital, faces the main campus across the Hocking River. The university's heart is College Green, at the south end of Athens's main thoroughfare, Court Street—named for the dominant County Courthouse. Many of the classroom buildings surround that Green, and it is overlooked by elegant Cutler Hall, a Regency-style red brick pile with white stone dressings, crowned with a central tower. Opened in 1819, Cutler Hall provided an aesthetic precedent for most of OU's buildings (even into the present century), as well as for much of the town's late-Victorian architecture.

A scenic view of Mirror Lake on the Ohio State University campus. (Ohio State University.)

Architect-planner Pamela Callahan, a long-time resident, describes Court Street, the six-block central business district, as an "architectural time capsule" and admiringly notes the visual integrity of the town and campus environments. Bookshops, clothing and other specialized stores, restaurants, fast-food outlets and bars—*lots* of bars—line Court, Washington, and State Streets. Brick-paved side streets and sidewalks lead to quiet blocks of houses, functionally and visually linking the town and university districts. When pondering what drew her back to Athens after completing her studies at OU, Callahan, a former New Yorker, grows lyrical:

> On most workday mornings I approach Athens from the north. . . . I come around the bend . . . and unveiled before me is a proper town. Steeples, towers and cupolas declare town center and the congregation of citizens. I see verdant hills surrounding the town and defining the river valley. The river channel is flanked by a string of lights along the bike path and the careful landscaping of the university golf course. . . . I notice the stadium and arena on my right and the intriguing Ridges complex peeking out of the wooded hillside straight ahead. I don't believe that I have ever seen a more picturesque highway entrance to a town and a university campus.[2]

Of course, 21st-century Athens is different from the Athens in which Maya Lin was born. It has undergone many physical and social changes—some evolutionary, some dramatically sudden. Some were generated by the physical growth of the university, others by such commercial realities as the decline of industries or the development of retail marketing strategies.

Shortly before Henry and Julia Lin moved to Athens with their infant son, Tan, in the late 1950s, Ohio University, like most tertiary institutions across America, was growing rapidly. Stimulated by the 1944 G.I. Bill, enrollments in the second half of the 1940s had increased from about 1,500 to a little over 5,600. The 1952 Veterans' Adjustment Act offered benefits to Korean War veterans, and, by the end of the 1950s, just when Henry joined the faculty, the number of OU students passed 8,000. The 1966 Veterans' Readjustment Benefits Act would

assist Vietnam veterans, and, in the 1970–1971 year, the student population exceeded 18,000. Of course, such growth demanded corresponding increases in the number of faculty. Today, the town's population is temporarily doubled by annual influx of more than 20,000 students. There are more than 860 full-time faculty members.

Ever since the first European universities were founded, there has been symbiosis between them and their host towns. Conflicts have also smoldered. Typically, as they expand, universities have been regarded by local citizens as a threat to "town" culture and therefore as something not to be trusted. Athens, of course, is no exception, and "town versus gown" relationships have not been always amicable. As the region's largest employer, OU continues to have an economic impact on the whole of Athens County. Through the academic year, the student population supports local businesses. As one journalist has remarked, "The simple fact is, Athens is a company town. It's just that the company happens to be a university."[3] Regardless of OU's contribution to the local economy, a few issues generate tension. In particular, residents claim that the university has too much power over the city through its self-declared independence of city zoning, development, and flood-plain legislation and (paradoxically) the steady increase in enrollments. None of this is to say that there has ever been a metaphorical Berlin Wall between town and gown; for decades, some non-university families, simply as random acts of kindness, have "fostered" students—especially overseas students—and helped them to settle in.

Quite apart from conflicts of interest between some permanent "townies" and transient-by-definition students, social problems have been exacerbated by localized differences in culture, politics, and affluence. Historically, the county has the cultural character of central and southern Appalachia, as well as its political and economic problems. Around 200 years ago, the rural areas were settled by subsistence farmers—mostly of Scots, Irish, or German descent—from Tennessee, Kentucky, or Virginia. Their "back country" mindset differed from that of their neighbors immediately to the north—migrants to "non-Appalachian" Ohio from New England and New York. Many northerners exploited the region's cheap labor and natural resources, while native Appalachians increasingly suffered political disfranchisement and indigence. As recently as the 1960s, one in three lived in poverty

(average per capita income was about 75 percent of the national figure). Indeed, over the preceding decade or so, soaring unemployment and harsh living conditions had driven more than two million Appalachians to seek a better life elsewhere. In 1963, President John F. Kennedy established the federal-state Appalachian Regional Commission to devise an economic development program for the area; little seems to have come of it. Except for a few professional people and car dealers, there were not many truly wealthy people in the town of Athens in the 1960s and 1970s. The upper-middle-class faculty and senior administrators of OU were perceived by struggling townsfolk as rich—although they were not.

Politically, Athens County has long been Republican. But the town of Athens is predominantly Democratic, and (because almost half of the county's population lives there) Democrats usually win city, state, and federal elections. Political schisms deepened around 1970, when student political activism reached a climax, first over civil rights issues and then over the Vietnam War. It seems that the Lin family remained aloof from politics at any level. That is perhaps understandable, considering what Henry and Julia had seen in their homeland.

As in most university towns, student behavior (read misbehavior) has been an ongoing problem in Athens. Since Lin's high school days, OU has had the reputation of being a "party school." Of course, the problems are seasonal. In the absence of students during the university's midyear break, Athens is quite a different place. In those weeks, apart from summer schools and the timid exploration by incoming freshmen and their families late in July, it returns to being a slow-paced Midwestern rural town. A recent short-term visitor wrote, almost wistfully,

> People here are nice. They say "good morning" to other people while they are walking down the street in the morning. I have never experienced this in New York.... There are not so many people, cars, especially in summer; we can use one word to describe this: "dead.".... Everybody, including students, enjoys their lives here.[4]

By the glimpses that Lin has given of her schooldays, we can deduce that she seems to have lived in a cocoon, much (but not all) of her

own fabrication. She has often spoken of a "very insulated and isolated childhood," claiming that her daily afterschool visits to Henry's studio kept her "separate from much of what was going on—not just in Athens, Ohio, but in the world." She specifically mentions the tragic events at Kent State University in 1970 and their loud echo at Athens. It seems implausible that an 11-year-old girl—a very intelligent girl— with a teenage brother and both parents employed at the university was not touched, even tangentially, by what happened in her home town in May 1970.

In the late 1960s, disgruntlement among university students was an international phenomenon that (as some believe) began in Paris, France. Disturbances were latent in American universities, too, where the Vietnam War was a major issue. The Lyndon B. Johnson administration erroneously believed that it could engage in "limited war" without affecting life at home, but the government conscripted America's youth; widespread antiwar feelings were engendered by the growing number of casualties in a conflict that America was showing little sign of winning. Many disapproved on ethical grounds: most victims were Vietnamese civilians, and the White House was supporting a corrupt Saigon regime. By summer 1967, more than half the U.S. population opposed continuation of the war; in October, around 35,000 protested outside the Pentagon.

In Athens, 1970 was "the year of the riots," sparked by a number of different causes. Demonstrations began in January, with students objecting to increased tuition fees. Tension soon began to build between students and the Athens police force and between both parties and the OU administration. Late in April, nine students were arrested for disrupting a Reserve Officers' Training Corps (ROTC) class. In response, 50 others gate-crashed a meeting of the President's Council to protest their detention, and, later, about 2,000 people gathered to support them. Over the next several weeks, the university would document 21 incidents of unruly behavior that created an "atmosphere of confrontation, anger, fear and anxiety." Another point of grievance was "the struggle of black citizens," although most OU students were white. The simmering unrest boiled over in early May, polarizing the town.

On April 30, President Richard Nixon ordered the bombing and invasion of Cambodia, ensuring the extension of the Vietnam War

and provoking huge protests on most U.S. campuses. Four days later, almost 1,000 National Guardsmen were sent to monitor a demonstration at Kent State University in northeast Ohio. On the second day of the protest, a few panic-stricken soldiers fired indiscriminately into the crowd of protesters for just 13 seconds, killing four students and wounding nine others. Kent State closed for six weeks. Across America, more than 400 colleges would shut down in a gesture of solidarity; in Washington, D.C., nearly 100,000 protesters marched on key locations, including the White House.

On that same fateful day, a large group of students and faculty had assembled on OU's College Green to make nonviolent demands for peace. When news of the Kent State calamity reached them, they mounted the largest demonstration in the state; 4,000 protesters very soon filled the Green. The next evening, about 3,000 rallied on the West Green. In response to President Sowle's urging them to continue a nonviolent protest, students demanded that the campus be closed for two days as an act of unity with Kent. The next day, hundreds of students asked local businesses to close temporarily as a mark of sympathy for the Kent victims; many complied. On the afternoon of May 6, about 2,500 students took part in a "March against Death" through uptown Athens to the National Guard Armory; that night, most of them again rallied on College Green for three hours.

There were several disturbing incidents over the next week or so. On campus, an ROTC room and another building were firebombed, and students occupied the library. In the town, stores were picketed; shopfronts were smashed; sit-ins were staged at intersections; fires were lit in the streets; and parking meters were removed. A climax was reached just after dark on May 14, when 1,300 students gathered on the North Green. To contain them, city police blocked Court and Union Streets, but, determined to march into "uptown," 800 demonstrators refused to disperse. Tear gas was much too liberally deployed, and a 90-minute street battle ensued: firecrackers, bricks, rocks, and bottles were thrown at the police, who reacted with more tear gas. Twenty-six students needed medical treatment, 7 were hospitalized, and 54 were arrested.

Acting on the authority of the state governor, Mayor Raymond Shepard called in the National Guard, who (doubtless mindful of the

events at Kent State) refused to act until Sowle closed the university. At 3:10 A.M. on May 15, the president regretfully announced the cancellation of classes, final examinations, and commencement ceremonies. With bayonets fixed to their loaded M-1 rifles, 1,500 National Guardsmen marched down Court Street and took up positions at alternate parking meters throughout central Athens. Students were given 36 hours to vacate the campus, and OU shut down until the beginning of the summer quarter.

Lin could hardly have been unaware of what was happening in her usually peaceful hometown. Although the riots happened at night, they left litter that no one could have failed to notice, and, come daylight, pungent remnants of the tear gas still hung in the air. Thirty-five years later, an Athens resident who had been 13 at the time wrote, "I grew up...about a city block from where all of this took place. I remember all of this vividly." How much greater would have been the impression on a younger, imaginative child like Maya Lin? One of her contemporaries comments, "We were in 6th grade [and] well aware of the war, not only from the news and TV, but from student protests prior to those very bad ones in 1970. Also some kids had older siblings...or other relatives and friends who served [in Vietnam]."[5] And Putnam, the elementary school that Lin attended, was on the OU campus, near the bottom of a hill that became something of a front line during the worst riots.

When her success in the Vietnam Veterans Memorial competition was announced, she explained that the War "didn't enter [her] world," adding, "I remember there were riots and my parents would never let me out of the house when there were riots."[6] An unsettling few days. But, for the most part, Lin's 18 years in Athens were pleasantly spent. It was a nice place to live.

NOTES

1. Terry Krautwurst, "Athens County, Ohio: Cream of the Country," *Mother Earth News* (May 1989), http://www.motherearthnews.com/Nature-Community/1989–05–01/Picturesque-Ohio.aspx.

2. Pamela Callahan, "Seduction of an Architect," www.ohio.edu/provost/upload/architect.pdf.

3. Krautwurst, "Athens County, Ohio."

4. Anon., http://www.hayes8454.spaces.live.com/blog/cns!61C2FB D0C57D6888!1300.entry.

5. Anon., "Personal Note," http://nightbirdsfountain.blogspot.com/ 2006_05_01_archive.html.

6. Maya Lin, "As American as Anyone Else—but Asian, Too," *Washington Post*, November 12, 2000.

Chapter 5

OUTSIDE, LOOKING IN: CHILDHOOD AND YOUTH

"Mine was a magical childhood." That was Maya Lin's simple summation in 2002.[1] Yet, her other memories of her early years and adolescence reveal tensions created by her ethnicity, her home life, her enviable intellect, and, as she herself has suggested, her personality.

Maya Ying Lin was born in Athens, Ohio's Sheltering Arms Hospital—local wags cruelly lampooned the name as "Slaughtering Arms"—on October 5, 1959. "Maya" was the name of the Buddha's mother (Julia Lin had a roommate by that name at Smith College), and "Ying" (the "Y" is silent) is commonly translated into English as "jade." The Lin family then was living in a rented house on Forest Street, just below the ridge of the town's highest hill. Woodlands envelop the fewer than 20 houses in the cul-de-sac, hardly wide enough for two cars to pass or even to have sidewalks. When Maya was only a toddler, Henry and Julia bought a modest wood-frame house on Cable Lane, about a mile or so northeast of "uptown" Athens. As noted, after her children had grown and moved away (as children do) and Henry had died, Julia remained there. She sold the house in 2003.

Cable Lane, a little wider than Forest Street but of much the same character, climbs through hills on the north side of town. The Lin house,

number 30, was approached through open, relatively level terrain. It was enclosed on three sides by heavily wooded hills; its long unpaved drive-way forked to the left of the lane. There was a patio and open space, but much of the property was wooded; in one corner, a small stream cas-caded between two of the slopes. Architecturally speaking, the house itself—two stories and a basement on an asymmetrical plan—was ordi-nary enough. The walls were clad with wide, white-painted clapboards, and the gable roof and lean-tos were covered with asphalt shingles. The differences from most of its contemporaries were to be found inside.

The New York columnist Patricia Leigh Brown wrote that the Lins lived in a "suburban house"[2]—a claim that invites comment. First, for the past 40 years, Athens's permanent population has been around 21,000; the town does not have suburbs. Moreover, "suburban" has long implied conformity; the songwriter Malvina Reynolds acerbically observed that "suburban" houses were "all made out of ticky tacky, and they all look just the same."[3] Because the archetypal suburban house competes with its neighbors, external appearance is paramount. Resale value, which is determined to a large degree by "keeping up with the Joneses," is a major constraint. But we, not the Joneses, live in our houses, which *contain* space rather than *define* it. Whatever is distinctive about that space ex-presses the way we live. Hidden in the woods and remote from central Athens, the Lin house had nothing to compete with, no one to impress.

Brown described the interior—probably quoting Lin—as "Japanese in its simplicity," with carefully placed furniture designed by Henry. Lin remembered,

> Everything we lived with at home [my father] made—most of the pots we ate off of, a lot of the furniture. He was a master craftsman—the joinery, the detailing was very clean—it was mod-ern. It was the 50s modernism, but it was also—in its simplicity, in the shapes, in the colors—he was brought up in China so that whole aesthetic.... I went to his childhood home in Fukien and it was very Japanese-based [*sic*].[4]

More of that later.

Despite the overshadowing hills and surrounding trees, the living rooms were partly open planned and well lit. A glass sliding door that

opened to the patio combined with large picture windows to provide continuity between the house and its environment. Interior walls and ceiling, drapes, carpets, joinery, and the wood mantle framing a brick open fireplace were all light in color. The furniture was low, with simple lines; a large, white, spherical paper lantern hung above a small table. And everywhere on shelves, tables, mantelpiece—even on the floor— were pieces from Henry's ceramics collection. A screen made of whimsical ceramic forms on hanging metal rods served as a room divider between his den and the rest of the first floor. Lin remembers "as a child spinning and spinning and spinning these colorful clay shapes...to me they were like a lunar landscape."[5]

A glimpse of her family home sheds light on Lin's "magical" childhood. The dappled, wooded ridges around the house formed a playground that any child would envy. Creeks had sculpted steep, narrow ridges in the gray shale and yellow clay; one of these ridges, perilous to negotiate, Lin named "The Lizard's Back." This extended yard provided playmates, too. Lin would later confess (having turned her back on a planned career in field zoology early in her college days):

When I was three or four...I spent a lot of time alone in my yard. I loved animals. So I would feed all the raccoons. I would feed the birds....The red cardinals would come to the window and chirp knowing it was dinnertime....I would sit still in the yard trying to tame this one rabbit. And I got so close to [it] at the end that I could've touched it. I just was very fascinated with nature and with animals.[6]

She and Tan engaged in a healthy sibling rivalry. In other words, they squabbled; he teased her (as older brothers will), and she tried to impress him (as younger sisters will). Whenever necessary, she would retreat alone to her room or to the woods. Her paradoxical recollection of their childhood? "We fought a lot, and are best friends. We're very different and yet we're very close." They shared ownership of a "pet" geode. In a post facto rationalization of her Vietnam Veterans Memorial design, Lin would claim that she imagined "taking a knife and cutting into the earth, opening it up....The grass would grow back, but the initial cut would remain a pure, flat surface in the

earth with a polished mirrored surface, much like the surface on a geode."[7]

With Tan or with girls from a small circle of close friends, Lin also spent hours damming the creek, finding turtles and salamanders, and excavating the friable sandstone bank that faced the driveway at Cable Lane. Out-of-doors play also took her beyond the yard into a network of dirt trails for bicycles blazed by generations of children through the woods beside the Hocking River. The stream was narrow, and, in many places, branches of the flanking trees almost met above it. Opportunities for adventure abounded. But following unprecedented flooding late in May 1968, the U.S. Army Corps of Engineering channelized the river around the town, changing the shape of Athens and destroying most of the trails. Soon after, the construction of a bypass obliterated the remainder.

Lin's formal education began at the "laboratory school" of OU's Department of Education. Housed in Putnam Hall, it was known simply as Putnam School or just Putnam. Besides teaching elementary school children, it provided a practicum for the university's teacher training programs; its faculty were also OU academics, and budding teachers were assigned to observe classes or to work as assistants. Classes usually had fewer than 20 students. Putnam differed from Athens's public schools in that it had a nursery section for three-year-olds and a kindergarten for four-year-olds. Lin attended those programs for young children. Most Putnam students were academics' children, from home environments where education was highly valued. Because career academics often move between universities, some students were transient; however, most in a given annual cohort progressed together, even through high school. Putnam also had a sprinkling of children whose families had no formal links with OU. For purposes of teacher training, there were also classes for children with learning difficulties. From first grade, Putnam taught a progressive curriculum, including French. By sixth grade, the children were performing such works as *Julius Caesar* and *Macbeth* in their entirety, as well as scenes from other Shakespearean plays. Creativity was encouraged by art and music classes, and in the science laboratory the children studied anatomy by dissection.

Putnam encouraged independence—a policy that suited young Maya, who by second grade was developing her own interests. Julia Lin

remembered that her daughter's artistic talent manifested itself early: "When she was only in the fourth grade, [Maya's] teacher insisted on testing her for specially gifted children."[8] Even then, environmental issues fascinated Lin. She belonged to a group called the Putnam Pioneers, a fourth-grade club that addressed a stern letter to the *Athens Messenger*: "We are studying nature and go on a lot of hikes. As our community project we have chosen to collect trash outdoors on our walks.... Our job would be easier if the trash were not there in the first place. But since it is there, let's try to get rid of it."[9] A few years later, the burning of toxic contaminants on Lake Erie would provoke the teenaged Lin to activism; in a supermarket parking lot, she demonstrated against whaling and the use of steel animal traps.[10]

Three-story Putnam Hall was yet another quasi-Georgian red brick pile beside the university's East Green. In front of it, East Union Street sloped down to Jefferson Hall, a women's residence. Only a few yards behind Putnam Hall stood Seigfred Hall, purpose-built in 1962 as the Space Arts Building. An arched link joined its two parts; the east wing was a featureless five-story brick cuboid, only slightly less red than its neighbors. By the time Lin started at Putnam, her father had become director of the OU School of Art. Hi ceramics studio was on the top floor of Seigfred's west wing, and, every day after school, Maya and Tan (as long as he was at Putnam) would go there. She wistfully, if a little tortuously, explained:

> We'd get out of school at three and we'd have two hours in my dad's pottery studio to wait before he was ready to go home. So just days, hours spent, playing with clay. And I think I would say that so much of my work deals with the plastic medium of clay.... My childhood is the 60s, and the notion of what plastic, fluid, design shapes were beginning to originate out of there, again, plays into the back of your head. But I think for me it was probably my father's potting that I would watch. That's something I really, really played with as a child.[11]

Throughout her childhood, Lin entertained herself "for hours and days," reading or building miniature towns in her room; sometimes she played chess with Tan. Although she was a voracious reader (her

taste ran to Tolkien's *Lord of the Rings*, Lewis's *Chronicles of Narnia*, Mervyn Peake's *Gormenghast* trilogy, and other books that she describes as "sort-of in between science fiction and fantasy"), she gave priority to creative pursuits in her leisure time. "Every day of my life," she said, "I was making something." Her précis of those years: "I was a class-A nerd."

In 1968, several Athens County school districts were consolidated. The new middle school and high school drew students from three public elementary schools, St. Paul's Catholic School (smaller even than Putnam), from nearby towns like The Plains and Chauncey and from Putnam. The middle school—sixth through eighth grades—was housed in the former Athens High School buildings, and the high school moved to a new campus in The Plains. Some Putnam children struggled to make the transition from their small, private establishment to the middle school, which had more than 100 students on each grade level; individual classes were larger, and existing associations were broken. Children were streamed according to academic ability, subject by subject, so that a student might have one peer group in, say, science but a different one in English. Putnam graduates joined the middle school in seventh grade; other students, arriving in sixth grade, had had time to define hierarchies or establish cliques.

There were major differences between the Appalachian Ohians and the ex–Putnam students, many of whom came from beyond Ohio—in some cases, even from beyond America. Superficial evidence of relative affluence, such as dress, was often overlooked by the children, but other distinctions, including vocabulary and accent, were recognized as being deeper. Although moderated, these distinctions still remain, and the "hillbilly" stereotype is perpetuated by the ill mannered and foolish. In the middle school, the cultural divide largely contributed to the way in which some judged their fellows. One observer comments, "The southern accent, when combined with lack of money or less education, created a group of readily identifiable kids who were often called 'hicks' or 'grits' or other derogatory term. Of course, name-calling went in both directions."

To Lin, who in many ways had been cocooned within Athens society (and even within the Chinese subset of the OU faculty), her Appalachian Ohian contemporaries must have seemed like people from an alien nation. Conversely, because her skin was a different color from

theirs, because she often dressed differently, and because she excelled academically, they would have found her "otherness" conspicuous. So her feelings of "not fitting in" (as she phrased it) were awakened when she started middle school. As a sixth-grader, she could not be expected to have understood those emotions, and she would make no attempt at analysis until more than a decade had passed. And 10 years after that, she claimed that she never had a close friend after sixth grade—that is, after Putnam—and was "pretty much isolated" by the time she reached high school: "I was sort of in my own little world, and didn't realize there was any other."[12]

Louis Menand, observing that adolescent alienation is either of "the kind where you reject your family and embrace your peers [or] the kind where the sentiments run the other way," concluded that Lin's was of the latter type. The Lins had a close-knit family life—just Henry, Julia, and the two children. As Menand points out, although they did not instill any sense of dispossession in her, Lin was raised by parents who, having themselves been dispossessed, had resolved that their children would never suffer that kind of trauma. They chose not to teach their children Mandarin—the universal form of Chinese. Lin observed that her parents claimed that she and Tan were uninterested, but the real reason, in part, was that they wanted their children to "fit in." So English was the language used in the household. Henry and Julia spoke different Chinese dialects—Fuzhounese and Shanghainese, respectively. According to Tan, they resorted to Mandarin only when they argued.

Admitting to a "very insulated and isolated" childhood and adolescence, Lin later claimed that she had very few friends. She and Tan didn't want to go out and usually ate their evening meal with their parents. Tan, although male and the first-born, was not (as some Chinese jokingly phrase it) a "little emperor." Lin appreciates that she was "lucky as a girl to never ever be thought of as any less than my brother. The only thing that mattered was what you were to do in life....As a child, I was never told I couldn't do something because I happen to be a girl."[13] Of her parents' expectations, she recalls, "The only thing they ever said was, 'We just want you to be happy.'" No prescriptions were offered for the achievement of that happiness, except that education was the key. But there was no pressure to perform well, and she "sort of" motivated herself.

[My mother and father] would do anything to get us through college. I remember, my parents were both teaching at Ohio University. I could have gone there for free. My brother could have as well. And they really wanted us to go out. They were so excited when I got into Yale.... They felt that everything—all the money they made—was so that we could get the best education.... When you've got parents that are working that hard for you is there an underlying expectation.[14]

As remarked, Lin grew up—to use her own words—"without a past." By the time she was 16, all her grandparents (none of whom she had met) had died. She personally knew almost nothing of her extended families in China. The only contact with them, even after the Bamboo Curtain was raised, was through censored letters in Mandarin, which she couldn't read, anyway. The deep sadness that haunted Henry and Julia, despite all attempts to disguise it from their children, inevitably expressed itself. Two occasions made lasting impressions upon Lin. The first was Julia's distress at the news of the death of her father, Chang Fu Xing, in 1975; almost 20 years later, Lin recollected, "My mother...was so close to [her father. I] remember when she got the letter that he had passed away. And she just was—and. . . ." Words then failed her. The second was in the spring of 1989, when the world witnessed graphic television footage of the brutal suppression of pro-democracy demonstrators in Tiananmen Square. Lin saw the anguish in her father's face: "The home they knew was completely changed by history. There wasn't a place of nostalgia to go back to." Henry Lin died only two months after the massacre.

Only in retrospect did Lin realize that she was brought up "white"— that is, in denial of her Chinese ethnicity. Certainly, when she was younger, she *wanted* to fit into Athens's predominantly northern European society and had no trouble doing so. In a sense, her parents' policy made it easier. Later accepting that she had been for years "almost completely oblivious" to her heritage, she claimed that it did not occur to her that she *wasn't* white. And, because the Lin family's microsocial (it might be said, ultramicro) circle consisted of liberal-minded academics, little overt racism was evident to them. That is not to say that racial discrimination did not exist in Athens; for example, one

nonwhite professor recalls that, as late as 1957, black students could not get a haircut in the town. And one of Lin's Chinese American contemporaries remembers a youth spent there as fraught with bigotry. Although declining, anti-Chinese feelings persist in the United States. In 2009, the online magazine *Asiance* reported that a recent survey had noted that much of the general population could not differentiate between Chinese and other Asian Americans. Sixty percent of Chinese Americans thought they had suffered racial discrimination; most had been verbally harassed.[15]

Lin has asserted on several occasions that she and her brother were the only Chinese Americans in their Midwestern community, once claiming that "I was unaware that I was Asian because *we were the only Asian family*."[16] In fact, there were several Chinese families in the academic community. Forensic chemist James Yingpeh Tong, OU's first Chinese professor, arrived from Wisconsin a full year before the Lins with his white American wife, Harriet. As student numbers burgeoned until about 1968, the university appointed several more Chinese faculty, mostly in the College of Arts and Science and the College of Engineering. Among them were the Weis, the Wens, and no fewer than three Chen families. James Tong's youngest daughter, Victoria, was in the same grade as Lin at Putnam; they continued through middle and high school together, graduating in June 1977. Why Lin does not remember her and other schoolmates such as Jacqueline Chen is enigmatic.

The Lins kept themselves to themselves. Most of the university's Chinese families arranged social gatherings, regularly sharing meals in various homes; they also conducted weekend Mandarin classes for their children. The Lins attended neither. Remarking that Henry in particular seemed disinterested in getting to know the Chinese community, Tong recalls: "[The Lins] have never been to our house. We have never been to their house. I don't think [they] ever came to the monthly Chinese dinner." He added that, although he and his wife knew many of the Fine Arts faculty and Julia Lin "very well," they had little to do with Henry.[17] Perhaps he chose a low profile because he was shy. Certainly, he was taciturn: the potter Dick Hay, a student from the early 1960s who used to baby-sit Tan and Maya, recalls, "In my three years of studying with Henry, I would guess that his spoken words to me could be easily counted."[18] Tong offers an alternative, although less plausible,

reason for Henry's aloofness: "Chinese who came to the U.S. in the McCarthy era generally had a hard time because the American suspicion that all Chinese might be communists. Some...probably isolated themselves for fear of guilt by association." Well, perhaps.

There is little point in speculating about the cause of Maya Lin's sense of alienation during her high school days. Perceptions of latent racism may have been part of it, although, by her own account, that is hardly likely. She was (from birth, she said) "Daddy's girl," and perhaps there are links between her father's unsociability—whatever its cause—and the withdrawn way of life that she chose in high school and later maintained. She once told a reporter, "I'm like a turtle. I live in my own world. Just because my work is public, I am not."[19] Another interviewer commented, "Lin maintains a reclusive lifestyle—she keeps her phone number unlisted, she works in a private studio rather than an office, and she rarely grants interviews. 'In order to know me, you have to know somebody who knows me.'"[20] But that didn't always work, either.

Another less definable phenomenon may have had a part in denying her a sense of "fitting in." The Chinese Americans novelist Gish Jen has observed that the feeling of being unaccepted is not limited to people of Chinese origin.[21] Anecdotal evidence suggests that the children of all immigrants have a sense of estrangement in their parents' adoptive land, even if they themselves are born there. Regardless of high social status or attainment, they feel that they don't *quite* belong—an uncomfortable perception that may be emotional and internal and not imposed by the actions or perceived attitudes of others. Further investigation lies within the province of a psychologist, not a biographer.

Lin has summed up her own experience:

Sometimes, a total stranger...will ask me where I am from....The question, however innocently it is asked, reveals an attitude in which I am left acutely aware of how, to some, *I am not allowed to be from here*; to some, I am not really an American. And I think it is that feeling of being other that has profoundly shaped my way of looking at the world—as if from a distance—a third-person observer.[22]

Anyway, by the time she reached high school, in the fall of 1973, her private perceptions and circumstances had somewhat soured her

"magical childhood." Adolescence had become a miserable ordeal, fraught with intensifying ambiguities. She felt that in the town of her birth she was on the outside, looking in.

Athens High School (AHS) was located in The Plains, a village of about 3,000 people, around five miles northwest of Athens. The student body, most of which was shuttled in by a fleet of buses, was about 1,200 strong. Lin's graduating class of 1977 was known as the "Rowdies." One basketball season, in which the school team lost almost every game, a "rowdy section" of seniors transferred its support to the cheerleaders—the only ones worth celebrating. Almost the entire class wore t-shirts emblazoned with "Rowdies," AHS's bulldog mascot, and individual nicknames. Lin was not by practice a Rowdy, and she avoided sporting events and social functions. An exception was that, at the end of her senior year, she took part in the school's traditional "Senior Follies"—a spoof of NBC's *Saturday Night Live*. She did not date or wear makeup. But, like some of her peers, she worked at the Richland Avenue McDonald's.

For four years, Lin retreated into her own world, consumed by study. Looking back, she admitted, "I was probably an incredible misfit. I had friends but it wasn't like I belonged. I didn't want to date. I just wanted to study. I loved to study. I was incredibly bookish. I think partly because I just wanted to get out of Athens a while."[23] But, a couple of years earlier, she had said—the contradiction should be noted—that, although her time at high school was "tough, and *yet I wouldn't have wanted to go anywhere else....* I loved getting straight A's, but that was more for [myself]."

However, there was one distraction—a hobby. Lin confessed, in 2003, "I love rocks, I love geology, I love the earth."[24] She explained on another occasion that, when she was in high school, she "just started picking up rocks." The compulsion grew: "It was really in college that wherever I went, I always made it a point to find a couple of rocks that would remind me of the place. They became very personal mementos. I have five or six crates in storage. I'll keep collecting them, and probably move them all out to [my summer home in] Colorado and put them outside someday."[25]

Given the single-mindedness that has always characterized her, it is hardly surprising that Lin excelled academically. By the time she reached her senior high school year, she was taking most of her courses by independent study. She also enrolled in basic computer programming

courses at OU to learn the languages Basic, Cobalt, and Fortran; the now-clumsy technology would later inform her design "Input" for the university's Bicentennial Park, dedicated in 2004.

Except for her gym teacher, with whom she shared a mutual dislike (and whose course was the only one that she failed), she enjoyed good relationships with the high school staff. She recalls

> this one chemistry teacher, Miss McCallan [in fact, Mrs. Paula Barensfeld, née McCallum]. I liked making explosives. She liked hanging out. We would stay after school and blow things up.... What you don't realize... is that some of your teachers are actually closer in age to you than you think.... By the time I was a senior in high school, she was maybe four or five years older than me.... Both my art teachers were just wonderful throughout. I really enjoyed my whole educational process. And it was fun. That's what I actually thought was really fun.[26]

Lin and several other students helped in the library. She maintained the periodicals section, and, according to the head librarian, Helen Porter, kept it "perfect at every minute."

One contemporary recalls that Lin spent a lot of time preparing for the Scholastic Aptitude Test and the Scholastic Assessment Test—standardized screening for college admissions—and adds, perhaps with just a little exaggeration, "at one point... she had memorized the dictionary to improve her vocabulary skills." Lin also joined the French Club, *Le Cercle Français,* and in 1975 took part in a five-day Easter vacation trip to Montreal and Toronto, Canada, with about 30 other students.[27] Little more has been recorded about those years.

In February 1976, Lin was inducted as a junior member into the AHS National Honor Society; to qualify, students needed a grade point average of at least 3.75 and had to have demonstrated "outstanding performance" in the areas of service, leadership, character, and citizenship. Success followed success. In mid-November, she was included in the 10th edition of the independently published *Who's Who among American High School Students,* one of the top 5 percent in the nation. And, at the end of the month, she was one of five AHS seniors named "commended student" by the independent National

Merit Scholarship—among the top 2 percent of America's secondary seniors. She graduated from high school in June 1977. As might be expected, she was co-valedictorian; Richard Whealey, also a former Putnam student, shared in the honor. Lin did not speak at the ceremony, but Whealey, urging his peers never to become conformists, provided a vocal rendition of "Little Boxes."

Academically, Lin had set a course to that point, and she had navigated it well. But, emotionally, she had sailed rough seas, buffeted for the reasons and in the ways already discussed. It would take her many years to resolve those issues. Two decades later, she told an interviewer: "I was counting the days, because I knew I didn't quite fit in...and I was desperate to kind of get out of there." And she reflected, "The other kids probably hated me" and—most perplexing of all—"I didn't fit in high school at all. And I don't know if it was because I was different. I think it was my age. I looked much younger than most of my classmates, and in a way they were really nice to me, but almost as a baby sister.... They were friends and they were friendly." She concluded:

I probably have fundamentally antisocial tendencies, let's face it. I never took one extracurricular activity. I just failed utterly at that level. Part of me still rebels against that. You couldn't put me in a social group setting. It's different with a group of friends, but as far as clubs go—I'm probably a terrible anarchist deep down.[28]

NOTES

1. Louis Menand, "The Reluctant Memorialist," *New Yorker*, July 8, 2002, 54–65.

2. Patricia Leigh Brown, "Maya Lin: Making History on a Human Scale," *New York Times*, May 21, 1998.

3. Malvina Reynolds, "Little Boxes," © copyright 1962, Schroder Music Company (renewed 1990).

4. Bill Moyers, "Becoming American," interview with Maya Lin, Public Affairs Television, 2003, http://www.pbs.org/becomingamerican/ap_pjourneys_transcript5.html.

5. Brown, "Maya Lin."

6. Moyers, "Becoming American."

7. Ibid.

8. Allison Morsek, "Artist Shows Women's Capabilities," *Post*, October 18, 1999.

9. Maya Lin et al., Letter to the Editor, *Athens Messenger*, February 20, 1970.

10. Anne-Marie O'Connor, "Maya Lin's Earthly Concerns," *Los Angeles Times*, April 1, 2008.

11. Interview with Maya Lin. "Art in the 21st Century," PBS, http://www.pbs.org/art21/artists/lin/clip2.html.

12. Menand, "Reluctant Memorialist."

13. Ibid.

14. American Academy of Achievement, "Maya Lin, Artist and Architect," Scottsdale, AZ, June 16, 2000, http://www.achievement. org/autodoc/page/lin0int-1.

15. "Still the 'Other'? Public Attitudes toward Chinese and Asian Americans," *Asiance*, April 21, 2009, http://survey.committee100. org/2009/press/AsianceMagazine_042009.pdf.

16. Kevin Lynch, "Maya Lin to Mark Anniversary," *Capital Times* (Madison, WI), April 25, 2001. Emphasis added.

17. James Yingpeh Tong, correspondence with author, May 2009.

18. Dick Hay, correspondence with author, January 2009.

19. Carol Vogel, "Maya Lin's World of Architecture, or Is It Art?" *New York Times*, May 9, 1994.

20. Richard H. Chang, "Maya Lin: Maintaining a Private Life Despite Creating Public Works," *AsianWeek* (March 3, 1995).

21. Jen Gish, "Becoming American: Personal Journeys" (interview), Public Affairs Television, 2003, http://www.pbs.org/becomingameri can/ce_witness11.html.

22. Maya Lin, "As American as Anyone Else—but Asian, Too," *Washington Post*, November 12, 2000.

23. Moyers, "Becoming American."

24. Ibid.

25. Margot Cohen, "The Collector: Maya Lin," *Wall Street Journal*, February 26, 2010.

26. American Academy of Achievement.

27. *Athens Messenger*, April 24, 1975.

28. American Academy of Achievement, "Maya Lin, Artist and Architect."

Chapter 6

ALMOST FOR "A LARK": AN UNDERGRADUATE AT YALE

Yale was only one of the colleges at which Maya Lin sought a place. According to her, no one else from Athens High had ever gone there, and she applied (she said) almost for "a lark." Of course, she and her parents were delighted when she was accepted by the prestigious Ivy League institution. But, given her imposing academic record, her alleged surprise is itself surprising. Certainly, one of her referees, Peter Lalich, a teacher at Athens, had no doubt—well, he was "almost positive"—that she would win a place; his recommendation described her as an "outstanding" student.[1]

Getting into Yale wasn't easy. In the late 1970s, although two-thirds of hopefuls were formally qualified, only one in four succeeded. Academic excellence was the main criterion. The exhaustive application form had to be endorsed by high school teachers' assessments of recent work. In addition, Yale required an evaluation of "motivation, intellectual curiosity, energy, relationships with classmates, and impact on the classroom environment" and the candidate's role in the school community. The applicant was asked to write essays—one about personal interests and another titled "Why I Want to Go to Yale."

As noted, education was prized in the Lin household. Because her parents were on the OU faculty, Maya could have enrolled there at

no cost, but they wanted her to "go out" (as she put it), to gain the best available education. For that, as she later gratefully acknowledged, they were willing to invest "all the money they had." That was hardly an exaggeration. When she entered Yale, Tan was completing a bachelor's degree at Carleton College, in Northfield, Minnesota; after that, he undertook graduate studies at Columbia University. To pay for his daughter's education, Henry Lin sold a 103-acre farm that he owned outside Athens.

Under duress, Yale had begun admitting women graduate students in 1869—almost 170 years after its foundation—but another century would pass before it first welcomed women undergraduates. In September 1969, 230 female freshmen, 154 sophomores, and 204 juniors entered the college community of more than 4,000 men. When Lin arrived, eight years later, the total undergraduate population had reached almost 5,100. For four years, she would be living in a physical and social environment totally foreign to her. She loved it.

Some writers describe the city of New Haven as "gritty." In the 19th century, its economic base changed from agricultural to industrial, and, in the 40 years after 1860, immigration from Ireland, Italy, and Central Europe increased the population to 108,000. An international export trade in clocks, small arms, tools, and garments burgeoned, changing the urban structure; the new manufacturing center engendered overcrowded tenement buildings. Most of the modern city was built in the early 20th century, as New Haven metamorphosed into an industrial metropolis; by the end of the 1920s, continuing immigration further swelled the population to about 160,000.

In the 1950s, more affluent families began an exodus to the suburbs. As business and industry followed them, New Haven's tax revenues diminished, and Mayor Richard C. Lee responded with an urban renewal plan that included demolishing entire neighborhoods—6,500 housing units were lost and very few replaced—to make way for commercial development and a six-lane connector highway. Struggling small retailers were displaced by the two-story, six-and-a-half-acre covered Chapel Square Mall, but it also soon went into decline. The connector, having wreaked tremendous social damage, was never finished. By the late 1970s, when Lin arrived at Yale, the New Haven municipality was on the point of bankruptcy, unable even to meet the

power bills for its street lights. While it grappled with these economic problems and their social consequences, the great university was on its way to becoming the third-richest nonprofit organization in the world, with extensive real estate holdings—all tax-exempt—and federal funding. Latent since 1716, hostility increased between Yale and its host city.

Regardless of how she saw herself before, Lin was now a rather small fish in a very large and probably bewildering pond. She remembers "the whole shock of being in a way not as well prepared academically for an Ivy League school" and believed herself to be "the dumbest person in [her] class, not the smartest"—a realization that she found "very, very intimidating."[2] Although her picturesque, semirural birthplace and New Haven were both university towns, they could hardly have been more different, both physically and socially. New Haven was two-and-a-half times the area of Athens, with about six times the population. And the ethnic mix was much different; New Haven was home to equal proportions (about 35 percent each) of whites and African Americans; another one-fifth of the population was Hispanic, and other groups, including Chinese Americans, accounted for the remaining one-tenth. In Athens, all had been familiar to Lin; in New Haven, she was an émigré, and much around her was strange; it would remain that way for some time. Meanwhile, Yale's cloistered halls offered some security. Yet, there was ambivalence in her response to her new environment: she later reflected, "I didn't have an adjustment problem....I found kids that were just like me, and for the first time I felt that I fit in."[3]

The Memorial Quadrangle at the heart of the campus had been altered in 1933 to create the first 2 of the university's 12 residential colleges, Saybrook and Branford. Although she would not live in its Gothic-cum-Tudor style brownstone buildings until her sophomore year, Lin was assigned to Saybrook. Even before they arrived, newcomers were arbitrarily allocated to a college. Unless a parent or sibling was a "Yalie," students had no choice. By providing a supportive, cohesive social structure at a personal scale, the college system, modeled on those of Oxford and Cambridge in England, was intended to make the broader university environment "digestible," so to speak. College life became part of Lin's educational experience during the four-year undergraduate program.

With the 1977 Saybrook freshman cohort, she lived for first two terms in one of the oldest dormitories on Old Campus—the five-story brownstone Wright Hall (since 1993, Lanman-Wright Hall), virtually next door to Saybrook. For the first time in her life, she was obliged to share a bedroom—and with strangers, at that. Wright Hall's crowded accommodation was offset to a degree by its centrality to classrooms, the other colleges, shops and the post office, and downtown New Haven. Commons, the University dining hall—rather like a larger, nonmagical version of Hogwarts' great hall in Harry Potter's adventures—was the hub of the freshman's social life. Since classmates in all the courses could be drawn from any of the colleges, eating meals in the 1,200-seat refectory was a bonding experience for the freshmen class.

Something else about Lin's daily visits to the Commons is worth noting. Flanking Grove Street, it is part of a complex of Beaux Arts buildings erected in 1902; the College Street wing houses the university's main auditorium. These buildings are joined at the corner by the main entrance, the Woolsey Rotunda, which in 1927 became a memorial. The names of Yale men who died in American wars since the Revolution are carved on marble tablets in its corridors. In her freshman and sophomore years, Lin frequently saw masons adding the names of those lost in Vietnam. Acknowledging that Woolsey Hall was "completely influential in the Vietnam Memorial," she later remarked, "You couldn't walk through the hall without touching the names."[4]

About a month after Lin arrived at Yale, the university was thrown into chaos when the militant Federation of University Employees called out 1,400 food services workers, maintenance staff, and janitors on strike. The stoppage lasted for about three months. One alumna remembers that the upperclassmen felt sorry for freshmen because they had been "deprived of the real Yale" in their first weeks. She wryly adds, "But since we hadn't known any other Yale... I never could see that we had much of a problem. Besides, I wasn't entirely sure what the 'real' Yale was."[5] Quite apart from dealing with the obvious cleaning and maintenance inconveniences, the university had to find ways to feed thousands of students. To some, it offered a partial refund of meal-plan fees. Managers staffed freshmen's dining halls—an unsatisfactory culinary alternative. Avoiding the food fights in the Commons, Lin chose to eat at the popular Yorkside Pizza and Restaurant. And she showed

initiative by collaborating with a suitemate to buy a coffee-making machine with refunded cash.

In her sophomore year, Lin moved into a College dormitory, to become a fully fledged Saybrugian. All unmarried sophomores were required to live on campus for at least two terms. There, the random mix of students acquainted her with a cross-section of fellow students with broad-ranging interests across the disciplines. Residents mingled in the college's student lounge, central common room, library, TV room, and (most significant) the dining hall—Saybrook's social heart. Within a pecking order, dormitories were allocated on a lottery system: seniors had first draw, then juniors, and finally sophomores, who were assigned to "quads"—suites with two double bedrooms and a living room.[6]

Ideally, "Yalies" gained an education that cultivated a "broadly informed, highly disciplined intellect." The eight-term bachelor degrees, whether in the arts or the sciences, were not vocational programs; such specialization would follow at the graduate level. All undergraduates took mandatory "foundational" courses—writing skills, quantitative reasoning, and a foreign language; they were also required to enroll in courses that reflected diverse content and approaches, including a prescribed number in each of the discipline areas of science, humanities and arts, and social science. Although a one-on-one adviser provided guidance, choices were left to individual students, who also had to prepare for later professional studies by selecting a "major," beginning in the junior year. And they were encouraged to spend one term abroad (also in their junior year), in order to experience another culture, improve language skills, or begin research for a senior project.

Some single-minded students provisionally chose their major before reaching college; others decided in their freshman year, and still others selected a broad discipline area without limiting themselves to a specific field. Lin had made a firm career choice while at high school. Or so she thought. "I was going to become a veterinarian. Then I sort of switched. In high school I was *definitely* going to become a field zoologist because I love animals and I love the environment."[7] When she entered Yale, she had no intention of studying architecture.

Flexibility was an obvious advantage of the Yale structure. Some students who enrolled with their academic voyage already charted changed course after a year or two, *because they could*. That's what

happened to Lin. Remarking, "I...think students who have chosen to go into...an architecture school from day one [are] missing out on the English courses, the science courses, the math courses," she would later advise, "If you can afford the time to do graduate and undergraduate, [you should] broaden your mind in undergrad and then specialize. Because I think for both art and architecture, you have your whole life ahead of you. Don't think that at age 18 you want to...just focus in on your own personal world....Open it up for a while. I think it's invaluable.[8]

In the second term of her sophomore year, she decided to change courses. Until then, although disappointed that "science was a bit more pre-med than anything else," she had chosen electives with a science career as her goal. She recognized that Yale provided her with a "fairly solid liberal arts undergraduate education minus the history" that encompassed anthropology, engineering, geography, mathematics, and "a lot" of geology courses. Because of her declared interest in field zoology and animal behavior, her first faculty adviser was a biology professor.[9] She recounted their conversation: "He says, 'Yale's animal behavioral program is probably not what you're going to approve of.' And I said, 'Well, why?' He said it's neurologically based and that it dealt with vivisection. I didn't even know what vivisection was....I looked at him and I said, 'You're absolutely right. Ethically there's no way.'"[10]

So the question arises whether Lin become an artist "on the rebound," as it were. Her own choice of words precludes any suggestion of deep reflection, much less of anguish, over the decision to change: "*All of a sudden* I found myself heading toward art, which is my main love....I think I just discovered in college that I really loved art and science. Architecture was a combination, tied into mathematics, structural engineering and art."[11] The apparently abrupt choice was solely her own. Her independence suggests that she did not seek parental approval. She told an interviewer:

[My parents] really firmly believed that you had to pursue something that you really had a passion for, that you really, really loved. My mother especially was very suspect [sic] of material things. The joke in our family is if we had gone into law or business, they might have felt less of us—like, "Well, it's you're just going for the

money." That would have been considered selling out.... The stories I know of friends of mine who basically wanted to go into the arts and their Chinese parents were just worried, terrified because how are you gonna [*sic*] make a living?[12]

Nevertheless, it seems inconceivable that she did not inform Henry and Julia of her change of plans. So where was her father's revelation that his late half-sister and her husband were also architects—and famous ones, at that?

Of course, Chinese parents alone were not the only ones alarmed by the announcement "Mom and Dad, I'm going to be an artist." For most, it conjured the vision of a romantic but tragic *La Bohème*-esque figure, stricken with consumption (or having a lover who is) and starving in a garret. Architecture is not as risky a career choice as fine art, but, for the creative person, it does have a downside: architecture is by definition a "second-hand" art. That is, an architect is a designer but seldom a maker; for all sorts of pragmatic reasons, the realization of his or her design is entrusted to others. Moreover, as George Bergstrom, the consulting architect for the Pentagon building, once explained, "The mind of the architect must interpret the need from another mind, apply it to his imagination, translate the concept to other minds and direct still other hands to give it form and substance."[13] For Lin, who had always delighted in hands-on making, that would have presented a problem. Twenty years after she chose an architecture major at Yale, she would declare:

I think like an artist. And even though I build buildings and I pursue my architecture, I pursue it as an artist. And in a way what I disliked about architecture was probably the profession. I still am an artist. It's much more individual. It's much more about who you are and what you need to make, what you need to say *for you*. Whether someone's going to look at it or not, you're still going to do it.[14]

Before being accepted, aspirants for the architecture major at Yale were asked to undertake an "Introduction to Architecture" class in the spring term of their sophomore year. They also had to submit a portfolio

and undergo a grade review of all the courses they had completed. The core of the major was a series of semester-long studios, except in the junior-year fall term. For Lin and her peers, "Fundamentals of Form" was taught in the spring of junior year by architect-sculptor Kent Bloomer, then head of the program. A "Senior Project" occupied the fall of senior year and included, among other offerings, Andrus Burr's funerary architecture studio, discussed later. In the final term, "Place and Dimension in Architecture" was taught by Alec Purves. In addition, there were mandatory "theory" components, as well as physics and calculus, an architectural philosophy course taught by Karsten Harries, and the redoubtable Vincent Scully's "History of Modern Architecture and Urbanism." Electives included drawing, painting, sculpture, and printmaking studios, art history, English literature, science, foreign languages, philosophy/religious studies, and an esoteric philosophy class, "Concept of Alienation," taught by Louis Dupré. Pre-architecture students could avail themselves of some of the best courses that Yale had to offer.

Prompted by an interest in Scandinavian design, Lin spent part of her junior year in an architectural studies program in Copenhagen, Denmark. When she became famous, her interviews revealed little about those few months overseas; it may be that she found it difficult to come to terms with the European way of doing things. But two specific experiences—one positive, the other negative—seem to have particularly impressed her.

She cherished one Danish project—an urban study of Nørrebro, in central Copenhagen. The neighborhood includes Assistens Kirkegård, a leafy, 200-year-old cemetery, 50 acres in area, with all manner of trees, long avenues, trimmed hedges, and expansive lawns enclosed by a 10-foot-high yellow-painted wall. It is an urban oasis shared by the living and the dead; *Frommer's Guide* calls it Europe's "liveliest cemetery" because in the summer it is taken over by local apartment-dwellers who, denied other open space, use it for strolling, picnicking, and sunbathing. The concept of a place of remembrance integrated into the continuing life of the city fascinated Lin. When she first saw the proposed site of the Vietnam Veterans Memorial, it was inevitable that this Danish cemetery would come, perhaps unsummoned, to mind.

The other memory—a distasteful one—of her summer in Copenhagen was that, for the first time, she had to personally confront racism. It took two forms. She recounts, "When they thought I was Chinese, they

Maya Ying Lin as a 21-year-old Yale University
architecture student from Athens, Ohio. Ms. Lin
would go on to win $20,000 for her design of
the proposed Vietnam Veterans Memorial.
(AP Photo/Scott Applewhite.)

would say things like, 'Oh, so do your parents own a laundry or a restau-
rant?' And they weren't joking. They were trying to be very kind, but
the stereotypes were pretty hellacious." The more overt manifestation
was based merely upon her physical appearance, as so much bigotry is.
As noted, it was summer, and Lin had a tan. She was confused when
whites refused to sit near her on a bus. Skinheads, also on public trans-
port, were belligerently insulting. When she told Danish acquaintances
about such behavior, they explained that she probably been mistaken
for a *Kalaaleq*—a Greenlandic Inuit—despised by racists among the
whites. The experiences foreshadowed the vile attacks that followed
her success in the Vietnam Veterans Memorial competition.[15]

Of course, before anyone becomes famous (for whatever reason),
he or she attracts little attention. So not much can be discovered of
what impression, if any, the "softly-spoken freshman who wore pale

green V-necks and listened to records with her roommates" made upon her community at Yale. Published sources contain a few fragments of a frustratingly incomplete mosaic. Lin's college friends described her as "powerfully artistic, emotional, fiercely independent, driven: intuitive and personal in her approach to art."[16] One suitemate, when pressed, remembered her as "very apolitical" [sic] and "very reserved." Another fellow student recalled that she was "lively and full of ideas."And one of her professors characterized her as "a bright and cheerful student who drew very well." Adding that she was not very diligent, he commended her for "having a good time as an undergraduate in an exciting environment."[17] Of her latter college years Lin said, "I just focussed on art and architecture, and I did nothing but I would schedule my classes so they met once a week, and then I would pull all-nighters."[18] Once again, her single-mindedness was to bear remarkable fruit.

NOTES

1. Rebecca Dana, "Reserved Lin Thrust into Political Role," *Yale Daily News*, April 2, 2002.

2. Andrew Marton, "Breaking down 'The Wall,'" *Fort Worth Star-Telegram*, January 9, 2005, 1D.

3. American Academy of Achievement, "Maya Lin, Artist and Architect," Scottsdale, AZ, June 16, 2000, http://www.achievement.org/autodoc/page/lin0int-1.

4. Louis Menand, "The Reluctant Memorialist," *New Yorker*, July 8, 2002, 54–65.

5. Mimi G. Sommer, "Maya Lin: Human Proportions on a Heroic Scale," *New York Times*, April 17, 1994, http://query.nytimes.com/gst/fullpage.html.

6. Kathrin Day Lassila, "From the Editor," *Yale Alumni Magazine* (September-October 2003).

7. "Residential Colleges: Not Just Dorms, but Microcosms of Yale's Community," *Yale Herald Online*, Freshman Issue, 1998, http://www.yaleherald.com/archive/frosh/1998/you/microcosms.html.

8. American Academy of Achievement, http://www.achievement.org/autodoc/photocredit/achievers/lin0–023. Emphasis added.

9. Ibid.

10. In 2000, Lin named her adviser as one Dr. Apville, "who I still talk to every now and again." An extensive Internet search has not found him, suggesting that, as with her high school chemistry teacher, she had mistaken his name.

11. American Academy of Achievement, "Maya Lin, Artist and Architect," http://www.achievement.org/autodoc/photocredit/achievers/lin0–023.

12. Sommer, "Maya Lin." Emphasis added.

13. Bill Moyers, "Becoming American," interview with Maya Lin, Public Affairs Television, 2003, http://www.pbs.org/becomingameri can/ap_pjourneys_transcript5.html.

14. George Bergstrom, cited in "Architects Scolded," *Time,* February 11, 1929.

15. American Academy of Achievement, "Maya Lin, Artist and Architect." Emphasis added.

16. Maya Lin (interviewed by Phil McCombs), in Brent Ashabranner, *Always to Remember, the Story of the Vietnam Veterans Memorial* (New York: Putnam, 1989), 42.

17. Moyers, "Becoming American."

18. Phil McCombs, "Maya Lin and the Great Call of China," *Washington Post,* January 3, 1982, F1.

Chapter 7

DESIGN IN MASHED POTATO: THE VIETNAM VETERANS MEMORIAL COMPETITION

In fall 1980, Maya Lin elected to study, as she put it, "how man deals with his own mortality in the built form." By her recollection, the term-long senior seminar was initiated by a small group of students. But Andrus Burr, the professor who prepared and taught it—and whose version is confirmed by others from the group—claims that, believing it would be an interesting theme, he had offered funerary architecture as an elective course. There were reasons for his interest: first, the relatively straightforward brief for a monument, compared to a multifunction building, suits novice designers; second, because his father had died recently, Burr had been pondering the nature of memorials; and third, he had visited the British War Graves Commission's World War I cemeteries in France. Serendipitously, as he was planning the course, he heard of the national competition for the Vietnam Veterans Memorial.[1] One student remembers that Burr was "very steeped" in the topic and that he put a lot of energy into the class.

The students' acceptance of his morbid theme can be seen in the context of a growing American interest in the relatively new discipline of thanatology—the "formal study of death and dying and the psychological mechanisms of dealing with them." The specialization had been

given impetus by the recent publication of several treatises, especially those of Swiss-born psychiatrist Elisabeth Kübler-Ross, who followed her groundbreaking *On Death and Dying* (1969) with 10 more books before 1981. At least 10 more scholarly works appeared in the United States during the same period. Academic fascination with Kübler-Ross's ideas may be gauged by the fact that 18 colleges and universities awarded her honorary doctorates in the second half of the 1970s. So Burr's seminar was no isolated phenomenon.

None of the group members was trained in the pragmatic "build-ability" of architecture, and they had been taught just a smattering of architectural theory and history. So the course followed the Beaux Arts studio model then common to many architecture schools; that is confirmed by the use of the French words *esquisse* (sketch design) and *critique* in some accounts of it; Lin even spoke of a *charette*, coined from the Paris *L'Ecole des Beaux-Arts* students' habit of completing their drawings on the tailgate of a wagon as they followed it to school in the early morning hours. But more of the studio later.

The core of the course was three major design assignments, and students were required to keep "visual diaries," preserving their "ideas" sketches for each and recording other design influences. Burr also presented a series of lectures. At one of the earliest meetings, in which the students sat on his apartment floor, he had them define "sublime" and visualize it by drawing. They also studied the gargantuan, unbuildable works of the 18th-century French neoclassical architect Étienne-Louis Boullée, famous for his cenotaph for Isaac Newton. On other occasions, Burr spoke about the proximity of death in the Victorian mind-set, contrasted with the denial of death in the modern world; the use of cemeteries for recreation; and (perhaps most significant) loss and the role of architecture in preserving memory. There was also an assignment to envision a crematorium.

Burr recalls that Lin was not the best performer in the class or even second best, but he remembers her as a pleasant, "happy-go-lucky, not very serious kid" and, as already noted, a "bright and cheerful student who drew very well [although] not very diligent." Apart from his opinion that her first design exercise—a gate for a small rural cemetery about a half-hour's drive from New Haven—was uninspired and poorly developed, little can be discovered about it. Her attitude toward it (and

perhaps her pique at his comment) can be measured by the fact that, despite that momentous year, she forgot even what it was, later mentioning "a cemetery cherub or something."[2]

The second project was a design for a World War III memorial. Lin proposed a concrete passageway intended to portray the horrors of war. Some years later, she described it as "a tomblike underground structure that I deliberately made to be a very futile and frustrating experience," adding that Burr had said "quite angrily" that if he had a brother who had died in that war, he would never want to visit her memorial. She was "puzzled that he didn't quite understand that World War III would be of such devastation that [nobody] would be around to visit any memorial, and that [her] design was instead a pre-war commentary."[3] Burr, admitting irritation rather than anger at what he saw as her general resistance to criticism, countered that she had resorted (as beginning students will) to "I meant it to be like that" to justify the inelegant, poorly developed ideas apparent in the sketchiness of her presentation drawings.[4] The final design project of the seminar required each student to prepare an individual entry for the Vietnam Veterans Fund Memorial (VVFM) competition, announced in Washington, D.C., in October 1980.

At any one time between 1965 and 1975, a half-million young Americans were fighting a war in Vietnam. One-third were draftees. Of the nearly 300,000 wounded in action, 75,000 were permanently disabled, and of the more than 58,000 who never returned, the average age was just over 23 years. After a 12- or 13-month tour of duty—about two-thirds of which was in combat—most servicemen were rotated back to the United States, where many faced contempt and antagonism because the nation was divided over the war. At best, they found indifference. As one veteran wrote,

Any acknowledgment of service rendered to country—not to mention real acts of heroism on the field of battle—fell by the wayside; in the eyes of many, those who had done their nation's bidding were pariahs. Many veterans...were ashamed even to admit that they had served. While some questioned the war, all of us knew we were just as worthy, had fought just as bravely as had our fathers and uncles and grandfathers before us.... We also

knew, in a country torn asunder by the politics of the war, that the only recognition we would get we'd have to give ourselves.[5]

The Vietnam Veterans Memorial was the vision of former corporal Jan C. Scruggs, who had served in Vietnam (1969–1970) as a rifleman in the 199th Light Infantry Brigade. Having suffered nine shrapnel wounds, he was hospitalized and decorated for valor. Home again, he earned qualifications in psychological counseling—studies that moved him to recommend in 1976 that the federal government establish counseling centers for veterans and build a national memorial to those lost in the war. But, with no political or financial backing, his single voice was not heard. His vision for a memorial was revived after he saw the movie *The Deer Hunter* in March 1979. He wrote, "I wanted a memorial engraved with all the names.... The nation would see the names and would remember the men and women who went to Vietnam, and who died there."[6] By separating two distinct moral issues—individuals who had performed military service and America's foreign policy—he believed that such a shrine would help heal the national psyche, which had been injured by the war. If the design was apolitical and the memorial was paid for by private donation rather than by the government, it would express popular gratitude to those who had served.

In April 1979, Scruggs laid his idea before a gathering of 40 veterans that had convened to arrange a "Vietnam Veterans Week." The consensus was that improved benefits was a more pressing issue than a memorial. At the close of the meeting, Washington attorney Robert Doubek, a former Air Force officer, advised Scruggs that the memorial could be achieved by a not-for-profit, tax-exempt corporation. Donations to it would enjoy tax deductibility. Ten days later, Scruggs retained Doubek, and, on April 27, they together established the Vietnam Veterans Memorial Fund (VVMF), with Scruggs as president and Doubek as secretary.

Scruggs's personal savings provided seed funding, and he took leave without pay from his job to lobby politicians. Although the VVMF announced its plans at a Memorial Day press conference, fund-raising was sluggish; by July 4, only $144.50 had been received. When it became public, that disappointing news moved another veteran, John Wheeler, to recruit still more veterans—four lawyers and an accountant—for the

VVMF advisory board. In August, Scruggs persuaded Senator Charles Mathias, a Maryland Republican, to sponsor legislation securing public land for the memorial. A real estate developer, a public relations specialist, and a fund-raiser were soon added to the Fund's board. None of the members had a design background; all were intent simply upon building an appropriate memorial, rather than creating a good work of art—whatever that might have been.

Wheeler suggested that a "reflective and contemplative" landscaped garden, evoking the service, sacrifice, and courage of the veterans, the missing, and the dead would not emphasize the war or the foreign policy underlying it. In November, Mathias's bill specified Constitution Gardens at the west end of the National Mall as a site for the proposed memorial; Representative John Paul Hammerschmidt presented parallel legislation to the House of Representatives. Some senators were obstructionist, but President Jimmy Carter signed Mathias's bill into law on July 1, 1980. The memorial design would be subject to the approval of the Commission of Fine Arts (CFA), the National Capital Planning Commission (NCPC), and the Secretary of the Interior, James Watt. Before construction could begin, enough funds had to be in hand to complete it. Details of the nationwide fund-raising campaign are beyond the scope of this book; suffice it to say that veterans' groups, charitable foundations, civic institutions, corporations, trade unions, and more than 275,000 individual Americans eventually donated $8.4 million.

Eager to secure the best design, the VVMF first thought of doing it itself (an idea that was immediately and providentially abandoned); alternatives were to select an architect or to conduct a closed competition among invited designers. According to Scruggs, the ultimate decision to open a competition to all adult Americans, regardless of qualification or experience, was constrained by three issues: the huge number of inquiries received from artists and designers; the limits of the VVMF's knowledge of art, architecture, and design, and the need for a selection process "befitting the importance of a national memorial and the significance of its purpose."[7]

In July 1980, the Fund engaged Washington-based architect Paul D. Spreiregen, an expert in architectural competitions, as professional adviser. He proposed four stages over 11 months. Planning was

scheduled for July through September 1980; in October, supported by the National Endowment for the Arts and the American Institute of Architects, the VVMF would invite designs. Preparation of entries would begin early in January 1981, with a March 31 deadline. The VVMF then would receive and display submissions, select the winner, and announce the result—all by May 1981. The first prize was set at $20,000 cash plus a commission to be involved in the realization of the design. The second- and third-place entries would receive $10,000 and $5,000, respectively; up to 15 "honorable mention" prizes of $1,000 were also offered. There were more than 5,000 requests from individuals and teams for the competition prospectus, for which a $20 entry fee was charged.

It is uncertain how Burr's seminar class came to adopt the VVMF project as an exercise. Lin asserts that one of the students saw a "bulletin" (at another time she said "poster") for the competition. She adds, "And we thought, 'What a great idea! We'll use that as our final project.'"[8] On the other hand, and as noted, Burr insists that he learned of the competition while he was planning the course. Dates are significant: fall-term classes began around the beginning of September 1980. Although the *New York Times* reported on the proposed memorial late in February, the competition was not mooted until July, and official promotion began only in October. It is possible that Burr serially planned the seminar and that the memorial was an afterthought, its inclusion negotiated between him and his students.

The evolution of Lin's design—and there's no question that it *did* evolve—has been obscured by frequent retelling and romanticizing of events. Judging by the time allocated for it, the competition hardly can be described as *the* major component of the seminar. And it must be noted that, although they were in their senior year, Lin and her classmates then were only paddling in the shallows of architecture. She summed up her approach to what she regarded as a purely academic exercise: "So I designed what I thought was the right solution *for a course*. But in a way, I think when you're doing something in architecture school, *you're doing it for yourself*."[9]

The idea of academic architecture brings us back to the pervasive Beaux Arts studios. In the many schools in America that applied the ancient French pedagogical model well into the 20th century,

theoretical design problems were set, completely ignoring functionality, site constraints, budgetary considerations, building technology, and even the rules of physics. Aesthetics were all. Challenges to practical constructability were overcome by building with ubiquitous "student stuff." That explains why the group, having "barely been given any information," could start designing before any of its members thought to acquire a copy of the prospectus. Burr wrote away for one, but there was some delay before it arrived "halfway in the design." The official distribution date of the document was November 24.

Having been made aware of the stringent requirement to include the names of all the lost, Lin recalls that she "thought up what ideas I had about how I wanted…to be honest about war, how I wanted [to] make it very honest about the names and…about acknowledging loss. I thought about what a memorial to the Vietnam War should be."[10] She decided to "put all that thinking aside" and visit the memorial site. Returning from the Thanksgiving holiday with her parents in Athens, she met up in Washington with three classmates who had driven the 300 miles from New Haven.

Lin has claimed that the memorial design "simply popped into her head" while she was photographing Constitution Gardens on that crisp November day.

I just sort of visualized it.…Some people were playing Frisbee. It was a beautiful park. I didn't want to destroy a living park. You use the landscape. You don't fight with it. You absorb the land-scape.…When I looked at the site I just knew I wanted some-thing horizontal that took you in, that made you feel safe within the park, yet at the same time reminding you of the dead. So I just imagined opening up the earth.[11]

Back in the Saybrook dining hall, she sculpted the first model of her design in mashed potato. According to her account in *Boundaries*, "It almost seemed too simple, too little." Myth or not, the story caught the imagination of many subsequent writers, and that potato has been re-served with all manner of garnishes and seasonings.

Art historian Michael J. Lewis points out that Lin's design, "rather than emerging fully developed, as she implies, was exposed during

*Maya Lin's submission for the Vietnam Veterans
Memorial Competition. (Library of Congress.)*

its intermediate and final presentations to the customary round of
comments by visiting critics, and it changed considerably in the pro-
cess." He adds that "this is not to denigrate [her] considerable achieve-
ment but merely to note that, like most artists, she is reluctant to shed
light on rejected drafts."[12] All the students' designs were subjected to
what Burr calls an "interim crit." Anyone familiar with architecture
schools understands what that involved. All the schemes, at a similar
stage of development, would have been candidly commented upon by
the peer group and vigorously defended by their creators. Of course,
Burr made his comments, too, as did architects Carl Pucci and Ross
Andersen—invited critics from New York.

Lin acknowledged that "the only clue that I had to what I had made,
was that for the final clip you invite visiting architects to critique your
work and then you get up and you present." She incorporated a number
of suggestions made during the studio critique of her final submission.
They included making the angle in the wall and aiming the wings at

the Washington Monument and the Lincoln Memorial. Nearly 30 years later, as Burr recalled:

> The Vietnam Memorial did not emerge full-blown, [but it] was by far Maya's best work....[She] presented a line of large scale dominoes in the process of collapsing down a slope into a V-shaped depression outlined by two retaining walls. [Pucci's] response was direct and to the point, "Get that stuff out of there and just leave the walls and you'll have a nice piece of minimal sculpture."[13]

Lin's recollection of that revision was different. She wrote in *Boundaries* that she "toyed with adding some large flat slabs that would appear to lead into the memorial, but they didn't belong. The image was so simple that anything added to it began to detract from it." Clearly, the falling slabs were a naive architectural pun on the political domino theory—that if one Southeast Asian state were to fall to Communism, in turn they all would.

Anyway, according to Burr, "The final drawing she presented was a sketch in [I think] black and white." He gave her an "A" grade for the project.[14] For the whole course she achieved only a "B," because she had put little effort into the visual diary and because her other design exercises were (in Burr's words) "not particularly stellar." Within a couple of weeks after the results of the competition were published, Lin telephoned him to ask that he raise her overall grade, because she was worried that a "B" would diminish her chances of getting into graduate school. He declined, insisting that the grade was commensurate with the work she had done.

Beyond the academic exercise, all class members were encouraged to enter the memorial competition. Only Lin submitted a design. Over the Christmas holiday, she met a friend's uncle, an architect who was helping her prepare a portfolio to show in her search for summer work. She explained: "He's looking through, and then he stops and he starts telling me...about this design for the Vietnam Memorial that he had heard about, and as he starts talking about it,...I'm realizing, I should enter this because I think it's an important thing to say. It's not going to win. And I entered it."[15]

That decision meant that she had to register quickly, by December 29, although that was by no means a commitment to participate. There were 2,573 registrants—making this potentially the largest competition of its kind ever held in America or Europe. The VVMF sent out the detailed design program two days later, and Lin finally decided that she would submit her completed proposal "as an exercise" sometime in the spring semester of 1981. All that remained to be done was the preparation of the final drawings and composition of the design rationale. Inspired by the end of Vincent Scully's lecture about Edwin Lutyen's 1932 Memorial to the Missing of the Somme in Thiepval, France, she began writing the essay as Scully spoke.[16] She wrote in *Boundaries*:

> The only thing left was to complete the essay, which I instinctively knew was the only way to get anyone to understand the design....I kept reworking and reediting the final description [with constant advice by telephone from her brother Tan]. I actually never quite finished it. I ended up at the last minute writing freehand directly onto the presentation boards...and then I sent the project in, never expecting to hear about it again.[17]

The VVMF at first had thought to convene a jury that represented the groups of people most affected by the war—Vietnam veterans, Gold Star parents, and wives of those still missing. But when Spreiregen pointed out that the judges must be able to "evaluate solutions to a design problem," professional designers were invited to form the panel. Because the winning design might include any combination of architecture, landscape architecture, and sculpture, Spreiregen recommended eight "highly respected, highly accomplished [professionals]...the most collegial, veritable senior gray eminences of American design," whose specializations spread across those arts: landscape architects Hideo Sasaki and Garrett Eckbo, architects Pietro Belluschi and Harry Weese, and sculptors James Rosati, Costantino Nivola, and Richard H. Hunt. Grady Clay, editor of *Landscape Architecture Quarterly*, was appointed chairman. To be sure that the jury was "philosophically attuned," each member was interviewed by the VVMF Board and asked to read several books about the Vietnam conflict. Later, the fact

that none was a veteran was touted by opponents of the design as a reason to reject it. Spreiregen and the VVMF tried to conscript a "general humanist"—that is, a nonartist—for the jury, inviting (among others) novelists James Michener and Herman Wouk, both winners of the Pulitzer Prize, and respected journalists Eric Sevareid, Alistair Cooke, and Walter Cronkite. All declined.

By the deadline, 1,432 entries had been received. To maintain entrants' anonymity, all followed the same format: each was identified by number only and was limited to two 30-by-40-inch panels showing plan, elevation, and cross-section at a scale of 1:360; other illustrations and a brief design rationale were optional. Architecture critic Wolf von Eckardt described the submissions as ranging from "architectural stunts to sculptural theatrics, from the pompous to the ludicrous, from the innovative to the reactionary." Some of the deservingly discarded kitsch proposals included a towering pair of army boots, an even larger steel helmet complete with huge bullet holes front and back, a pedestal surmounted by a rocking chair labeled "Resting," and numerous sentimental neoclassical groupings; there were also (von Eckardt wrote) "handsomely styled columns, pylons, tablets and structures that belong at a world's fair or amusement park" and other schemes "depressingly like constructivist graveyards."[18]

The VVMF was given access to a hangar at Andrews Air Force Base in Maryland to display the panels—more than 2,300 yards of them. Begun on Monday April 27, 1981, the judging took five days to complete. A first cull left 232 "could-be" entries. By noon Wednesday, just 90 were short-listed, and the selection was reduced to 39 by the following morning. The winning design was chosen Thursday afternoon. After they completed a detailed discussion of the final three, Clay polled the jurors. Spreiregen adjudged their proceedings as the most thorough discussion of design that he had ever heard. They awarded second prize to New York architect Marvin Krosinsky's team, which had proposed a sculptural building with a lumpy abstract bronze figure. Third prize went to EDAW, a landscape architecture team led by Joseph Brown of Alexandria, Virginia; it included Fredrick Hart's heroic sculpture of a soldier. At noon on Friday, Spreiregen and Clay presented a synopsis of the jury's remarks to VVMF representatives. After a tense silence, "Jan Scruggs rose, came forward,...and proclaimed, 'I like it!'" Immediately,

all the VVMF members leapt to their feet "in a joyous expression of acceptance, hugging each other in congratulation."[19]

Chosen unanimously, the winner was entry number 1,026, by Maya Ying Lin.

NOTES

1. Andrus Burr, correspondence with author, June 2009.

2. Bill Moyers, "Becoming American," interview with Maya Lin, Public Affairs Television, 2003, http://www.pbs.org/becomingamerican/ap_pjourneys_transcript5.html.

3. Maya Lin, *Boundaries* (New York: Simon & Schuster, 2000), 4:10.

4. Burr, correspondence.

5. Tom Berger, "To Realize a Dream, Many Lent Their Skills, Time, and Commitment," http://www.articlesisland.com/news-and-society/politics/.

6. Jan C. Scruggs, introduction to *Reflections on The Wall*, http://photo2.si.edu/vvm/scruggs.html.

7. Jan C. Scruggs, "Process for Selecting Design for National Vietnam Veterans Memorial" (memorandum), December 14, 1981.

8. American Academy of Achievement, "Maya Lin, Artist and Architect," Scottsdale, AZ, June 16, 2000, http://www.achievement.org/autodoc/page/lin0int-1.

9. Ibid., 5. Emphases added.

10. Brian Lamb, "*Boundaries* by Maya Lin," C-Span, *Booknotes*, November 19, 2000, http://www.booknotes.org/Transcript/?ProgramID=1589.

11. Brent Ashabranner, *Always to Remember: The Story of the Vietnam Veterans Memorial* (New York: Dodd, Mead, 1988), 42.

12. Michael J. Lewis, "Mumbling Monuments," *Commentary* 111, February 2001, http://www.savethemall.org/media/mumbling.html.

13. Burr, correspondence.

14. One (and *only* one) source says that she presented a clay model for the class; see Jan C. Scruggs and Joel L. Swerdlow, *To Heal a Nation: The Vietnam Veterans Memorial* (New York: Harper & Row, 1985), 67–68.

15. American Academy of Achievement, "Maya Lin, Artist and Architect," 1.

16. Martin C. Pedersen, "A Monumental Discussion with Vincent Scully," *Metropolis*, March 29, 2006, http://www.metropolismag.com/story/20060329/.

17. Lin, *Boundaries*, 4:10.

18. Wolf von Eckardt, "Storm over a Viet Nam Memorial," *Time*, November 9, 1981.

19. Paul Spreiregen, "The Vietnam Veterans Memorial: Lessons for September 11," *Infinite Connection*, http://alum.mit.edu/news/What Matters/Archive/200209/.

Chapter 8

ANNUS HORRIBILIS: BUILDING THE VIETNAM VETERANS MEMORIAL

"There's no escape from its power." "He [sic] knows what he's doing, all right." "No other place in the world like that." "As though the ground had subsided away, leaving the rock on which are the names." "Not a thing of joy, but a large space for hope." Those were just some of the comments made by the jurors as they faced Maya Lin's naively rendered entry in the Vietnam Veterans Memorial design competition.[1]

Before them in the Andrews Air Force Base hangar hung a sheet of grey art board, on which three drawings were pasted: a simple plan, elevation and section, and two abstract pastel perspectives—black geometric shapes on a featureless turquoise field. There was also a small page of smudged and corrected hand-lettered text and a lettering sample—"IN MEMORIAM" in Trojan upper-case. Lin describes the presentation as "very mysterious, very painterly, and not at all typical of architectural drawings." Just so. The VVMF's adviser Paul Spreiregen remarked, "They almost look[ed] like kindergarten drawings. A lay jury would never, never have chosen that design."[2] But the jurors knew how to read Lin's sketches, and the VVMF board, which didn't, trusted them—for which America and the world must be thankful. The veterans saw only bizarre shapes; Jan Scruggs said that at first thought it looked like a bat, or perhaps a boomerang.

Lin was convinced that her lucid 850-word rationale persuaded the jurors. Her brother, Tan, had been "absolutely critical" in editing it. She recalled, "I would read over the phone. I had mailed it to him, and then he had gotten it, and he was correcting it."[3] It is worth quoting at length:

> Walking through this park-like area, the memorial appears as a rift in the earth, a long, polished, black stone wall, emerging from and receding into the earth. Approaching the memorial, the ground slopes gently downward and the low walls emerging on either side, growing out of the earth, extend and converge at a point below and ahead. Walking into this grassy site contained by the walls of the memorial we can barely make out the carved names upon the memorial's walls. These names, seemingly infinite in number, convey the sense of overwhelming numbers, while unifying these individuals into a whole.
>
> The memorial is composed not as an unchanging monument, but as a moving composition to be understood as we move into and out of it. The passage itself is gradual; the descent to the origin slow, but it is at the origin that the memorial is to be fully understood. At the intersection of these walls, on the right side, is carved the date of the first death. It is followed by the names of those who died in the war, in chronological order. These names continue on this wall appearing to recede into the earth at the wall's end. The names resume on the left wall as the wall emerges from the earth, continuing back to the origin where the date of the last death is carved at the bottom of this wall. Thus the war's beginning and end meet; the war is "complete," coming full-circle, yet broken by the earth that bounds the angle's open side, and continued within the earth itself. As we turn to leave, we see these walls stretching into the distance, directing us to the Washington Monument, to the left, and the Lincoln Memorial, to the right, thus bringing the Vietnam Memorial into an historical context. We the living are brought to a concrete realization of these deaths.
>
> Brought to a sharp awareness of such a loss, it is up to each individual to resolve or come to terms with this loss. For death is in

the end a personal and private matter, and the area contained with this memorial is a quiet place, meant for personal reflection and private reckoning. The black granite walls, each two hundred feet long, and ten feet below ground at their lowest point (gradually ascending toward ground level) effectively act as a sound barrier, yet are of such a height and length so as not to appear threatening or enclosing. The actual area is wide and shallow, allowing for a sense of privacy, and the sunlight from the memorial's southern exposure along with the grassy park surrounding and within its walls contribute to the serenity of the area. Thus this memorial is for those who have died, and for us to remember them.[4]

Given the prestige of the competition and the huge number of entries, the VVMF had expected that the winner would be a well-known designer or architect. But when records were checked to identify the author of No. 1026, the judges found the name "Maya Ying Lin," the age, 21, and the address, Saybrook College, New Haven, Connecticut.

On the last day of spring-semester lectures in 1981, Lin was called out of class to take a telephone call from the VVMF. It was sending a delegation to New Haven to ask questions about her submission, face to face, and it is a comment on her modesty and youthful naiveté that the news gave her no clue to her success. Thinking that the veterans wanted to discuss technical issues, she later claimed that it never occurred to her that she might have won the competition. She recalled, "Even after...Colonel Donald Schaet [told me] that I had won (I think my roommate's face showed more emotion than mine did at the time), it still hadn't registered. I don't think it did for almost a year."[5] The Boston Globe reported, "The honor and attention associated with winning the design competition have brought Lin a whole galaxy of new feelings and experiences, but she said that none means more to her than the fact that 'for the first time in my life, something I did or made affected more people than myself. And it was great.'"[6]

What a year that promised to be! Her victory should have heralded the best time of Lin's young life. On the contrary. Years later, she would tell Harvard cultural historian Louis Menand that her experiences in Washington had been "beyond miserable."

Apart from having to familiarize herself with the complexities of the construction industry, Lin needed to be informed about political machinations at many levels. Thrown in at the deep end, as it were, for the next 10 months she would meet resistance from (ironically) the VVMF, the architects of record, politicians and their minions, and—most vehement, vexatious, and vitriolic—many powerful people who obstructed the realization of her design. But she would courageously maintain her artistic integrity, weathering attacks on her gender, youth, and ethnicity. *Chicago Tribune* columnist Joan Beck observed that some veterans had "publicly raged that not only has Maya Lin never seen war close, she was only 15 when the Vietnam fighting ended. Furthermore, she first conceived her memorial as a class project at elitist Yale." She sardonically added that Lin was "(unbearably) a female. Even worse, her Chinese ancestry is obvious, even though she was born in...Ohio."[7]

Twenty-five years later, the *Washington Post's* culture critic, Philip Kennicott, would reflect in that Lin had "fought the good fight,...proving herself, fresh out college, a formidable force against the crass manipulations and demagoguery that so often attend the design and use of public space in the Federal City." Explaining that she had "endured a lot of shabby treatment...from people who wanted to scuttle her design because it lacked bombast, and from others who simply couldn't take seriously the ideas and vision of a woman, an Asian American, a young person, a Washington outsider," he concluded that she had "emerged both a hero, because she won, and a martyr, because she endured a lot of grief. She struggled and suffered for her art, and Washington [was] a better place for it."[8]

To formally announce the competition winner and present the $20,000 prize, a media conference was organized in Washington for May 6. A few days earlier, Lin was flown down to meet VVMF board members. That first encounter warned her of trouble ahead; she sensed the veterans' desperation to get the memorial built quickly, whatever it took.

Aware that Lin's "beautiful...but highly ambiguous" semiabstract drawings would not clearly explain the design to a lay audience, Spreiregen engaged the architectural illustrator Paul Stevenson Oles to urgently prepare more conventional renderings. Having checked Lin's intentions, Oles produced three charming colored pencil and charcoal

perspectives. He remembers, "Maya asked, shyly, if 'she could be included in the picture.' I agreed…, if she would be willing to appear on the arm of the illustrator." A rear view of the pair is in the foreground of one of the drawings.[9] Harry Weese's staff constructed a cardboard model, also to be shown at the conference. Lin recalls, "They didn't talk to me, they just made [a model] and they had pushed the design way to the back [of the site]." When she pointed out the inaccuracy, she was told, "No, no, no, it's just a press conference model. Don't worry about it." Her response: "It is such a simple piece, everything matters."[10]

The presentation ensured that the design became national news, spread first through the popular mass media and a little later by architectural journals. Not all critics applauded it, but most were positive. The American Legion and the Veterans of Foreign Wars publicized it and, as the VVMF had hoped, launched fund-raising drives. Lin, thrust into the publicity campaign, found herself doing a lot of interviews. She was personable, petite, and pretty, straight from central casting (as one veteran recognized), and the VVMF board was not slow to cynically exploit her in its own fund-raising. But it soon became clear that her priorities did not suit her sponsors' urgent aims. Lin was concerned that what she had envisioned got built and she feared, justifiably, that the VVMF was happy to "just do it." Designer and client were at cross purposes, almost from the beginning.

Much has been written about the Memorial as high art and as a place of social healing, so this chapter is not so much about the design as about Lin's experiences during its construction.[11] However, in order to grasp the underlying issues of what has been called "The Controversy," a brief description is needed of what America now knows simply as The Wall. Each of the two south-facing wings is a little under 247 feet long, made up of 74 separate 40-inch wide panels faced with a 3-inch veneer of highly polished black granite, imported from Bangalore, India. They point to the Washington Monument and the Lincoln Memorial and meet at a 125-degree angle, together forming "a surface that reflects the sky and the ground and those who stand before it." At their junction—the "apex" of the memorial—they are just over 10 feet high; at their outer ends, they are only a few inches above the ground. The panels are inscribed, row upon tragic row, with the names of the almost

60,000 servicemen and women who never returned from the Vietnam War. Beginning and ending at the apex, they appear in chronological order by the date of loss; a symbol beside each indicates whether the death was confirmed or the individual remained missing. The tallest panels bear 137 lines of names in Optima upper-case typeface, a little over half an inch high; the shortest panels are blank.

Panel 1 East is inscribed, "In honor of the men and women of the Armed Forces of the United States who served in the Vietnam War. The names of those who gave their lives and of those who remain missing are inscribed in the order they were taken from us." Panel 1 West reads, "Our nation honors the courage, sacrifice, and devotion to duty and country of its Vietnam veterans. This memorial was built with private contributions from the American people. November 11, 1982." Simple.

In June 1981, the National Capital Memorial Advisory Committee (NCMAC), under Secretary of the Interior James Watt, endorsed the design "in principle." At hearings in July and August, the Fine Arts Commission (FAC) and the National Capital Planning Commission (NCPC) also conditionally approved it. All three bodies insisted that wheelchair access and site drainage form part of the design development stage. In response, each wing was lengthened to provide a gentler slope. Because grass would soon be ruined by heavy foot traffic, a granite pathway and a safety curb were added at the base of the wall. Stormwater drainage was installed under Constitution Avenue.

For a few weeks in the summer, Lin went home to Athens and obtained practical experience in the architectural office of David Reiser. After teaching for a while at OU, in 1973, he had set up a practice— effectively the only show in town. Lin, mentored by architect Pamela Callahan, worked on a small planning project in the village of Middleport, on the Ohio River. Returning to Washington and eager to get the memorial under way, she was frustrated by the bureaucratic impediments common to many construction projects, especially public works in the national capital. As the competition prospectus provided, the VVMF was obliged to appoint architects and other consultants, because Lin was ineligible for an architect's license. And she knew nothing about project management.

A licensed architect whose name appears on the project's building was needed. From the outset, differences arose between Lin and

Spreiregen, who was the first nominee. Spreiregen locked horns on the same issue with the project director, Robert Doubek, who still asserts that the VVFM board interviewed several candidates before settling on the local firm Cooper-Lecky. He also recalls that Lin engaged an attorney to support her choice. She later spoke of her "very internal, very tough struggle" about who would work with her. Acting on the advice of Cesar Pelli, then dean of the Yale School of Architecture, it was Lin who recommended the Cooper-Lecky partnership. She believed that W. Kent Cooper, who led the design development team, was the "absolute right choice." But she conceded that an internal power struggle led to a "little bit of ill will, so that they didn't know where I was coming from and I didn't know where they were coming from. And it all was all smoothed over in the end, but it left the entire process a little difficult, going through."[12] Anyway, in mid-August 1981, Cooper-Lecky was commissioned to produce contract documents and supervise the construction. Lin was retained as consultant.

Nevertheless, working relationships remained ill defined, and, to adopt Doubek's metaphor, there were arguments over "who was the mother of the baby." As late as 2008, William Lecky would falsely claim that it was he who *brought in Maya Lin...as a design consultant.*"[13] At another time Lecky asserted that he, not Cooper, was the active architect of record, "working along with Maya Lin in our office for the first few months and then continuing for the next two years to get the memorial built."[14] The facts were otherwise. It seems that after The Wall gained international fame, he wanted to share in the accolades.

The translation of Lin's simple renderings into "architectural language" yielded 10 sheets of preliminary drawings. The firm then produced about 70 sheets of contract documents—site plans, plans, elevations, sections and details; schedules; engineering drawings; landscape architecture drawings; topographic maps and specifications. Unacquainted with how architecture is made, the veterans had believed, "It's so simple." And again Lin's response: "I am obsessive about detailing, down to the whatever."

These earliest experiences in Washington came as culture shock. She had never had dealings with Vietnam veterans, construction management firms, or engineers; for their part, they had never been met head-on by a student, fresh from college, who could tell them what

to do. Unabashed by her instant celebrity, Lin maintained a balanced perspective, telling one journalist, "In a sense, this could be a bad thing happening to me, because I'm too young." The writer commented that by "winning she had inadvertently set an impossibly high standard for herself."[15] That remained to be seen.

Lin later realized that even her appearance was incongruous: a self-confessed fashion disaster wearing Frye boots, she turned up at Cooper-Lecky's office in cut-off dungarees and with her jet-black waist-length hair combed out. She now concedes that she looked like a 1960s an-tiwar radical or, worse, "a little bit like Cousin It." People *did* notice. The *Washington Post* reported that, going to a Grace Jones concert, she wore to "a porkpie hat, 'something my favorite architect, Frank Lloyd Wright, might have worn,' she said, and a quilted battle jacket with a printed skirt—'just my normal clothes.' "[16] Although it was by then part of her daughters' "dress-up clothes," she still owned the hat in 2005; in the disruptive days of The Controversy, she thought it was "perfect" because it hid her face from the cameras.[17] Anyway, she sought advice from the syndicated etiquette columnist "Miss Manners" (aka Judith Martin) on how to dress appropriately for business. But, as will be seen, differences far more profound than clothing styles existed between her and her coworkers.

Almost from the outset of the project, many people who were *supposed* to be on Lin's side misread her. She accepted that as understand-able in the case of the VVMF, given their assumptions of what an artist was, and because her background was so different from theirs. After working with them for two years, she would concluded that "the fund has always seen me as female—as a child." She complained,

> I went in there when I first won and their attitude was—O.K. you did a good job, but now we're going to hire some big boys—boys—to take care of it. I said no! I wanted to help put together a team that knew about landscape, granite. Their basic attitude was I gave them the design and they could do what they wanted with it. They expected me to take the [prize] money...and run.[18]

Moreover, the architects of record treated her more as an apprentice than as the designer of the memorial. She was compelled to defend her

ideas against strong personalities, experienced architects who thought they knew what the memorial should be like better than she did. As consultant, she was paid fifteen dollars an hour—quite a handsome rate that may have provoked envy in her office mates.

Soon the veterans and the architects alike realized that they had underestimated Lin's strength of will. Doubek is still unsure whether it sprang from a precocious maturity or whether she was simply (as he candidly puts it) a brat. Lin herself suspects that they considered her to be "one of the most stubborn, egomaniacal creatures they ever saw." She defied their demands to make design variations with "The judges chose it. If you want to change something, reconvene the jury," and she later acknowledged that she was "very tough [and] very stubborn when I had to be.... I wouldn't yell. I would just shut down, get colder and colder."[19] Only 20 years later was she able to identify "the conceit of youth" that the English artist-philosopher William Morris had once seen in himself; she then mused, "I probably went in there with more of an egomaniacal young artist confidence.... When you're young you're so idealistic and you're so headstrong, or at least I was." And she added, "When you're young, maybe [conviction] is all you have."[20]

Critical praise for the design was extensive. Architectural journals used such words as "dignified," "stunning," and "eminently right." Paul Goldberger, the *New York Times* architecture critic, wrote, "Miss Lin's design appears to be one of the most subtle and sophisticated pieces of public architecture to have been proposed for Washington in many years."[21] But her greatest champion was art critic Wolf von Eckardt, who wrote,

Lin's design has been called "minimal art," whatever that means. There is nothing minimal about this concept. Nor is it abstract, in the sense of being apart from human experience. It is, rather, a direct evocation of an emotional experience, which... is what art is all about. The design may not instantly be grasped [but] it is hard to imagine any better solution to the problems a Vietnam Veterans Memorial poses.[22]

Lin's scheme and those of the minor prizewinners were displayed for several months at The Octagon in Washington. At the November 8,

1981, opening of the show, the American Institute of Architects (AIA) presented her award; the citation reads in part "she spoke softly where others were wont to shout."[23]

Despite the VVMF's enthusiasm—indeed, the approval of most returned servicemen—for Lin's apolitical, abstract proposal, a small but vocal group of influential veterans in Washington and elsewhere roundly condemned it. Only three days after the winning design was announced, Texas billionaire H. Ross Perot, despite his earlier generosity to the VVMF, had condemned The Wall as "something for New York intellectuals," perhaps (to his mind) the most scathing phrase he could conjure. He became the self-appointed leader of the anti-Lin forces, whose attacks continued in the national press through 1981.[24] Having successfully contended with her "friends," Lin now was called upon to face her foes.

The FAC met on October 13, ostensibly to consider the suitability of the Bangalore granite. But the hearing was railroaded by a civilian attorney in the Pentagon, Tom Carhart, a twice-decorated veteran and former VVMF volunteer. He may have been piqued over his failure in the competition; one source suggests, probably apocryphally and certainly unkindly, that his entry was "derived" from Arthur Zaidenberg's *Anyone Can Sculpt*.[25] Carhart passionately denounced Lin's Wall as "pointedly insulting to the sacrifices made for their country by all Vietnam veterans...by this we will be remembered: a black gash of shame and sorrow, hacked into the national visage that is The Mall." The entourage of newspaper and TV reporters that he brought to the meeting seized upon the lurid "black gash" phrase and spread it nationwide. However, the FAC simply affirmed its earlier approval; the chairman, J. Carter Brown, said that Lin's proposal needed no "corny specific references" to the war and no "bits of whipped cream on pedestals"—a not-so oblique denigration of the white quasi-classical memorials that dot the National Mall.

Only five months earlier, the popular press had lauded the design. Carhart's vehement, sustained assault changed that, and suddenly editorial attacks far outnumbered commendations. An opinion piece in the *National Review* called it "Orwellian glop"—whatever that was supposed to mean. The *Review* also criticized Lin for listing the names chronologically, contending, "The mode of listing the names make them individual deaths, not deaths in a cause: they might as well have

been traffic accidents."[26] Other antagonistic columnists included the *Chicago Tribune*'s architecture critic, Paul Gapp, who dubbed the design "inane" (he later recanted), and the right-wing commentator Pat Buchanan, who fallaciously and maliciously asserted that jury member Garrett Eckbo was a communist. The arch-antimodernist Tom Wolfe called the design "something out of the Chinese Cultural Revolution," and the conservative activist Phyllis Schlafly snidely dubbed it "a tribute to Jane Fonda."

Elsewhere, Carhart was to offensively describe The Wall an "open urinal." At the most despicable level of opposition, even Lin's Chinese American heritage was attacked: Carhart is also alleged to have suggested that the memorial should be inscribed "designed by a gook." As Marita Sturken has observed, the media eventually defined Lin as not American but "other," and that definition created "a critical issue of whether or not that otherness had informed the design itself."[27] The racist outpourings, only sometimes covert, were taken up by others. Understandably, all of this bewildered Lin: "There were certain things I was aware of intellectually that I had never seen before. In the academic world where I grew up, my femaleness, the fact that I was Oriental, was never important. You didn't see prejudice. People treated you first as a human being."[28]

Over the ensuing months, Carhart spread his venom through the pages of the *Washington Post* and the *New York Times*. Perot, somewhat less articulate, dug up a few epithets of his own: he called the design "a tombstone," "a slap in the face" for the survivors of Vietnam, and "a trench." He gave Lin the racist nickname "Eggroll." His bank balance being larger than both his vocabulary and his imagination, he sponsored other dissenters, and the insults flew for several months—The Wall was derided as a "degrading ditch," a "black spot in American history," "something resembling an erosion control project." Those who failed to recognize its meaning damned the design as a negative political statement about the shame of a lost war; others opposed it because it was not another traditional alabaster anachronism—no 'warriors' monument of gleaming white marble. Heritage Foundation policy analyst Milton Copulos complained that it was "just names on the wall. There [is] no mention of what they had done, no flag, none of the things you would associate with a memorial."

Conservative politicians joined the hue and cry. James Webb of Virginia, later a U.S. senator and a Vietnam veteran, spoke of a "sad, dreary mass tomb, nihilistically commemorating death" and asked in a *Wall Street Journal* article, "At what point does a piece of architecture cease being a memorial to service and instead become a mockery of that service, a wailing wall for future anti-draft and anti-nuclear demonstrators?" Representative Henry Hyde conducted a "Christmas offensive," lobbying his peers. A letter to President Ronald Reagan from 27 Republican congressmen denounced the design as "a political statement of shame and dishonor" and asked that an alternative be selected. But, most critically, Watt opposed it. Because his jurisdiction included the National Mall, he had power to veto the scheme.

Early in January 1982, Watt told the VVMF that he would review the project personally—a euphemistic threat to scotch it altogether if they didn't bow to their adversaries. The veterans asked their ally, Senator John Warner, a Virginia Republican, to chair a meeting. When it convened at the end of the month, the VVMF's delegates, outnumbered by at least five to one, reiterated the competition criteria and offered to include a flag and make changes to the inscription. Their compromise was rejected. After a four- or five-hour impasse, General Michael Davison, a supporter of Lin's design, proposed to build the "admittedly nonconformist memorial but add to it a statue to symbolize the spirit of the American fighting soldier." Forced to a bargain, the VVMF agreed; in return, the opponents agreed to stop their political maneuvering to impede construction of Lin's design. All changes were subject to FAC and NCPC approval, as well as Secretary Watt's; those hurdles cleared, groundbreaking could take place on March 1. A second meeting was planned, to discuss suitable sculptures.

On February 4, the VVMF advised Watt of the negotiations. Although he was satisfied with the outcome, he inexplicably waited three weeks before seeking the two commissions' agreement with the "concept" before allowing construction to begin. The precise locations of the flagstaff and the sculpture were still undecided. On March 4, the NCPC approved the additions in principle; five days later, the FAC followed suit, suggesting that the additions might be located at the western entry of Constitution Gardens. With the stipulation that the

memorial could not be dedicated until the statue was in place, Watt finally gave his approval on the morning of March 11.

By coincidence, Warner had convened the second meeting between the VVMF and its opponents that afternoon. Once again, the antagonists attending far outnumbered the handful of VVMF representatives. Immediately before the meeting, Perot moved to change the agenda— supposed to be about the design of the sculpture, the discussion was now to be about the *location* of the additions. A majority voted, by a show of hands, that the flagstaff should be at the apex of The Wall and the sculpture within the triangular area that it formed. The VVMF promised nothing.

The months of conflict had drained Scruggs. Besides, as Louis Menand has observed, he was hardly "of aesthetic bent.... All he wanted was a memorial; he had little interest in a work of art. 'Let's put the names on the Mall and call it a day' was his philosophy. When objections began, he was disposed to compromise."[29] Lin later confided to Tom Finkelpearl,

> They wanted to place the sculptures at the apex, with the flagpole right on top.... It would have been horrible. But if I had gone to the press right away, the whole process would have stopped. So I gambled. I felt that we needed to get construction started so I kept quiet for four months, which got us to the groundbreaking.... If I had been a strict idealist I would have said from the start, "I will not threaten the aesthetic integrity of the piece," but we would have gotten the heroic sculpture.[30]

Site works started on March 16. Ten days later, a small group braved a blustery morning to watch 125 ex-servicemen and a few political luminaries each turn a spadeful of soil to officially break ground for the memorial. Lin was not there. A couple of weeks earlier, she had told a journalist that she planned to spend part of her prize to travel to Paris and then on to China with her family (that didn't happen). She declared, "I am trying to disassociate myself from the memorial. The project is done for me."[31]

One battle may have been over, but Lin's war had hardly begun.

NOTES

1. Jan C. Scruggs and Joel L. Swerdlow, *To Heal a Nation: The Vietnam Veterans Memorial* (New York: Harper & Row, 1985), 46.

2. Cited in Robert F. Howe, "Monumental Achievement: Maya Lin Strives to Go beyond the Wall," *Smithsonian* 33 (November 2002).

3. Bill Moyers, "Becoming American," interview with Maya Lin, Public Affairs Television, 2003, http://www.pbs.org/becomingamerican/ap_pjourneys_transcript5.html.

4. Statement by Maya Lin, March 1981, http://www.vvmf.org/index.cfm?SectionID = 77. It is widely cited elsewhere.

5. Maya Lin, *Boundaries* (New York: Simon & Schuster, 2004), 4:12.

6. Robert Levey, "Washington, Lincoln to Overlook Her Memorial to Viet Veterans," *Boston Globe*, July 18, 1981.

7. Joan Beck, "In Defense of the Vietnam Memorial," *Chicago Tribune*, October 2, 1982.

8. Philip Kennicott, "Why Has Maya Lin Retreated from the Battlefield of Ideas?," *Washington Post*, October 22, 2006.

9. Library of Congress, *American Treasures*, circa 2005, http://www.loc.gov/exhibits/treasures/trm022.html.

10. Brian Lamb, "*Boundaries* by Maya Lin," C-Span, *Booknotes*, November 19, 2000, http://www.booknotes.org/Transcript/?ProgramID=1589.

11. For a scholarly treatment of The Wall and its political implications, see, for example, Charles L. Griswold, "The Vietnam Veterans Memorial and the Washington Mall: Philosophical Thoughts on Political Iconography," *Critical Inquiry* 12 (Summer 1986): 688–719; Karal Ann Marling and Robert Silberman, "The Statue Near the Wall...," *Smithsonian Studies in American Art* 1 (Spring 1987): 4–29; Marita Sturken, "The Wall, the Screen, and the Image: The Vietnam Veterans Memorial," *Representations* (Summer 1991): 118–42, reprinted in Nicholas Mirzoeff, ed., *The Visual Culture Reader* (London: Routledge, 2001); Robin Wagner-Pacifici and Barry Schwartz, "The Vietnam Veterans Memorial: Commemorating a Difficult Past," *American Journal of Sociology* 97 (September 1991): 376–420; and Daniel Abramson, "Maya Lin and the 1960s: Monuments, Time Lines, and Minimalism,"

Critical Inquiry 22 (Summer 1996): 679–709. Many other references can be found in the bibliography.

12. Lamb, "*Boundaries* by Maya Lin."

13. Al Cox, "AIA Northern Virginia Congratulates Two New Fellows," *AIA Northern Virginia News* 44 (March-April 2008). Emphasis added.

14. William Lecky, Prepared Statement to Senate Committee, June 3, 2003, 38, http://www.gpo.gov/fdsys/pkg/CHRG-108shrg65/pdf/CHRG-108shrg65.pdf.

15. Levey, "Washington, Lincoln to Overlook Her Memorial to Viet Veterans."

16. Nina Hyde, "Dressing up for Jones," *Washington Post,* November 25, 1981.

17. Andrew Marton, " Breaking down 'The Wall,' " *Fort Worth Star-Telegram,* January 9, 2005, 1D.

18. Maggie Lewis, "Vietnam War Memorial: 'Violence Healed over by Time,' " *Christian Science Monitor,* August 6, 1981.

19. Addendum to Elizabeth Hess, "A Tale of Two Memorials," *Art in America* 71 (April 1983): 123.

20. American Academy of Achievement, "Maya Lin, Artist and Architect," June 16, 2000, Scottsdale, AZ, http://www.achievement.org/autodoc/page/lin0int-1.

21. Paul Goldberger, "Vietnam War Memorial to Capture Anguish of a Decade of Doubt," *New York Times,* June 6, 1981, 7.

22. Wolf von Eckardt, "Of Heart and Mind…," *Washington Post,* May 16, 1981, B1.

23. Benjamin Forgey, "Model of Simplicity," *Washington Post,* November 14, 1981.

24. For thorough chronological documentation, see Edward J. Gallagher, "The Vietnam Wall Controversy," http://digital.lib.lehigh.edu/trial/vietnam/.

25. Wilbur J. Scott, *The Politics of Readjustment* (New York: Aldine de Gruyter, 1993), 132.

26. "Stop That Monument," *National Review,* September 18, 1981.

27. Sturken, "The Wall, the Screen, and the Image," 125.

28. Addendum to Hess, "A Tale of Two Memorials," 123.

29. Louis Menand, "The Reluctant Memorialist," *New Yorker*, July 8, 2002, 54–65.

30. Tom Finkelpearl, "The Anti-Monumental Work of Maya Lin," 1991, http://forecastpublicart.org/anthology-downloads/finkelpearl.pdf.

31. Michael J. Weiss, "Maya Ying Lin's Memorial to the Vietnam War Dead Raises Hope—and Anger," *People* 17 (March 8, 1982).

Chapter 9

ACCRETIONS AND AGGRAVATIONS: CONTINUING CONFLICTS IN WASHINGTON

The major aspects of Maya Lin's memorial design had been resolved by the beginning of 1982. Although no longer a consultant to the Cooper-Lecky Partnership, she continued to work in its office, where as an intern, she was paid at about half her previous rate to design water fountains for the 1984 Louisiana World Exposition. She also was helping to renovate a dilapidated row house in Georgetown that she rented with two designer roommates. For some reason—perhaps she anticipated the imminent need to defend the integrity of her design— her overseas travel plans were on hold. And she was waiting until fall, when she intended to return to architectural studies either at Harvard or Yale, whichever one would accept her.[1]

Early in April, the VVMF appointed a "sculpture panel." Its four members were all veterans; two, Arthur Mosley and William Jayne, supported Lin's design, and two—author (and later U.S. senator) James Webb and Milton Copulos—implacably opposed it. The panel's task was to select an artist to make the compromise sculpture, approve its design, and determine its location and that of the flagstaff. All the competition entries that involved statuary were reviewed, but the

choice of artist was almost inevitable. Frederick Hart's realistic work had been awarded first prize in the figurative category and (as part of Joseph Brown's entry) third overall prize. Hart was asked to produce maquettes of preliminary designs. He had attracted public attention in the early 1970s for his "creation sculptures" on the west facade of the National Cathedral, but, despite that success and his undoubted ability, he remained at the edge of the art world. To his chagrin, his passé magnum opus was ignored by art critics, who had become unsympathetic to "old school" sculpture.

When, in 1980, Hart learned of the proposed memorial, he had offered the VVMF, unsolicited, "a pavilion structure... influenced by elements of a Buddhist pagoda... containing two works of sculpture, one a realistic depiction of two soldiers and the second a more abstract form of Plexiglas with internal images." He had been declined. When the competition was announced, working in collaboration with the landscape designers EDAW, he proposed a semicircular white wall bearing the names of the dead and missing. At one end, the realistic figure of an infantryman knelt beside a fallen comrade, and, at the other, a medic ran to help. Of course, the solitary serviceman now intended to augment The Wall would not resemble either of Hart's earlier designs.

In mid-June, the VVMF agreed to consider a grouping of three soldiers, and, a couple of weeks later, Hart was asked to develop a scale model. The location of the statue and the flagstaff was a contentious issue from the start. Webb and Copulos insisted that, regardless of aesthetic impact (and even of the commissions' approval), it should be determined on political grounds. Ostensibly as a "gesture of good faith" (but more likely to avoid further delay), the VVMF endorsed the sculpture panel's recommendations without modifying the vote of the previous March. In an about-face, Scruggs would aver, "We *really fought* for Maya's design, but we're happy with the compromise.... Some didn't like [the original proposal] because it was too abstract, too unconventional. [But now] the way it's done does not detract from the design. *It makes it 100 percent better, much more beautiful.*"[2]

For Lin, that was the final straw. The VVFM had betrayed her. Worse, she learned of their cave-in neither from them nor from Cooper-Lecky but from a television program. It baffled her that the veterans did not have the nerve to admit to the concession they had made without

bothering to consult her. Whom could she now trust? At the time, she was teaching a summer course at Phillips Exeter Academy, in New Hampshire. Upon learning that the statue would be an integral, even a prominent, part of the memorial, she angrily objected, "This farce has gone on too long.... Past a certain point it's not worth compromising." As for Hart, she couldn't comprehend how "anyone of integrity [could] go around drawing mustaches on other people's portraits."[3]

Although the FAC had not approved the exact placement of the new elements, Secretary Watt insisted that a decision had to be made before he would allow construction to start. Lin announced that she would appeal to the FAC, scheduled to meet in September. She asserted, "Its silence, its ability to move people and let them think their own thoughts—that's the memorial," adding, "It's like a still pond or a quiet glade in the woods; add something to it, add noise, add clutter, add anything and you begin to detract. Your mind gets drawn away."[4] Her attorney threatened legal action to halt construction unless the accretions were abandoned. Perot issued a counterwarning: he would sue to stop The Wall until the statue and the flagstaff were in place. Scruggs, on the horns of a dilemma, was afraid that a stand-off would give Watt an excuse to defer work. He hastily arranged to have a memorial panel—six were then complete—installed and unveiled as quickly as possible. By July 21, it stood alone in Constitution Gardens, like a scaled-down monolith from 2001: A Space Odyssey.

Over the following weeks, others added their protests to Lin's. The president of the AIA labeled the additions "ill-conceived" and "a breach of faith,"[5] and the respected Chicago architect Harry Weese, who had sat on the competition jury, scornfully remarked, "It's as if Michelangelo had the Secretary of Interior climb onto the scaffold and muck around with his work." Knowing exactly where the blame lay, he later weighed his words more carefully: "I view the adulteration of Maya Lin's design by any dissident group as arbitrary, capricious and destructive and the approval of such by any reviewing agency or authority irresponsible and beyond the pale of due process. Art is uncompromisable."[6]

Staring down the objections, the VVMF, apparently unconcerned about the despoliation of Lin's design, pursued its "whatever it takes" course to get the memorial completed. In mid-August, its sculpture panel presented a final report; deferring to the opponents, it recommended

the erection of a 60-foot bronze flagstaff, 40 feet behind the angle of The Wall and 18 feet to its west. The sculpture group would stand close to The Wall, within its angle. On September 20, at a subdued ceremony in Washington's Pension Building, a 15-inch-high maquette of Hart's proposed eight-foot bronze grouping was unveiled—"figurative in style and humanist in substance," it portrayed three standing "grunts": a Caucasian, an African American, and a Hispanic. Lin did not attend. Hart would receive more than $300,000 for the finished work—15 times the first prize in the competition.

At a five-hour meeting on October 13, the FAC heard 25 witnesses speak in defense of the compromise design; only 9, including Lin, spoke against it. After proceedings were adjourned to inspect the site, J. Carter Brown, chair of the Commission, announced its approval. However, it vetoed a location close to The Wall, because it believed that the additions would detract from Lin's design. The best location (the commission said) would be near the west entrance to Constitution Gardens. Hart hailed the resolution as "Solomon-like." Lin was less effusive; she regarded the sculpture as a completely separate entity.

In mid-November 1982, nearly 10 years after the end of the Vietnam conflict, a five-day National Salute to its veterans reached its climax with the official dedication of the memorial. On the morning of Saturday, November 13, a parade began to the beat of military and high school bands. More than 15,000 men—many in wheelchairs—paraded along Constitution Avenue, and at noon there was a fly-past of Phantom bombers and "Huey" helicopters. The 75-minute dedication ceremony commenced at 2:30 in the afternoon, before a crowd of 150,000; live radio and TV coverage increased the audience to millions. The *Washington Post* reported:

> The ceremony, like the memorial, was movingly simple. The oldest [participating] child was 18, the youngest 10.... They placed a wreath of red roses and [chrysanthemums] at the center of the memorial. Folk singers...sang "America the Beautiful" and "Where Have All the Flowers Gone," the wrenching antiwar song that filtered up from the Mall so many times during the years of the protests. Yesterday, it moved many to tears as it asked the question the memorial will ask the ages: When will we ever learn?[7]

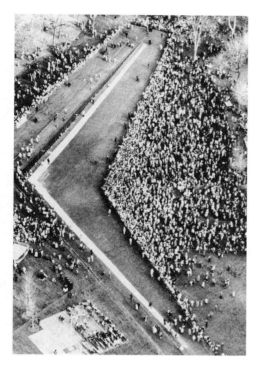

Crowds gather around the new Vietnam Veterans Memorial during the dedication on the National Mall in Washington, D.C., on November 15, 1982. (AP Photo/Charles Pereira.)

When Scruggs announced, "Ladies and gentlemen, the Vietnam Veterans Memorial is now dedicated," the throng pressed forward, flattening the crowd control barriers and trying to touch the names on The Wall. Although Lin was its creator and had painstakingly and courageously overseen the execution of her design, her name was not mentioned during the dedication. But on Veterans Day 1992—10 years later—she was publicly recognized. Journalist Linton Weeks described the scene: "She steps up to the podium and receives a standing ovation. She smiles and apologizes to the crowd. 'I didn't really have a speech prepared. I'm not very good at these things at all. Oftentimes, I just let the works speak for themselves.'"[8]

In the fall of 1982, having graduated cum laude from Yale, Lin enrolled in the master of architecture program at Harvard's famous Graduate School of Design. But the time was out of joint. She decided to drop out early in 1983, after less than a semester. As wrangles continued over the memorial and the additions, unremitting demands upon her to testify in Washington intruded upon her studies. She ruefully

Maya Ying Lin and vice president-elect Al Gore participate in Veterans Day ceremonies at the 10th anniversary of the memorial in Washington, D.C., on November 12, 1992. (AP Photo/Marcy Nighswander.)

recalled that, during one shuttle flight from Cambridge, "I realized I was writing a paper for a course…on the shuttle back from testifying. I was thinking this is a really bad time to be in graduate school.… I inevitably wasn't really able to focus on work at all."[9]

Lin spent most of 1983 working full time in the Boston architectural practice of Peter Forbes and Associates. Forbes recounts how she walked into his Myrtle Street office without "prior contact or recommendation." He added her to his staff of four, then working mainly on residential commissions. Until she enrolled at Yale, at the end of the year, she was building scale models and learning how to prepare design drawings and basic construction documents—that is, she did what any green architectural intern would do.[10]

Meanwhile, back in Washington.…Within a couple of weeks of the dedication, storms of discontent were gathering over the location of the accretions. Dissidents had lobbied Watt and Congress to overrule the FAC. In late December 1982, toward the end of the "lame

duck" session of Congress, two opportunistic representatives tendered resolutions to establish the locations "as originally intended." Senator Mathias, pointing out that such a move was "inconsistent with [the] Congressional mandate and in violation of the principle of separation of powers for the Congress," forestalled them. But, early in January, Copulos threatened, "It ain't over.... They ain't seen nothing yet."[11]

At the end of the month, Watt, claiming to be under pressure from Congress, stated that the locations involved political issues that might not be resolved for more than a year. One commentator observed that Watt regarded himself as the final authority on any appropriate memorial statement on the Vietnam War, whether aesthetic, artistic, or symbolic. Watt began pestering (and that is the word) the FAC to reconsider its opinion. J. Carter Brown responded, "We'll see what happens.... We are a review body, and we'll approach it with an open mind." The FAC met again on February 8. Once again, witnesses wanting to leave Lin's design intact were outnumbered, but, after three hours of emotional debate, the FAC voted unanimously to make the statue and the flagstaff part of an "entry plaza" in a grove at the western end of Constitution Gardens, several hundred feet from The Wall. About a month later, the NCPC unanimously ratified that decision, and, through the summer, the VVMF relocated paths and installed the flagstaff.

As well as their artistic quarrel, Lin and Hart clashed personally. The reasons for Hart's antipathy are not difficult to guess. Outclassed by her in the original competition, he clearly found Lin's youth and gender difficult to contend with. He variously described her to one interviewer as "an ingénue," "a Cinderella," and (sarcastically) as "a poor little girl who is getting kicked around by the Secretary of the Interior."[12] While the two artists may have been intellectually comparable, socially they were polarized. Hart's youth had been destabilized by misfortunes in his working-class family; Lin had been secure in a middle-class professional environment. Hart was a high-school dropout who persisted for only six months when he later returned to the University of South Carolina; Lin was a high school valedictorian with a bachelor's degree with honors from Yale. Apprenticed to the Italian stone carver Roger Morigi, Hart had honed his sculpting skills "on the tools"; although she grown up in an intense craft setting, much of Lin's art education had been theoretical and abstract—not to say ideological.

The seeds of her resentment of Hart's sculpture were sown when he told her to her face that it would enhance the memorial. Admitting that "the only person [she] really felt kind of very much less of [*sic*] was the sculptor of the three statues," she explained that

> as an artist, you should know to respect another person's art. And I remember the whole controversy was he wanted the statues right there at the apex. And I remember a meeting when he literally turned to me and said.... "My sculpture will improve your work." I would never in a million years disrespect another artist that way...Obviously it was very traumatic and upsetting, but I didn't take it personally. I felt that everyone's entitled to their opinion.[13]

Still incredulous 20 years later, she remembered, "I just couldn't believe someone could be that rude." She did not regard Hart as an artist.

Their differences erupted publicly in April 1983—too late to change the outcome determined by the commissions. In an interview published in *Art in America*, Lin obliquely cast doubts on Hart's integrity: "From what I gather, Hart thought a long time before accepting the commission. It wasn't necessarily going to be good for his reputation, but the price was right." She complained that "He goes on and on about working with my piece rather than against it. But you can't really work with a piece if you don't have a dialogue with it. He claims that my memorial is 'rude in its neglect of the human element.' How can someone like that work with my design?" As for his statue, she said, "It's trite. It's a generalization, a simplification. Hart gives you an image—he's illustrating a book." Therein lay the essential incongruity. Hart's work, realistically rendered down to the bootlaces, demands little input from an audience. Everyone sees the same literal image that demands no interpretation; everyone receives the same prepacked thoughts. But when a visitor stands before the highly polished surface of The Wall and sees his or her own reflection looking back from among the names of the lost, each endows the experience with a unique significance.

Yet, Hart, who on one occasion described Lin's design as "a telephone book listing of dead people," had accused it of being nihilistic,

contemptuous of life, and "intentionally not meaningful." It was, he said, unrelated to ordinary people—however they might be defined. He boasted, "I researched for three years—read everything. I became close friends with many vets," and he dismissed The Wall as "a serene exercise in contemporary art done in a vacuum with no knowledge of the subject.... The collision is all about the fact that Maya Lin's design is elitist and mine is populist." Then, totally disregarding her articulate rationale, he gratuitously added, "People say you can bring what you want to Lin's memorial. But I call that brown bag aesthetics. I mean you better bring something, because there ain't nothing being served." And, for good measure, he threw in: "It takes a tremendous amount of egocentricity and arrogance for artists to feel that no one should interfere with their work—when it's for the public."[14]

Hart's belittling of The Wall is challenged by the four million "ordinary people" who visit it each year and who, more often than not, depart in tears. As one observer notes,

> Around the [Hart] statue, people talk louder and breathe easier, snap vacation photos unselfconsciously, eat Eskimo Pies and Fritos. But near the wall, a young Boston father tells his rambunctious son, "Hush, Timmy—this is like a church." The visitors' processionals do seem to have a ritual, even liturgical quality. Going slowly down toward the vertex, looking at the names, they chat less and less, then fall silent where the names of the first men killed...and the last...appear. The talk begins again, softly, as they follow the path up out of the little valley of the shadow of death.[15]

And the art world's opinion is summed up in the words of the esteemed architectural historian Vincent Scully: "[The Wall] has to be seen not only as the most important monument but also as the single most significant work of architecture to be constructed in the United States during the second half of [the 20th] century."[16]

President Ronald Reagan dedicated Hart's *Three Soldiers* on Veterans Day 1984 and signed a deed conveying it and The Wall to the U.S. government. It was only his second visit to the memorial; the first had lasted for just seven minutes. As the days stretched into months, Hart

waited for critical responses to his work in the national press or the art journals. But there were only noncommittal announcements. Lin, then settling in to postgraduate studies at Yale, was not at the dedication. Perhaps she believed, or wished, that her bitter Washington experiences were at last behind her. Sadly, that was not so.

Just when the location of the statue and the flagstaff was officially confirmed, the Vietnam Women's Memorial Project (VWMP) was born. Its proponents were beleaguered by infighting, and it was not until April 1986 that a campaign was launched to place a seven-foot-tall statue of a "sad-eyed Army nurse" by Minneapolis sculptor Rodger Brodin "next to" (an ambiguous phrase) The Wall. The following month, the VVMF agreed that the women's memorial could be erected somewhere on its two-acre site.

Arguments for and against the proposal were aired in the press until September 1987, when Secretary of the Interior Donald Hodel approved the concept. Once again, the final decision belonged to the FAC and the NCPC. Lin, having completed her master's degree, was then an intern in New York. She wrote to the FAC, registering her opposition and repeating her warning—any addition to the memorial would set an undesirable precedent.[17] After two hours of "stirring testimony," an October 21 meeting of the FAC voted 4–1 against the proposal: it agreed that any change would lessen the impact of Lin's memorial; regardless of its artistic merit or location, an addition probably would be "anticlimactic and disappointing, which would be a very sad thing." But that was not to be the end of the matter. The Women's Memorial was a much hotter political potato than Hart's sculpture because of its implications for the women's vote. So Congress interfered. With strong bipartisan support, Senator David Durenberger introduced a joint resolution to authorize a women's memorial; this time no one dared object on quasi-constitutional or any other grounds.

Toward the end of February 1988, the Senate Energy and Natural Resources Subcommittee on Public Lands, National Parks, and Forests conducted another hearing. In evidence, Lin contended, "In allowing this addition you substantiate the assumption that our national monuments can be tampered with by private interest groups years after the monuments have undergone the proper legal and aesthetic approval processes." She was supported by J. Carter Brown;

Reginald W. Griffith, executive director of the NCPC (which had also rejected the proposal); and five others. But 10 witnesses, including delegates representing several veterans' groups, spoke in favor of the women's statue. Lin, resigned to its probable approval, admitted, "It's going to happen, and I just don't see where it will end."[18]

In May, the Senate in committee approved the bill by a 16–1 vote, and a month later the full Senate passed it, 96–1. Seventy percent of witnesses at a June hearing of the Committee on House Administration spoke for a bill authorizing construction of the memorial, and after much political to-ing and fro-ing, on November 15, President Reagan signed it into law. By then, Brodin's insipid piece had been discarded, to be replaced by a group of four bronze figures by Glenna Goodacre—shades of the Hart work, and in the same realistic style. Standing in a garden designed by George Dickie, mercifully several hundred feet from The Wall, it was dedicated on November 11, 1993.

That was the moment of Lin's disengagement from the machinations of Capitol Hill. Yet, as late as March 2009, she admitted to lingering internal conflict: "It's not bad memories....Let's put it this way: I didn't have a really nice time." During a rare and unavoidable visit to Washington, D.C., she said that she was

desperately trying to move past the Memorial as fast as possible as an artist. I was trying to prove to myself that I could balance out my life in a different way....It's not that I don't love the Memorial...but you do feel it's like this big galumphing elephant. And I think you move on. And yet, at the same time, it's a big piece. It will always be my biggest piece and I'm very proud of it.[19]

NOTES

1. Michael J. Weiss, "Maya Ying Lin's Memorial to the Vietnam War Dead Raises Hope—and Anger," *People* 17 (March 8, 1982).

2. "Vietnam Memorial Designer Rejects Changes," *Boca Raton News*, July 8, 1982. Emphasis added.

3. Rick Horowitz, "Maya Lin's Angry Objections...," *Washington Post*, July 7, 1982.

4. *Boca Raton News.*

5. "Vietnam Memorial Designers, AIA Strongly Denounce Alterations," *Journal of American Institute of Architects* 71 (August 1982): 9–10.

6. Harry Weese to Jan Scruggs, October 6, 1982. Emphasis added.

7. Judy Mann, "Remembering," *Washington Post*, November 12, 1982.

8. Linton Weeks, "Maya Lin's 'Clear Vision,'" *Washington Post*, October 20, 1995.

9. Cited in Michael M. Grynbaum, "Soft-Spoken Lin Packs Artful Punch," *Harvard Crimson*, December 2, 2005.

10. Peter Forbes, FAIA, correspondence with author.

11. "Protracted War," *Washington Post*, January 5, 1983.

12. Addendum to Elizabeth Hess, "A Tale of Two Memorials," *Art in America* 71 (April 1983): 120–27.

13. Bill Moyers, "Becoming American," interview with Maya Lin, Public Affairs Television, 2003, http://www.pbs.org/becomingamerican/ap_pjourneys_transcript5.html.

14. Addendum to Hess, "A Tale of Two Memorials."

15. Kurt Andersen, "Hush, Timmy—This Is Like a Church," *Time*, April 15, 1985.

16. Vincent Scully, "Vietnam Veterans Memorial," in Maya Ying Lin, *Maya Lin* (Milan: Electa; Rome: American Academy in Rome, 1998).

17. Maya Lin to the Fine Arts Commission, October 21, 1987.

18. Kara Swisher, "Maya Lin's Memorial Defense," *Washington Post*, February 24, 1988.

19. David Montgomery, "The Long, Long Journey of Maya Lin," *Washington Post*, March 19, 2009.

Chapter 10

NEW HAVEN, NEW YORK: NEW BEGINNINGS

Maya Lin returned to Yale at the end of 1983. The Vietnam Veterans Memorial saga had been published in the national media and in hundreds of provincial newspapers, and her name was fast becoming a household word. As The Controversy faded from memory, America recognized the aptness and power of her design. *Time* magazine would later observe that, "as soon as it was dedicated...all but the most relentless cranks were moved and subdued. No other American memorial has been the vessel for so much authentic emotion."[1] Images of it were shown in a 1983 group exhibition at the San Francisco Museum of Modern Art, and, in February 1984, the AIA honored it with the Henry Bacon Medal for "architecture whose purpose is to portray, promote, or symbolize an idea of high spiritual concern"—only the fourth edifice to be so recognized in almost 20 years. In that same month, the Sidney Janis Gallery, in New York, presented images of it in an exhibition, "American Women Artists—the Recent Generation," and at the end of the year a model was included in another group show, "Sites and Solutions: Recent Public Art," at Albright College's Freedman Gallery in Reading, Pennsylvania.[2]

Michael Parfit has remarked that the Vietnam Veterans Memorial brought Lin celebrity and "extraordinary freedom right at the start of her working years." He continued, somewhat hyperbolically:

> She held the ticket to prolonged fame in her hand.... She could have become a person of grandeur, building great monuments for only the greatest of events. Princes would have begged her for an audience; warriors would have wondered if their battles were worthy of being noticed by Maya Lin; the president would have invited her to the ranch.[3]

So many "could haves" and "would haves"! But Lin didn't see it like that. Her imperative was to get out of the capital and back to academia, her "only safe haven." Securely ensconced in Yale, she confided that she was "still touchy" about all that had befallen her in Washington and said, "I really believe in the memorial and gave a lot of myself in getting it built. It drained me."[4] After many more years, she told a reporter, "I wanted to pretend it never happened. I went back to school and tried to forget it."[5] And, as late as 2003, she spoke on national television of her inability to cope with the emotional battering that she had endured, conceding that she had refused to acknowledge the hurt: "I was just bottling it all up.... I was bawling.... So my way of getting over it was to throw myself right back into first Harvard then Yale."[6]

As explained, Harvard had been the wrong place at the wrong time for her to find sanctuary. Perhaps she could have returned there at the end of 1983, but retreating to Yale's familiar milieu was a more attractive prospect. Besides, Vincent Scully, who had staunchly defended her throughout The Controversy, wanted her to work as a teaching assistant in his Modern Architecture course—a role she would fulfill in 1984–1985. She counted that a great honor, and so it was.

It is difficult to improve upon Patricia Leigh Brown's delightful summation of the double life that Lin was constrained to live while undertaking graduate studies:

> There's Maya the Yalie. That Maya lives in a dormitory room, wears knee-length, button-down shirts and has a passion for piggyback rides. She delights in devouring cinnamon toast at "The

Lizzie," as the crusty Elizabethan Club is known. She bops around Yale, frequently using such phrases as "That's cool" and "It's happening." She carts textbooks with names like *Mechanical and Electrical Equipment for Buildings*, "the most godawful boring stuff ever created." She flies down stairs, scarf trailing behind her.... That Maya wants to be a student, a kid. . . .

There's another Maya Lin. That one tucks a toothbrush into the pocket of her Army jacket, takes the train to Grand Central Station in New York and is greeted by an Apple Computer limousine.... The limo whisks her to a Japanese hair stylist and then to a fashion photographer. The resulting photographs reveal a painfully beautiful young woman unrecognizable to her.... Dreamily self-possessed, she wows them at New York cocktail parties and is repeatedly in demand as a designer. And she is awestruck by the fact that so many famous people she admires, famous grown-ups, admire her. Life has been "kind of weird" for Lin.[7]

According to faculty member Alexander Gorlin, the Yale School of Architecture, housed in Paul Rudoph's concrete magnum opus, was "humanistic, professional, and open to a thousand flowers blooming"— whatever that means.[8] It offered a three-year master of architecture degree, open to any sound liberal arts graduate, during which each student was encouraged to develop a personal design philosophy. Of the 39-strong 1984 cohort, only six were Yalies. Most held arts degrees; a few had degrees in science, fewer still in fine arts, and two had a background in environmental design. Only David Hotson, with whom Lin would later frequently collaborate, came from outside the United States. Just nine were women, suggesting that attitudes about gender roles in architecture had changed a little since Lin's aunt had been denied a place in Penn State's architecture program 60 years earlier.[9]

At the program's core was the design studio, where students' ideas were presented for evaluation by their peers, teachers, visiting critics, and practitioners—even, on occasion, the public. It was complemented by lecture courses in architectural history and theory; professional practice; building technology, materials, and construction; city planning; landscape architecture; and visual representation. Students could enroll in electives from other university departments, and domestic or

overseas travel was encouraged—even mandated—in some courses. Dean Cesar Pelli, who had counseled Lin about choosing an architect of record for the Vietnam Memorial, resigned in 1984 to pursue his New Haven architectural practice; he was succeeded by the Chicago architect Thomas H. Beeby. The permanent faculty was augmented by a stellar international array of visiting lecturers, including Frank Gehry, Francesco Dal Co, Rem Koolhaas, Rob Krier, and Richard Rogers.

It seems that Lin was a quite ordinary student. Most of Lin's classmates had completed their undergraduate degrees after her, and it was ironic that she might have had teachers in graduate school who had entered the Vietnam Memorial competition. It is entirely possible that she encountered envy, either covert or open, from both fellow students and professors. At first, she underperformed, a lapse that she later put down to her scarring experiences in Washington. In her own words, "I get to my first year in graduate school and I'm a basket case. I mean, I'm doing the work, but I'm never finishing anything."[10] She was, she confessed, terrified and "having trouble getting back into it. It was difficult, literally, to get through the year."[11] It is perhaps significant that, apart from a photograph of the class of '86, neither she nor her studio projects were included in issues of *Retrospecta*, the School's annual report of student work.[12] Anyway, by her own admission, she had a "hard time in grad school."

Lin was genuinely worried that she would be seen as a "one-hit wonder." Despite several well-received public works, it would take her at least 10 years to realize that she was much more. While still at university, she was torn between architecture (for which she used the literary metaphor of prose) and sculpture (which she equated with poetry). When she asked herself, "What do you do for an encore?," she was certain that she did not want to be typecast as a monument designer. So, although she continued her architectural studies, by her final year she spent a great deal of time in the sculpture department. She confessed, "I began to find my voice in sculpture."[13] She reflects:

> I think my professors were always trying to guide me—I had just gotten the coup of the century with the Memorial, so why wasn't I behaving more like an architect? But I had started to think more like an artist. As much as I love architecture my processes and my

premises are much more those of an artist. I'm very committed to buildings but I won't give up the art.[14]

Lin studied sculpture under Richard Serra, himself a "Yalie," and, as mentioned, architecture under Frank Gehry, known for his sculptural forms. There is a story that, having been told by her professors that she could study either discipline but not both, she used to "sneak" to the School of Art to take sculpture classes. "Sneaking" sounds more exciting than formally enrolling, but students at Yale could take external electives only with the permission of the relevant teacher. So it is likely that Lin simply enrolled in classes taught by Serra, Ursula von Rydingsvard, and others. Whatever the case, she later protested that she quickly tired of "paper architecture, of designing things that never got built," adding, "The problem with architecture is that it's a greedy profession. It starts sucking up all your time."[15] For Lin the maker, working hands-on was very important, if not paramount—and it remains so. Years later, one of her former architecture professors told her that he knew she was never going to be an architect; ironically, at that moment, she had two architectural commissions. At times throughout her career, the two arts have coalesced. Nevertheless, she still sees her works as belonging to separate fields—as distinct parts of herself. She once mused, "Architects call me a sculptor, and sculptors call me an architect. I don't think either wants to claim me."[16]

In the summer of 1984, she received her first independent commission since The Wall. It was for a stage set, and that (quite coincidentally) linked her with her aunt Huiyin, who had spent a year studying stage design at Yale. The composer Noa Ain asked Lin to create a set for the jazz chamber opera Trio, coproduced in July by the American Music Theater Festival and the Philadelphia College of Art. It also played at Arts at St. Ann's, in Brooklyn Heights, and, in mid-October, it had a five-performance run at Carnegie Recital Hall.[17] The events leading to the work were serendipitous. Ain remembers seeing "a very lovely young Maya...in a "conversational [television] interview" with a horrible aggressive Texan who was treating her as if she knew nothing...."He was obsessed with the idea that the only way to memorialize all the dead was to 'sculpt real men.'...Maya was calm but very clear about her point of view." After the program, she called her

producer and told her that she had to get Lin's phone number because she was "the perfect artist to visualize a set for *Trio*."[18]

Hilary Blecher, the opera's director, remembers Lin as "low-key," very modest and eager to learn in an unfamiliar artistic field. After Blecher explained her vision for the production, the budget constraints and the physical differences in the venues, Lin designed a set consisting of connected gauze screens on vertical poles, which stagehands could maneuver from beneath to form a variety of interconnected spaces. Blecher emphasizes that Lin's ideas "were always in line with her basic vision: going to the essence of what she wanted to say and then saying it as powerfully and simply as she could, more often than not with very surprising and imaginative elements."[19] The set, ephemeral by definition and intrinsically fragile, no longer exists.

The demands of postgraduate studies and of celebrity left little time for extracurricular activities. There was another "public" work, albeit a small one, uncommissioned and no longer extant. Lin bought a job lot of 18-foot-long zinc rods, painted them green and black, and embedded them in a straight line among the reeds in the bank of the Mill River in New Haven's East Rock Park. Even this ephemeral piece, "Aligning Reeds," embodied her consistent intent to have the viewer personally interpret her art. She recalls:

> There was only one viewing point...where you could tell this was a man-made intervention because that was the only point where they all lined up. From any other angle it looked like they were just part of the reeds along the bank. I went back a week later and I was standing there looking at them from across the stream, and these two fishermen were there. [They were saying,] "What do you think it is? Is it alive? Is it natural?" And they turned to me and said: "What do *you* think it is?" And I said: "Oh, I don't know!"[20]

Although the beloved China of Julia Lin's youth was gone forever, in summer 1985, she took her children to visit their ancestral homeland. Henry, whose health was failing, was unable to go with them. The tour, which took in Shiyan, Shanghai, Beijing, and Fuzhou, was an epiphany for Maya. For the first time, at the age of 26, she experienced being part

of an extended family. She did not identify exactly whom she met, and it seems that she has made little effort to maintain contact, but it must be remembered that socially, culturally, and linguistically, she is American; moreover, not all those relatives would have spoken English.[21]

She was deeply impressed by what she believed was her father's childhood home in Fuzhou. Characterizing it as "very Japanese based," she explained, "I was sort of stunned because I've *always* felt my aesthetic is almost at times closer to the Japanese sensibility than the Chinese sensibility... it was laid out like a very traditional vernacular Japanese house. I found out it was also a Chinese style house—it was a mix."[22] And she added, "Apparently my grandmother loved Japanese architecture." Lin later described "a house over-looking the river, with two or three courtyards. The rooms were not compartmentalized; spaces flowed through sliding screens, treating the architecture as a passageway. It was just magical.... I was blown away. I had an affinity to this place." As Patricia Leigh Brown poetically reported, "She felt as if she had stumbled onto the unseen source of her own creative stream."[23]

But whose house was it? In 1842, Maya's great-great-grandfather Lin Zhen Gao established the family's "ancestral" home at No. 7 Nanhou Street (now No. 17 Yang Qiao Dong Road) in the famous Three Lanes and Seven Alleys, a 40-hectare district with 268 houses of the Ming and Qing dynasties—in Fuzhou City. At the beginning of the 20th century, several branches of the Lin family, including Maya's grandfather Changmin (with his first two wives) and his cousin Lin Juemin and his wife, lived in the enclave. A recent Fuzhou newspaper article describes

> three east-facing complexes on the west side of the yard, surrounded by solid walls. A corridor, with green bamboos on both sides connected the first and second complexes. Behind the third were the front and back living rooms lived in by [two other branches of the family]. By the dooryard, a natural compound was formed—the Nan Bei yard.[24]

Unlike the courtyard dwellings that Lin would have seen elsewhere, the typical Fuzhou dwelling was symmetrically disposed along a central north-south axis. According to a description by the writer Bing

Xin, who later lived in the house, it was "not like the *siheyuan* in the north, with a row of rooms, [but] had a oblong yard.... Beside the living rooms, there were parlors and studies, and in almost all of them the pillars and walls were hung with drawings and calligraphy." It was not like a "Japanese house"; rather, Japanese houses were like *it*.

When Juemin was martyred, in 1911, the extended family sold the ancestral home to Bing Xin's grandfather and moved to the relative security of the countryside. So Changmin left the Nanhou Street house several years before his sons (of whom Maya's father was the eldest) were born. Recently, one of her distant cousins claimed that Changmin and "close relatives" moved to Juta Xiang Avenue, another subdivision of Three Lanes and Seven Alleys. Changmin built neither house but, prompted by the changes in his knotty domestic arrangements, simply relocated. His grandfather's house "by the river" is not in the Qixiang area.[25]

The identity of the ancestral home may be a harmless myth of the kind passed down through most families. But, to summarize: the Nanhou Street house certainly was *not* Japanese. It was simply a distinctive regional form. Any similarities between its morphology and what Lin had observed in pictures of Japanese architecture (she never visited Japan before 1986) were coincidental. Neither was it built by her grandfather. Moreover, Lin's offhand "Apparently my grandmother loved Japanese architecture" must be seen in the light of family history, including the fact that her paternal grandmother was conservative, untraveled, and relatively uneducated.

Design is essentially about making choices. A designer reviews alternatives based on what has been seen, experienced, or informally inculcated as socially appropriate. Perhaps—and only perhaps—cultural memory plays a part in the process. In some cases, those options—inevitably limited in range—are augmented by a formal design education. Anyway, from that potpourri, whether a plethora or a paucity, a designer makes pragmatic, sentimental, practical, or aesthetic selections. We can only speculate about how Lin discovered Japanese domestic architecture or how much she understood of it in her university days. No regular courses in oriental architecture were offered in the Yale School's formal program, but, in the fall semester of 1984, the Japanese architect, teacher, and writer Kazuo Shinohara was Saarinen

Visiting Professor. Although Lin would have unable to enroll in his studio—she was a junior, and it was an advanced elective—she may have attended his public lectures. Significantly, between 1958 and 1978, Shinohara's international reputation had been established by his "reductively modernized versions of the traditional Japanese house."

Whatever the source of her knowledge, she perceived congruities between the Nanhou Street house and Japanese houses, which she admired. She later claimed that, before visiting Fuzhou, she could never understand why Japanese architecture so strongly appealed to her, but it seems that her conclusions were based partly upon misapprehensions. "[My father] was influenced by this house, then he shared his aesthetic with us—he made all the furniture, the pottery we ate off of [sic], so that's where the affinity gets connected [sic]."[26] On another occasion, she confessed the guilt that she felt because she found Japanese architecture attractive. She described her confusion:

> The Japanese had blown up my grandfather....What is wrong with me? I'm inspired by Asian [culture], but it's...the wrong [culture]—And there I was, in that house, realizing the circle was closed for me....I got where this aesthetic was formed by, and what my dad had given to me in a way. And that was quite strong.[27]

Over the years, writers have complicated the issue. In 2009, the *New York Times* art critic Holland Cotter verbosely expounded, "Through her father, a ceramicist who grew up in a Japanese-style house in China, she developed an affinity for the nature-saturated, but also nature-framing, aesthetic embodied in the Zen rock-and-sand garden, and in the Chinese ink-and-brush landscape, with its misted and surreally scaled vistas." Without warning, Chinese wash drawings were held out as further generators of Lin's aesthetic; it is unclear whether the elaboration was Cotter's or hers.[28]

However, Henry Lin's aesthetic was built not upon an oriental but upon a European foundation. To begin with, he never was a ceramicist in China. And as already noted, the ceramics program that he undertook in Seattle was directed by Paul Bonifas, a protégé of Amédée Ozenfant, one of the founders of Purism. The other, incidentally, was

the arch-Modernist Swiss architect Le Corbusier. In their 1918 manifesto, *Après le Cubisme*, the two utopians called for a vision of art and the world that would "give attention to the basic, essential form of objects." Bonifas, as general secretary of their journal, *L'Esprit Nouveau*, spread their ideas—ideas that he would later share with his students in Seattle, including Henry Lin. So, although Lin categorized her father's work as "1950s modernism," it was in fact *1920s* modernism.[29] The interiors of the Lin house in Athens, Ohio, were hardly "Japanese." The traditional Japanese dwelling was severely bare; only the *tokonoma* alcove was reserved for restrained displays of artwork, family treasures, or seasonal decorations. A Japanese house would have seemed almost empty in comparison to the Cable Lane house, in whose rooms every horizontal surface—including the floor—was cluttered with Henry's pottery.

Lin received a master of architecture degree from Yale on May 26, 1986. Believing that she had a link with Japanese architecture, and in order to "absorb some of that cultural climate," she spent much of the summer studying in Kyoto, Japan. The nature of her study is uncertain; it may have been quite informal, although one source claims that she had an internship in the office of Fumihiko Maki, whose National Museum of Modern Art was then being completed in the city. Kyoto is famous for its Zen meditation gardens, some of which, including the famous Ryoan-ji Temple, are more than 500 years old. Lin claims that these courtyards, with their elegant raked-gravel and rock designs, were "incredibly influential" in her own work.[30]

Returning to the Unites States in the fall, she established Maya Lin Studios in Lower Manhattan. With her boyfriend, sculptor Peter Boynton, whom she met while they were graduate students—he was enrolled in Fine Arts—she rented a walk-up fourth-floor loft at 112 Prince Street to serve as both home and workplace. The six-story iron-front building, designed in 1889 by Richard Berger, had been converted for use as studios in 1975; by the time Lin moved in, half a dozen Yale-trained artists were sharing it. There she indulged her love of sculpture, producing small experimental works in such malleable materials as beeswax, lead, and, sometimes, shattered safety glass. She would continue to live there for nine years, even after she and Boynton separated. The reason for their break-up is, of course, private, but, by Lin's own account, it seems

surprising that their relationship lasted as long as it did. Artistically, they failed to see eye to eye, even from the beginning:

> When we started going out, we decided to do an art and ar-
> chitecture collaboration. We argued for two weeks and almost
> didn't build it, because we were so different. It was to be a tree
> house in Windham, [Vermont].... We wanted to build "an as-
> cent into a collision," a piece about how two people collabo-
> rate. But we started having these "art arguments." Peter was
> very expressionistic. We finally just looked at each other glar-
> ingly one day. And Peter said, "O.K., what's more beautiful,
> the human figure or a pencil?" And I looked at him and I said,
> "A pencil!" He said, "That's it! We're not doing this and I'm
> not going out with you!" And I said, "Wait a second" and tried
> to explain why I thought abstractions can be more beautiful
> than reality.[31]

It is now impossible to think of Lin as just another architecture intern; nevertheless, in order to have legal status as "architect," she needed to be licensed. In New York State, graduates were required to undertake three years' supervised practical experience before taking the licensing examinations. So, in October 1986, Lin returned to the practice of Peter Forbes and Associates (for which she had worked in Boston in 1983) at its New York branch office. She worked in a small team, designing houses and (among other things) a country club and renovating a Victorian mansion in Connecticut. By 1987, she had be-come an associate, but the office began winding down in 1988, and, within a couple of years, it would close its doors. By then, Lin, with other irons in the fire, had left the firm. She has never completed an internship.

In 1987, Yale awarded her an honorary doctor of fine arts degree— one of only two of its college alumnae who had been so recognized. The citation read:

> While an undergraduate at Yale, you touched the nation's heart
> as it is given over a lifetime only to a few. Your Vietnam War
> Memorial speaks with beauty and truthfulness both to the broken

hopes and the shining promises of our era, a courageous symbol of
completion at a critical time in our country's history. Your University, which nurtured this great work of art, is honored to recognize the clarity of your mind, the skill of your hand, and the
compassion in your soul.[32]

The Vietnam Memorial would always remain, to put it conservatively, a hard act to follow. Then, in the spring of 1988, the Southern
Poverty Law Center, in Montgomery, Alabama, asked Lin to consider
designing a memorial to martyrs of the civil rights movement.

NOTES

1. Curated by Judith Tannenbaum, the exhibition was presented at
Gallery 400, the University of Illinois at Chicago, in January–February
1985.

2. "The Best of the Decade," *Time*, January 1, 1990 (http://www.
time.com/time/magazine/article/0,9171,969072,00.html#ixzz0Ylhw
QHLA.

3. Michael Parfit, "35 Who Made a Difference: Maya Lin," Smithsonian.com, November 1, 2005, http://www.smithsonianmag.com/arts-
culture/lin.html.

4. Patricia Leigh Brown, "For Her, Too, Some Shattering Memories," *Philadelphia Inquirer*, November 6, 1984.

5. Regina Hackett, "Maya Lin Emerges from the Shadows," *Seattle
Post-Intelligencer*, October 19, 2000, http://www.seattlepi.com/visualart/
maya.shtml.

6. Bill Moyers, "Becoming American," interview with Maya Lin,
Public Affairs Television, 2003, http://www.pbs.org/becomingameri
can/ap_pjourneys_transcript5.html.

7. Brown, "Shattering Memories."

8. Alexander Gorlin, "Passion Plays," *Metropolis*, April 2006,
http://www.metropolismag.com/story/20060320/.

9. In 1985, Professor Milka Bliznakov founded the International
Archive of Women in Architecture, http://www.celebratingresearch.
org/libraries/virginiatech/iawa.shtml.

10. Moyers, "Becoming American."

11. Brown, "Shattering Memories."

12. Each issue of *Retrospecta*, edited by students, contains examples of work from courses and reports on lectures, symposia, exhibitions, and studio reviews.

13. Weihua Zhang, "Maya Lin Shares Message of Perseverance," *The Chronicle*, Savannah College of Art and Design, June 15, 2001.

14. Richard Lacayo, "Talking to Maya Lin," *Time*, June 15, 2009, http://lookingaround.blogs.time.com/2009/06/15/talking-to-maya-lin/.

15. Carol Vogel, "Maya Lin's World of Architecture, or Is It Art?," *New York Times*, May 9, 1994.

16. Peter Tauber, "Monument Maker," *New York Times*, February 24, 1991.

17. Carnegie Hall Corporation, correspondence with author, June 2009.

18. Noa Ain, correspondence with author, January 2010.

19. Hilary Blecher, correspondence with author, January 2010.

20. Lacayo, "Talking to Maya Lin."

21. Peng Yining, "Venerating Vanishing Flash of Memory," *Global Times* (PRC), October 18, 2009, http://special.globaltimes.cn/2009–10/477980.html: "[Lin] has an uncle in Xi'an and a cousin in Beijing. Lin struggled to think of [his] name: Liang Congjie who founded Friends of Nature.... 'Oh, that's terrible. I almost forgot his name,' Lin said. 'I should go to see them, but every time I come to China there's a time crunch.'"

22. Moyers, "Becoming American."

23. Patricia Leigh Brown, "Maya Lin: Making History on a Human Scale," *New York Times*, May 21, 1998.

24. "Lin Changmin's Ancestral House Is Located at Nanhou Street," *Fuzhou Evening News*, April 26, 2008.

25. *Fuzhou Evening News*. In 1991 Yang Qiao Road was extended, and the rear of the house was restored before being opened to the public as the Fuzhou Xin Hai Revolution Memorial. In 1996, it was listed as a Provincial Heritage Conservation Unit, and, in 2006, it became a Key National Heritage Conservation Unit.

26. Jan Garden Castro, "One Who Sees Space," *Sculpture* 21 (September 2002): 36–43.

27. Moyers, "Becoming American."

28. Holland Cotter, "Where the Ocean Meets the Mountains," *New York Times*, May 7, 2009. Emphasis added.

29. Moyers, "Becoming American."

30. Michael Krasny, "Thinking with Her Hands" (interview), *Whole Earth* (Winter 2000), http://www.wholeearth.com/issue/2103/article/125/thinking.with.her.hands.

31. Peter Tauber, "Monument Maker," *New York Times*, February 24, 1991.

32. *Yale Alumni Magazine* (June 1987), 45.

Chapter 11

OUT OF THE WINGS: THE ARCHITECT AS ARTIST

After The Wall, Maya Lin's life would—could—never be ordinary again. Yet, by returning to her studies and entering an internship with Forbes, she had consigned herself to a four-year interlude of ordinariness. Then, in the fall of 1987, she began to re-emerge, and, before the end of the decade, she was committed to a handful of major projects that prophesied the diversity of her later oeuvre—earthworks, sculpture, landscape architecture, kinetic art—in fact, everything except architecture, the art for which she had trained.

Many young architects get their earliest work—often a small, domestic job—from family or friends. It was no different for Lin, although her first commission was neither small nor domestic. She was asked to design a chapel for Juniata College, in Huntingdon, Pennsylvania.[1] The link between her and the liberal arts institution was her parents' acquaintance with Dr. John Calhoun Baker and his wife, Elizabeth Evans Baker, whom they had known since before she was born. John Baker had been the popular 14th president of Ohio University when Henry Lin took up his appointment there; he had retired in 1961 but remained active for some years, pursuing his interests in business and international affairs. A 1917 Juniata graduate, he was a member of its

Board of Trustees from 1936, retiring in 1987. He remained active until his death in 1999, at the age of 103.

A gift from Elizabeth Baker supported the creation, in 1971, of a peace and conflict studies curriculum at Juniata—a forerunner of similar programs throughout the nation. The following year, in partnership with Huntingdon attorney C. Jewett Henry, another Juniata trustee, the Bakers purchased 172 acres of land a little east of the campus and donated the parcel to the college. It was later named the Baker-Henry Nature Preserve. Soon afterward, Elizabeth, enchanted by the beautiful rolling landscape dotted with woodlands, proposed to build there "a place, removed from the pressures of daily academic life, for groups or individuals to meditate." The idea appealed to her husband, who was then chairman of the Board of Trustees, but, because he had misgivings about several practical issues, no action would be taken for nearly 20 years. In 1985, Dr. Andrew Murray founded the Juniata College Institute for Peace and Conflict Studies; it was almost immediately renamed in honor of the Bakers. Murray suggested that, instead of the "rustic, almost cabin-like building" that Elizabeth had envisioned, an open-air meditation place could be established. Robert Neff, Juniata's new president, agreed. Elizabeth engaged some local architects, but the schemes they submitted in 1987 were "artistically and religiously heavy-handed and singularly unappealing." It was then that she thought of Lin, "whose work [she said] we all admire." That work, of course, could only have been The Wall.

Anyway, early in autumn, Elizabeth asked Lin to lunch at the Bakers' Essex Falls, New Jersey, home. Although attracted to the project, Lin was unprepared to commit to it until she had seen the site. Making a detour on her way to visit her parents late in the following spring, she was delighted with what she found at Huntingdon and later enthused, "Working with this landscape is like coming home. It's not so much a challenge, it's a joy." Henry Lin encouraged his daughter to accept the task, and she offered her professional services as a gift to the Bakers.

Soon after, she shared her ideas with them. Her early description—it changed little in the execution—was of a "sculpture in two parts, and in two places." At the center of a 14-acre open field, she proposed to carve a 40-foot diameter "chapel" as a shallow bowl in the earth, defined by 53 rough-cut granite blocks. It would be approached by climbing

24 smoothly polished granite steps on a 500-foot slope. Intended for individual meditation, the second part—Lin called it the "private chapel"—would be a 5-foot diameter solid circle of smooth bluestone atop a slightly higher neighboring hill, set flush with the woodland floor. It would not be visible from the main circle, which would be clearly seen from it; the idea was that an individual could never be totally separate from the community. In time (Lin explained), grass and moss would grow over the edges of the stones in both places, integrating the natural and synthetic elements. For a few months in the fall of 1988, two versions were contemplated, but a final proposal was resolved the following spring.[2]

The vandal-proof, low-maintenance design allayed John Baker's fears, and, with the approval of Professor Neff and the trustees, Elizabeth commissioned Lin's "sculpture." Lin went to the Montpelier, Vermont, quarry to select the stones, and in the summer she supervised construction by the college's maintenance staff. The Peace Chapel was dedicated on October 14; Elizabeth Baker died just eight months later.[3]

A couple of months before the peace chapel was due to be opened, Lin's beloved father passed away in Santa Barbara. She commented,

The Peace Chapel at Juniata College, 1989. (Courtesy of Juniata College.)

"After my father died . . . I was looking down at him, that his hands were extremely delicate and graceful, a potter's hands. You know, I thought of my father as a much stronger, forceful-type person."[4] On the occasion of the dedication, Juniata awarded Lin an honorary degree. The local branch of the Veterans of Foreign Wars (VFW) asked if it also could honor her, and the college agreed to make the VFW's presentation of a dozen roses part of the degree ceremony. Former college president Robert Neff recalls, "Three older men came and gave her the roses. It was one of the most touching moments of the day."[5] The ceremony had been announced in *USA Today*, as well as in Pennsylvania and Georgia newspapers. Being creative has never paid the bills, and the publicity would have done Lin's incipient career no harm. Peter Forbes and Associates was winding down its New York operations, and, in February 1988, Lin had been approached by the Southern Poverty Law Center (SPLC) in Montgomery, Alabama, to design a Civil Rights Memorial; by the spring, despite her fear of being typecast as a maker of monuments, she was on the verge of accepting the commission.

The nonprofit SPLC was founded in 1971 by law partners Morris Dees Jr. and Joseph J. Levin Jr.—both whites. With the Georgia civil rights activist Julian Bond as its first president, it was committed to monitoring the implementation of civil rights legislation, challenging segregation and unfair electoral boundaries, and securing better working conditions for women. It set out to cripple hate groups by obtaining huge damages settlements against them; for example, in 1979, it successfully sued the notorious Invisible Empire of the Ku Klux Klan.

From 1981, the SPLC mounted an Intelligence Project—first through Klanwatch and later through Immigrant Watch—to monitor and publicize the hate crimes of white supremacists. For all that, in the 1980s, racist offenses increased, and the SPLC, seeking to educate a new generation, decided to honor by a memorial the people who had been killed in the civil rights movement. Cost was not an obstacle, because the Center's effective fund-raising program had accumulated substantial reserves. Until 1984, its executive director, Edward Ashworth, had worked in Washington, D.C. Often, on his early morning jogs, he had passed the Vietnam Veterans Memorial, and he "never failed to see people [there], almost always with tears, touching the names of their dead friends, fellow soldiers, and relatives." He suggested that

the SPLC approach Lin to design a Civil Rights Memorial. The Board agreed, and (as often happens when someone has bright idea) he was given the task. He found that it was easier said than done:

> I started by contacting Yale, where I knew she had gone. Of course, they said they could not give out that information without authorization. I then thought, if you are a talented artist, where would you be? New York or the West Coast came to mind, so I started with New York. I checked the phone book; there was no listing published. I then called information. They had no listing for a Maya Lin, but had several listings for an "M. Lin." I got them all and started calling the list.[6]

When he finally contacted her, late in February 1988, he discovered that she was suffering from a bad case of influenza. Although she was (as he puts it) expectedly skeptical, she listened to his request. He insisted that she was the correct—the only—designer for the memorial. Lin recalled, "I had two feelings at the time. One, I really did not wanna [sic] be typecast as a memorial designer. Two, I could not believe that there hadn't been a national civil rights memorial."[7] Anyway, she allowed Ashworth to send her information about the SPLC and its proposal—videotapes of PBS's 1987 TV series *Eyes on the Prize,* Juan Williams's companion book of the series, hot off the press, and another videotape about the Klan.[8] Lin spent a couple of months digesting it all, and, in May, she flew to Montgomery to meet SPLC executives and to visit the proposed site.

Inspiration came during the two-hour flight from New York. Reviewing the material, Lin reread Martin Luther King Jr.'s paraphrase from the Old Testament book of Amos: "But let justice roll down as waters, and righteousness as a mighty stream." She said:

> The minute I hit that quote I knew that the whole piece had to be about water....I learned that King had used the phrase not only in his famous I Have a Dream speech at the Washington Civil Rights march in 1963 but at the start of the bus boycott in Montgomery eight years earlier, so it had been a rallying cry for the entire movement. Suddenly the whole form took shape, and

half an hour later I was in a restaurant in Montgomery with the people from the Center, sketching it on a paper napkin.[9]

What Lin drew for Morris Dees and Richard Cohen, SPLC's legal director, would become a 40-foot-long by 9-foot-high slightly curved black Canadian granite wall bearing the words "Until justice rolls down like waters and righteousness like a mighty stream. Martin Luther King Jr." Water from a small pool on an upper plaza would flow smoothly down its face. That part of the memorial Lin called its "universal" element; she promised to return to Alabama with the "specific." Lin designed the memorial as the entrance plaza for SPLC's headquarters. A few weeks, later she produced a model of an asymmetrical cone of granite—a water table almost 12 feet in diameter tapering to about 2 feet at the base. Less than three feet high, it would have a film of water flowing over it; the names of martyrs of the civil rights movement would be engraved in its flat surface. The sculpture would define "a contemplative area . . . to remember the Civil Rights Movement, to honor those killed during the struggle, to appreciate how far the country [had] come in its quest for equality, and to consider how far it [had] to go."[10] She took more than a year to work out what she called the "logistics of building the sculpture."

Meanwhile, her clients determined whose names would be included on the water table. Around its perimeter, arranged chronologically, entries are incised in the stone, each letter lined with platinum. The litany begins with *Brown v. Board of Education*, the 1954 Supreme Court decision that banned segregation in public schools; it ends with the 1968 assassination of Martin Luther King Jr. Twenty-one of the inscriptions nominate seminal events in the civil rights movement; the remainder describe 40 individual martyrs. The lettering was designed and executed by John Everett Benson, a stone carver whom Lin had consulted for the "date stones" of the Vietnam Veterans Memorial; the architect of record was Robert Cole, of the local firm of Cole and Hill.

The memorial was dedicated on Sunday afternoon, November 5, 1989, when an audience of 6,000 joined the families of some whose names were inscribed on the table to hear speeches from survivors, including the indomitable Mrs. Rosa Parks. Lin, herself mourning the recent death of her father, watched the ceremony from inside the SPLC

headquarters building. Ashworth recently wrote that it "touches people in a way that statues and other monuments do not. . . . I think that is Maya's true artistic genius, that ability to tap into the human core that allows that cathartic release."[11]

Lin was determined that this memorial would be her last and told journalists that, having begun and ended the decade with memorials, she felt "fortunate to have done them, and [was] closing the door with a happy feeling."[12] But another shrine, albeit of a different kind, was already on her agenda.

Following in the path of a number of formerly single-gender U.S. universities, in 1968 the faculty at Yale had approved a "coeducation plan." After Vassar withdrew from an anticipated merger, Yale's president, Kingman Brewster, announced that the college, hitherto a "sex-segregated old-boy's club," would admit women undergraduates in 1969. By 1972, the overall male-female student ratio had been reduced to five to one, but the number of women in the freshman class would not exceed the number of men until 1995.[13]

According to Lin, "some time in 1988 or 1989," Benno Schmidt Jr., then the university's president, telephoned her to ask if she could create a sculpture "commemorating women at Yale."[14] It seems that he didn't make clear what he wanted. She recalled:

That one, I sat on for over a year, reading about co-education at Yale, women at Yale, the history of gender at Yale. And all I remember, having gone there for seven years, is that every little stained-glass image, every sculpture, every statue was a man. As I start reading, I'm thinking [this memorial was] not about when Yale officially went co-ed. . . . It was about numbers. . . . I one day woke up and I wrote a little spiral of numbers. Commemorating women at Yale, we have a beginning, but certainly, it's ongoing. So I thought of a spiral.[15]

Meanwhile, defying the coeducational policy, two of Yale's "secret societies"—the notorious Skull and Bones and Wolf's Head—continued to exclude women. Lin's memorial was overshadowed by a controversy surrounding the former group until an April 1991 postal poll of its alumni narrowly voted for going coed. At the end of the year,

Wolf's Head followed suit, by an overwhelming majority. Shortly after the Skull and Bones hullabaloo, construction of the sculpture, known as the *Women's Table*, was postponed for "lack of interest."[16]

Lin consulted information expert Edward Tufte and his wife, graphic designer Inge Druckrey, about setting out the design of the face of the memorial. The *Women's Table* is a cantilevered, elliptical green granite water table, 36 inches high on a bluestone base. Water bubbles from an off-center fountain and flows smoothly across the surface to run off the edges to pool underneath the table. A spiraling engraved timeline records the annual number of women student enrollments from the foundation of the University until 1993. There are zeros until 1873, when the Graduate School of Art was the first part of the university to admit women; as the spiral reaches the edge of the table, the inscriptions become four-figure numbers. Located in large open gathering area in front of Sterling Library on Rose Walk, the *Women's Table* was dedicated on October 1, 1993. Of it, Lin said, "My work speaks to women emerging in society, becoming a presence in the work force, in the schools, to vote. I think of the *Women's Table* site as creating a heart to Yale which it never had.[17] And a *Yale Herald* editorial commented, "If Skull and Bones brought Yale women into the spotlight Maya Lin's Women's Table kept them there. Its unveiling [indicted] the University's incomprehensible exclusion of women from 1701 to 1969."[18]

Late in 1988, a successful entry in a design competition provided a chance for Lin to break the memorial nexus. In August, a 24,000-seat sports Coliseum, designed by Odell Associates, was opened in Charlotte, North Carolina. About a year earlier, the Charlotte-Mecklenburg Art Commission had announced its choice of a 22-foot high semiabstract bronze sculpture by New York artist Joel Shapiro to stand at the stadium entrance; the estimated cost was $400,000. Art Commission member Robert Cheek called Shapiro's work a "headless Gumby"—an unkind allusion to a 1950s TV animated cartoon figure—and radio DJs John Isley and Billy James led a campaign of derision against the figure, generating months of heated debate in the local press and leading to years of "stinging controversy" over public art.

The City Council having rejected the Shapiro figure, in November 1988, the commission engaged consultants—Lee Kimche McGrath, director of the State Department's Art in Embassies program, and Milton

Bloch, director of Charlotte's Mint Museum of Art—to find an alternative. A competition was advertised in the regional press, and a prospectus was sent to selected artists across America. There were 105 entries. The consultants and an ad hoc committee of the Commission reduced the number to 14 in mid-January. A short list was chosen the next day—sculptors Albert Paley and Robert Morris (both from New York) and Lin and Henry Arnold, styling themselves the "Lin/Arnold Joint Venture." About a month later, the finalists met with the committee to review the site, and, when Morris withdrew early in March, the commission asked the others to provide models. Public comment was invited. On May 25, the Art Commission unanimously accepted the Lin/Arnold design, and, a couple of weeks later, the City Council voted 9–0 to authorize it—at well under the budgeted cost of almost $377,000. It had settled for something less controversial, and the city would be able to boast that it had commissioned an art work by the designer of the internationally famous Vietnam Veterans Memorial.

Lin had worked with the landscape architect before. The Vietnam Memorial had required lowering the level of Constitution Gardens, which Arnold had designed in the early 1970s. Her account of their collaboration is confused: "Arnold was the original landscape architect for Constitution Gardens in Charlotte, NC, the site for *Topo* [the new name for the Coliseum project]. I was very conscious of working in someone else's space. In redesigning the space, I figured I should defer to him, call him in on it. It was the right thing to do. We applied as a team to a competition for art at a sports stadium."[19] The fact is that, if she wanted to win the Charlotte competition (or why enter?), she needed someone with the expertise and experience that she lacked. Arnold has commented, without rancor, that *Topo* was "truly collaboration. I had a lot to do with the technical aspects, and [Lin] had more to do with the aesthetic aspects. But we both agreed on how it was to be done." And, he added a little ruefully, "It's true that my name often disappeared. It always happens when you work with somebody who has that kind of name and fame."[20]

It was hoped that the scheme would be realized in January 1990. But debate arising from the various stakeholders' scrutiny took four months, instead of the usual one. Arnold's revisions were approved on April 26—too late for planting. When tenders closed on May 21, only

one bid had been received, so the contract was re-advertised. The project was managed by David Garner of the City Planning Office, and construction began early in August; scheduled for completion by late October, it took until the following January, making it a whole year late. The working title, *The Playing Field*, was changed to *Topo*, and the work was dedicated on June 10, 1991.

For Lin, *Topo* was cathartic. She thought that it was the "breakthrough" work that would separate her—certainly in her own mind and possibly in the public perception—from funereal architecture. She also saw it as a way to re-establish her connection with the land, which she believed she had lost in urban projects. Inexplicably disregarding the Juniata Peace Chapel, she would later claim, "*Topo* was my first open, large-scale earth work site."[21] At another time, admitting her acute awareness of becoming "typecast as someone who only works with the dead," she explained, "We decided to do something playful.... I was trying to get back to working directly with the landscape, like the Vietnam piece.... We decided that we would do a completely green sculpture.... Henry and I just looked at each other and said, 'How can we resist?'... So we threw in a game."[22]

In *Topo*, nine huge Burford holly bushes clipped into spheres— one journalistic wit labeled them "steroidal topiary"—were planted along the 1,600-foot-long, 60-foot-wide median of the access road to the Coliseum. Landscape consultant John Greene found the mature bushes in the sweeping driveway of a private house; luckily, the owner was prepared to sell them. They were intended to look like balls in a game, rolling down the 1-in-30 slope, following an imaginary path determined by small earthen berms. The roadways were lined on their outer sides with 140 willow oaks. The original design also called for lights under the holly bushes and a sprinkler system to produce mist so that the spheres would appear to float—details that were abandoned because of cost.[23]

Topo is the only of Lin's large project not to survive. When the Charlotte Coliseum closed, in October 2005, the "site-specific" artwork lost its reason for being. Five months later, to help fund a new sports arena, the entire 170-acre property was sold to an Atlanta-based firm of developers that planned to redevelop it as a mixed-use project named City Park. The Coliseum was imploded on June 3, 2007, leaving *Topo* with nowhere to go, so to speak. The sale agreement provided that the

developer must give the Lin/Arnold Joint Venture the option to re-move the installation. But *Topo* had been its sole collaboration, and the Joint Venture had been defunct for 16 years.

Moreover, under the terms of the original commission, should it or a new owner decide to dispose of the artwork, the City Council was obliged to "consult with the artists and make reasonable efforts to maintain the integrity of the art." The artists had the right—however impractical that was—to reclaim and move the sculpture. Lin failed to respond to questions about what action she wanted taken; Arnold claimed that he was not been formally notified. While it seems that Lin had lost interest in *Topo*, perhaps even years earlier, Arnold had confirmed his ownership of the work by visiting it from time to time to see that the topiaries were being properly maintained. Confronted with its destruction, he was philosophical enough: "When you do works of landscape architecture, you are working with plants that have limited life spans. . . . The *Topo* [sic] lived their natural life under the conditions where they were growing. I'm sorry that it was lost, but I think it was time."[24] *Topo* was demolished in 2008.

From the mid-1980s, New York's Metropolitan Transportation Au-thority (MTA) initiated an Arts for Transit program that reserved 1 percent of its construction budget for artworks in renovated subway stations. For each project, artists were selected through what was ef-fectively a closed competition. A project manager, with consultants and New York City's Department of Cultural Affairs, submitted a list of about 60 candidates to a panel of experts, who reduced it to a short list of four; these were then invited to submit proposals, which would be put to a final vote. The selection panel included artists, some well-known curators, and a railroad representative; all were interested in "artists who worked environmentally, who had national and interna-tional reputations and whose work conceptually could encompass large and disparate areas."[25] In 1989, Lin was chosen through this process to create a piece for the newly renovated Long Island Rail Road section of the reconstructed Pennsylvania Station.

Eclipsed Time, positioned 15 feet above commuters' heads on the ticketing area ceiling at the station's Seventh Avenue entrance, would be five years in the making. Lin's first large interior art installation and her first kinetic sculpture was fabricated in Long Island City, Queens, and assembled in her studio. She described it as an indoor sundial, but

it is much more than that. The highest of the three layers of the large elliptical sculpture is a dark-colored panel lit from behind by a complex grid of fiber optics, producing hundreds of pinpoints of light. The lowest layer is a disk of sandblasted plate glass, 14 feet 6 inches in diameter and etched with numbers for hours and marks for quarter-hours. Behind it, a lacquered aluminum disk moves on a track from side to side on a 24-hour cycle, casting its shadow on the disk. At midnight, when the two disks are aligned, they are almost completely dark, with only a corona of light around them; at noon, the glass is fully illuminated.

The works discussed in this chapter encompassed the return to center stage of Maya Lin the sculptor (she was awarded a National Endowment for the Arts Visual Artists Fellowship for sculpture in 1988), the environmental artist, the memorialist, and the mathematician. But of Maya Lin the architect little had been seen.

NOTES

1. For a history of the school see Earl C. Kaylor Jr., *Juniata College: Uncommon Vision, Uncommon Loyalty* (Huntingdon: Juniata College Press, 2001).

2. Janice Hartman, Juniata College Archivist, correspondence with author, January 2010.

3. For a detailed account of the chapel project, see Marta Daniels, *Peace Is Everybody's Business: Half a Century of Peace Education with Elizabeth Evans Baker* (Huntingdon, PA: Juniata College, 1999).

4. Brian Lamb, "*Boundaries* by Maya Lin," C-Span, *Booknotes*, November 19, 2000, http://www.booknotes.org/Transcript/?ProgramID=1589.

5. Robert Neff, correspondence with author, March 2010.

6. Edward Ashworth, correspondence with author, December 2009.

7. Bill Moyers, "Becoming American: The Chinese Experience," interview with Maya Lin, Public Affairs Television, 2003, http://www.pbs.org/becomingamerican/ap_pjourneys_transcript5.html.

8. Ashworth, correspondence. Lin's recollections of the arrangements vary. In 1989, she said, "I told him that it would be fine to send me something." (See Jonathan Coleman, "First She Looks Inward," *Time*, November 6, 1989); in 2003, she said that *she asked* for the information (Moyers, "Becoming American").

9. William Knowlton Zinsser, "I Realized Her Tears Were Becoming Part of the Memorial," *Smithsonian* (September 1, 1991).

10. "Maya Lin, Memorial Designer," http://www.splcenter.org/crm/lin.jsp.

11. Ashworth, correspondence.

12. David Grogan and Linda Kramer, "Maya Lin Lets Healing Waters Flow over Her Civil Rights Memorial," *People* 32 (November 20, 1989).

13. For discussion, see M. M. Lovell, "Death, War, and Public Memory: Iwo Jima, Vietnam, and the Wild West," http://www.brown.edu/Research/JNBC/presentations_papers/documents/M.Lovell_Bologna_2004.pdf; "Education: Woman and Man at Yale," *Time*, March 20, 1972, http://www.time.com/time/magazine/article/0,9171,942551,00.html.

14. Lin told Brian Lamb in 2000 that "it was 1988 when he called me in '88–'89 [sic]." Lamb, "*Boundaries* by Maya Lin."

15. Moyers, "Becoming American."

16. Andrew Cedotal, "Rattling Those Dry Bones," *Yale Daily News*, April 18, 2006, http://www.yaledailynews.com/magazine/short-feature/2006/04/18/rattling-those-dry-bones/.

17. Cited in Mimi G. Sommer, "Maya Lin: Human Proportions on a Heroic Scale," *New York Times*, April 17, 1994, http://query.nytimes.com/gst/fullpage.html.

18. "The Commemorative Accusation: 1991–2," *Yale Herald Online*, March 28, 1997, http://www.yaleherald.com/archive/xxiii/3.28.97/ae/headlns.html.

19. Tom Finkelpearl, "The Anti-Monumental Work of Maya Lin," http://forecastpublicart.org/anthology-downloads/finkelpearl.pdf.

20. Mark Price, "Catching up with…Henry Arnold," *Charlotte Observer*, October 20, 2008.

21. Moyers, "Becoming American."

22. Finkelpearl, "Anti-Monumental Work."

23. Lin later said that the Joint Venture acquired 14 bushes (Cooper Union School of Art, *Maya Lin: Fall 2000* [New York: Cooper Union, 2000], 20).

24. Price, "Catching Up."

25. Karin Lipson, "A Separate Peace," *Newsday*, July 27, 1994.

Chapter 12

A HECTIC DECADE: THE 1990s

Having taken up architecture by default, Lin has hardly followed it with undivided passion. That is evidenced by the Maya Lin Studio website, which illustrates only eight buildings among the almost 30 works displayed. She reflected a few years ago that her "head [had] always been equally balanced between the academic analysis, the science world, and the art, intuitive side":

> Even though the art and architecture are very different—and the monuments are these hybrids—you want them all to be coming from a similar aesthetic, you want them all to be connected together. Like when you're inside my buildings, they give you a strong connection back to the landscape, like the earthworks and monuments.[1]

However, as already noted, she saw the need to avoid being typecast "as a person whose work concerns death and destruction" and set about creating a body of work to demonstrate how serious she was about the discipline of architecture. Her first commission was an interior layout

for an art gallery, only a stone's throw from her studio—hardly a magnum opus, it nevertheless was an important milestone in her career.

Lin's client was Rosa Esman, a publisher and art dealer who had recently included one of her wax and metal wall pieces in a group exhibition. Esman had opened a gallery at 24 East 80th Street, in New York, in 1972 and since then had moved it twice. When a 10-year lease at 70 Greene Street, in SoHo, expired in 1990, she leased 3,000 square feet on the ground floor of a newly renovated six-story building at 575 Broadway. Working with a limited budget and engaging William Bialosky, a former Yale classmate as architect of record, Lin created what Esman describes as a "very successful open airy space at minimal expense, using industrial materials."

> The partitions were fabricated from corrugated [translucent acrylic] sheets in a [steel] frame. The sheets permitted light to pass through the room behind, and the dark metal stripping provided a clean contrasting edging. The most expensive element was the front desk. The lower part was made of plaster board, or plywood, mounted with a thick angled lead slab. It contributed to the industrial look, and enhanced the brightness of the gallery.[2]

Lin has described architecture as "a greedy profession." In 1994, having just completed her first house, the Lawrence and Judith Weber residence (again with Bialosky as architect of record), she confided, "I pursue [my architecture] as an artist. I deliberately keep a tiny studio. I don't want to be an architectural firm. I want to remain an artist. I don't want to be overwhelmed by running a big firm and having to delegate authority."[3] One journalist reported:

> When asked to differentiate between her dual pursuits of architecture and sculpture, she noted that the disciplines share a common language but are set apart by their syntax: "Sculpture to me is like poetry, and architecture is like prose." . . . She will point out that when she enters her studio to work on small-scale sculpture, she is alone and in control, unconstrained by an architect's obligation to adhere to a client's specifications and budget.[4]

Fifteen years later, that resolve persists; at the end of 2009, she emphatically told an interviewer, "If you're not careful, architecture as a profession will take over everything.... Before you know it, you have a 60-person office. I don't want to be run by a practice, and I will not give up my art."[5]

Her initial hesitation to accept the Weber commission perhaps demonstrates her unwillingness to be ensnared by architectural practice. The client, who had long-standing business connections in Japan, wanted to build a Japanese courtyard house. In 1990, he serendipitously came across an article about Lin in an in-flight magazine, and, a few years later, having unsuccessfully attempted to contact her through a New York art gallery, he left his contact details and a description of his project. It was some months before he received a postcard from Lin—"Please contact me if you're still interested."[6] For the Weber's property outside Williamstown, Massachusetts, she designed a house whose unique lead-covered roof echoed the gently undulating landforms of the Berkshire Mountains visible to the south. That roof cost as much as the rest of the building, and she expressed its form in the open-plan interior. Like one her heroes, the great Frank Lloyd Wright, she designed every detail of the house "down to the towel racks." Each living space overlooked the Japanese garden—the Webers hired Shinichiro Abe of Zen Associates—or the picturesque landscape.

While the house was under construction, Lin, working with former Yale classmate David Hotson, also produced the Museum for African Art in New York City. Behind the cast-iron facade of a rented 1860s store on Broadway in SoHo, she renovated the ground floor and basement to provide two exhibition spaces, together with a special events room, curatorial and storage areas, offices, and a museum shop. True to her hands-on design approach, she virtually lived on site toward the end of the project. The *New York Times* architecture critic called the work a "visual essay in good will,"[7] and, nearly 20 years later, another reviewer described it as a "buried treasure in [her] otherwise abundantly publicized oeuvre."[8]

There is not space enough in a short biography to describe, much less analyze, each of Lin's buildings. Suffice it to say that, in her earliest works, emerging and connected attitudes can be identified that would characterize her entire architectural opus: a close affinity with

nature; an environmental care expressed in the recycling of materials or (on occasion) whole buildings; and a response to issues of social justice.

In 1992, Lin began taking her conservation advocacy into boardrooms. She became a director of the San Francisco–based Energy Foundation, a coalition of large philanthropic institutions concerned with promoting clean, sustainable energy, especially in the United States and China. And when, at about the same time, she began to serve on the National Advisory Board to the San Francisco Presidio Council, she suggested that the 1,500-acre historic precinct be made into a global center for the environment.

In 1992–1993, Ohio State University's Wexner Center for the Arts, in Columbus, awarded Lin a visual arts residency. She was commissioned to create a site-specific work in its new building, designed in 1989 by the architect Peter Eisenman. The result was *Groundswell*. Choosing three locations that Eisenman had intended to be inaccessible and using a hopper suspended from a crane, Lin dumped 43 tons of shattered recycled windshields and tempered window glass. Only at the entry level did she deliberately contour the material; elsewhere, it remained just as it fell. She explained,

> I was working in my studio—smaller, personally scaled works I could physically make myself—were being shown with broken car glass, lead, beeswax. . . . *Groundswell* is a play on the Japanese raked gardens of Kyoto, as well as the Indian burial and effigy mounds of Athens, Ohio. . . . So it's a melding of a conscious idea on my part to sort of blend East/West culture, but it's also about bringing a studio artwork mentality out of doors.[9]

Lin's Wexner residency culminated with her first solo exhibition, "Public/Private," a retrospective of drawings, scale models, and photographs of her sculptures and architectural design that demonstrated the correlation between her two kinds of art.

She was then completing the *Women's Table* at Yale and *Eclipsed Time* in New York's revamped Penn Station. She had also started work on *Wave Field* next to the University of Michigan's Francois-Xavier Bagnoud Aerospace Building and *10 Degrees North*, an interior environmental installation in the Rockefeller Foundation headquarters in New

York City. And that was not all. In her SoHo studio, she was preparing those "smaller, personally scaled" pieces for several joint exhibitions in New York galleries and elsewhere. That hands-on studio work has remained an essential (although less well-known and often unremarked) part of her artistic endeavors. It it may be compared to the sustained under- note characteristic of some musical instruments over which the "melody"—analogous with Lin's larger creations—is imposed.

As Lin re-emerged from self-imposed seclusion, it was inevitable that her major works would attract public attention and that she, despite shrinking from the limelight, would be celebrated. She was among 10 inductees into the Ohio Women's Hall of Fame in 1990, and, over the next few years, she received honorary doctorates from Smith College (her mother's alma mater), Williams College, Brown University, and Harvard. She was also much in demand as a visiting lecturer, giving talks of the "my work" kind favored by architects at such prestigious venues as the New York Metropolitan Museum of Art and Minneapolis's Walker Arts Center, as well as at universities throughout North America. In summer 1994, she took up a residency at the Pilchuck Glass School in Seattle, and, at the end of the year, she accepted an Avenali Professorship in the Townsend Center for the Humanities at the University of California at Berkeley. There soon followed national and international honors and awards. In 1996, Lin received one of only two American Academy of Arts and Letters Award in Architecture and the Louis Vuitton Moët Hennessy Foundation's *Science pour l'Art* Award. She was also appointed to the editorial advisory board of the Southern Poverty Law Center's magazine, *Teaching Tolerance*, whose antibias message reaches millions of young people throughout the United States. In 1995, she had joined the advisory board of Studio in a School, a visual arts program that fosters the creative development of mostly low-income youth in New York City; she maintains that role.

At the dedication of the civil rights memorial, in November 1989, director Frieda Lee Mock had started filming *Maya Lin: A Strong Clear Vision*. The documentary, sponsored by a grant from the Global Fund for Women, was a well-tempered blend of family photographs, archival footage of the Vietnam Memorial controversy, "talking head" sequences featuring Lin, and coverage of her contemporary work. The film, produced by Mock and Terry Sanders, received the 1995 Academy Award

for Best Achievement in Feature Documentary. Incidentally, the award was widely challenged by critics and commentators, because Mock had been head of the Academy's documentary committee for the previous two years. Although she had recused herself, there were whispers of bias, and the Academy consequently revised the nomination procedure for documentaries.

Seeing the film just once opened old wounds for Lin. She told journalist Jim Sexton that she had "blanked out from what went on until [she] saw the movie." He reported that when she learnt that the documentary would include scenes featuring opponents of the memorial, she was "very upset. I was like, 'Let's not show this film. Let's put it away.' Again, it was my automatic desire to just not deal with it." But (wrote Sexton), "in some way the documentary seems to have freed her to talk about the ordeal."[10]

The rumblings about the Oscar returned Lin to the media spotlight—for her, always an uncomfortable place. She retreated into her work and, making herself what politicians call a "small target," again drew a curtain across her private life. So, for Lin, the early 1990s—she has called them manic—began a strenuous time; there has been little respite since. Looking back on those years at the end of 2009, when she was about to embark upon an extended world tour, she confided that the planned trip was "a sabbatical from a very hectic couple of decades."[11] Her professional activity in those years is well documented. Her private life is quite another story, but another major life change was afoot.

As noted, the reasons for ending her relationship with Peter Boynton and just when it occurred are (expectedly) not matters of public record—nor should they be. The couple's last reported association was early in 1992, in the exhibition "Culture Bites," at the Cummings Art Center of Connecticut College, New London.[12] Boynton continues to work in New York, producing what some would consider to be quirky sculpture.

Lin met entrepreneur Daniel Wolf at a New York dinner party sometime in the early 1990s. They became engaged when sheltering from a thunderstorm in a derelict horse trailer during a hiking trip in Colorado—an occasion that Lin has described enigmatically as a "test of character."[13] Wolf, whom she married in December 1996, is more

lyrical and romantic: "We knew each other for a while. When we fell in love, it was like a tidal wave came over us. It was as if someone came out of the water, lifted us up, and sent us soaring. It hasn't stopped."[14]

Four years older than Lin, Wolf, the son of oil executive Erving Wolf and his wife, Joyce,[15] was raised in Colorado. After a preparatory education at Phillips Exeter Academy, he studied art at Bennington College, in Vermont. He began dealing in 19th-century photographic prints during his college days, and, with his father's help, in 1977, he established Daniel Wolf Galleries in New York City. Over the next decade, he built it into a million-dollar business. In 1984, collaborating with museum staff, he assembled for the J. Paul Getty Museum, in Malibu, the world's largest private collection of museum-quality photographs. He sold his personal collection of American landscapes to the Denver Art Museum in 1990.

Wolf's other interests have been diverse: book editor, documentary film producer, exhibition curator. He even planned to launch a fashion cable TV channel with actress Diane Keaton. Beside all this, he is a compulsive collector. Lin says that, when they met, "there was not a single square foot of floor space free in his apartment. You had to hop to get to the dining room table. He collected pre-Columbian pottery and minerals... sculpture, pre-Columbian works, stone matates, minerals, Neolithic ceramics, and... bronzes."[16] At the core of his eclectic acquisitions is what he describes as a "humongous" collection of Memphis pieces. The Memphis movement, emanating from Milan, Italy, around 1980, was a reaction against the so-called New International Style, spawned by the Bauhaus; intended to shock, it employed gaudy colors and absurd forms. In 1987, Wolf commissioned the Austrian architect Ettore Sottsass, the "father" of Memphis, to design a three-story house for him—"a riot of color and sumptuous materials"—near Ridgway, Colorado. Much of Wolf's collection is in storage, but his New York duplex is crowded with the work of 20th-century American architects and designers, including Greene and Greene, George Mayer, Charles Rohlfs, and Frank Lloyd Wright. His catholic taste in furniture styles extends from Chippendale to De Stijl.

Of course, getting married demanded social readjustment on the parts of both Lin and Wolf; according to some psychologists, marriage stands at number six on the "stress-inducing scale," after such life

events as the death of a spouse or imprisonment.[17] As Wolf observed, "You get married a little bit late in life, and everyone comes to the table with a set aesthetic.... I'm excessively this, and she's excessively that. We love each other's that, but we're each inherently this."[18] Lin points out that, despite his fascination with Memphis, her husband married a minimalist who prefers uncluttered spaces. But she has promised not to alter the Ridgway house. Perhaps remembering the bitter conflict over proposed additions to her Vietnam Memorial, she asserted, "I would never want to touch or modify someone else's creation."[19] But she confesses that, "one of these days," she wants to do build a Zen studio bathhouse in the nearby woods"—the analogy with Frederick Hart's *The Three Soldiers* statue among the trees in Constitution Gardens cannot be missed.

It was a different story in Manhattan. Three months after their wedding, Lin began to remodel Wolf's former apartment in an Upper East Side building that had one housed a women's college. It had been renovated in the 1970s, with faux paneling and, according to Lin, it resembled an interior from *Boogie Nights,* a movie about the Californian pornography industry. *New York Times* columnist Patricia Leigh Brown's summation of the work-in-progress was more measured: "an aesthetic 'Upstairs/Downstairs,' an interplay of intriguing contrasts."

> Mr. Wolf's zone is an oak-paneled Gothic parlor, a double-height room with peeling paint and hundreds of objects: Frank Lloyd Wright and Thonet furniture, assorted Warhols and bulbous stone vessels teetering on balconies.... By contrast, the top floor, designed by Ms. Lin, is a seamless, light-filled oasis devoid of handles, doorknobs and collectibles. It is a dreamy place for stargazing through skylights, a space, like much of her work, that seems to distill calm to its physical essence.[20]

Meanwhile, Lin pursued her professional career, accepting those commissions that suited her, making large and small art, contributing to group exhibitions, and designing buildings.[21]

Having so successfully employed flowing water in the civil rights memorial and in the *Women's Table,* Lin used it again in three large sculptural works of the 1990s. In February 1995, her installation *Reading a Garden* was among 16 selected from 350 applicants nationwide

as part of a public art collection for extensions to Cleveland Public Library. The Eastman Reading Garden, designed in collaboration with her brother, Tan, architect Malcolm Holzman, and landscape architects Olin Partnership, was dedicated in September 1998. It provided three reading areas around an L-shaped pool. Visitors descend on a "river of words etched into paving...along a meandering path toward an L-shaped reflecting pool where sheets of water...continually fall. [They] stand on a square stone panel that [appears] to float like a leaf on water trickling down the smooth sides of the waist-high fountain."[22]

Contemporary with the library garden was a wall sculpture, *A Shift in the Stream*, in the minimalist lobby of the headquarters of the Principal Financial Group, by the architectural firm Lewis Kruse Blunck in Des Moines. One commentator called the long, jagged crack in the smooth, two-story-high wall a "radical subversion" of the space.[23] Once again, the movement of water is integral: "As you walk closer to the wall, you hear the soft murmur of a continuous stream of water flowing in the wall's crevice, into which you can just fit your hand to touch the water."[24] Also notable among her larger sculptural pieces is *Sounding Stones*, at the entrance to the Daniel Patrick Moynihan Federal Courthouse Plaza in lower Manhattan. Dedicated in 1996, it consists of a line of four large blocks of Norwegian black granite; each was drilled to allow a view of its neighbors and to permit observers to hear the sound of internal fountains—again, flowing water—that cannot be seen.

While these works were in progress, Lin produced two architectural works in New York, once again with David Hotson as architect of record. In 1996–1998, she designed a Park Avenue apartment for the California software entrepreneur Peter Norton and his family. Inspired by puzzle boxes and transformer toys, she made dexterous use of precisely engineered partitions to achieve a space that could shift between a one- person flat and a house large enough for the whole family when they were in New York. It was "a home that could fold in on itself, like origami or a transformer toy, changing its shape or function depending upon how it was used."[25] In 1997, she designed accommodation for the Asia/Pacific American Institute at New York University; the space was later converted into a journalism school.

Lin's life no doubt became even more hectic following the birth of her first daughter, India Wolf, at the end of October 1997. Nevertheless, throughout the rest of the decade, she continued to participate in

group art exhibitions and to deliver lectures throughout the country, even after her second daughter, Rachel Wolf, was born in July 1999. And, between babies, other things were happening, and there was an overlap (but hardly a clash) between motherhood and work in Lin's life. How she dealt with that, she has managed to keep private.

In 1997–1998, she was named the William A. Bernoudy Resident in Architecture at the American Academy in Rome, Italy—an honor that culminated in the first exhibition of her work outside the United States. There were other honors, too. In 1997, the Cosmos Club Foundation presented her with the John P. McGovern Arts and Humanities Award; in the same year, New York University gave her an honorary degree. In 1998, she was appointed to the board of the New York–based Natural Resources Defense Council, America's most effective environmentalist organization; she still occupies that position.

The following year, she received an Excellence Award from the Industrial Designers Society of America and the Rachel Carson Leadership Award from Pittsburgh's Chatham University. The latter recognized that

> Lin brings a contemporary perspective by her fusion of technology with transcendental forms of nature. She has repeatedly incorporated the notion of landscape and topology in her work through her interest in the environment and concern over the treatment of the natural world.... Maya Lin has been praised for her sensitivity to aesthetic concerns and her ability to address complex historical and social issues.[26]

Toward the end of the "hectic decade," Lin demonstrated her versatility as a designer: a range of production furniture—*The Earth Is (Not) Flat*—for Knoll, including a chaise longue, a dining table, and chairs, and the award-winning *Stones*, a series of fiberglass-reinforced, cast recycled stone garden stools and tables.

Lin's second major solo exhibition, *Topologies*, was organized by the Southeastern Center for Contemporary Art, in Winston-Salem, North Carolina. Through 1998–1999, it traveled to the Cleveland Center for Contemporary Art, New York University's Grey Art Gallery, the Des Moines Art Center, and the Contemporary Arts Museum, in Houston.

Besides several larger interior installations, it included models, drawings, and photographs of projects from the preceding decade. When the show was in Cleveland, there was an occasion when Lin, as a proud new mother, let her determination to keep her private life private briefly slip. One newspaper reported:

> "Got pictures!" she announced moments after sitting down for a glass of ice water in the [art] center's cafe. She quickly stood up and strode away to retrieve the photographs. They showed India and Lin posing on various pieces of Knoll furniture.... [and] Lin's husband... with India on a grassy slope in front of the family's vacation house in [Colorado].[27]

As well as silk scarves and a watch face, the versatile Lin designed the logo for *Warm Spirit,* a range of organic cosmetics marketed by her husband and his business partner, Nadine Thompson.

But the project in the 1990s that revealed most about her future direction was the Langston Hughes Library for the Children's Defense Fund (CDF), on the former Alex Haley Farm near Clinton, Tennessee. Built in collaboration with Knoxville architects Martella Associates, it was dedicated in March 1999.

The CDF was founded in 1973 by Marian Wright Edelman "to ensure a level playing field for all children." The Library's 5,000-volume reference collection consists primarily of works by African American authors and illustrators and specializes in such areas as children's advocacy; nonviolence; the Civil Rights Movement; African and African American culture and history; and children's literature. It is intended for use by advocates for children, educators, civil rights leaders, literary figures, teachers, and students who come to Haley Farm for leadership development.

The new accommodation was integrated with a 60-foot by 30-foot rough-hewn timber 1860s barn, cantilevered above a pair of corn cribs. Lin encased the cribs in glass, converting one into a gift shop and the other into an entry with a stair and elevator. The new library interiors—maple and particleboard surfaces and beige carpet—are sheathed in the rustic structure, or at least parts of it. Lin used recycled and environmentally sustainable materials throughout the building, and the

Maya Lin's The Listening Cone *(2009), the permanent sculpture in her* What Is Missing? *project at the California Academy of Sciences. (Bruce Damonte Photography/San Francisco Arts Commission.)*

mechanical system uses an adjacent pond as a natural heat sink to regulate the internal climate. The design, says Lin, provides the visitor with "a strong visual connection" to the surrounding landscape. She told *New York Times* columnist Fred Bernstein that she aimed to separate exterior and interior, "so you experience entering the building as a peeling away of a rough outer skin," and described the style as "both Shaker and Zen." He commented,

> Outside, between the cribs, there's a cube of black marble, with water bubbling out of its top. Ms. Lin didn't just agree to place the familiar stone in the entrance court; she insisted on it. "I knew without it there would be no proper point of arrival," she explained. Isn't the stone reminiscent of the monuments she wants to put behind her? "This is a totally different granite," Ms. Lin answered. "It has a splash of white running through it." Later, she

warmed to the idea that this was her signature. "The stone...is a reminder I was here."[28]

The Library had the elements that would be seen in Lin's later work: a growing affinity with nature, environmental awareness, sensitivity to social disadvantage, and sustainability.

NOTES

1. Cathleen McGuigan, "Escaping from the Shadow of the 'Wall,'" *Newsweek Web*, January 23, 2007, http://www.newsweek.com/id/70211.

2. Rosa Esman, correspondence with author, November 2010.

3. Carol Vogel, "Maya Lin's World of Architecture, or Is It Art?," *New York Times*, May 9, 1994.

4. Judith E. Stein, "Space and Place," *Art in America* (December 1, 1994), http://www.highbeam.com/doc/1G1-15954647.html

5. Meredith Mendelsohn, "Maya Lin," *Art+Auction* (December 2009): 40–48.

6. Paul Reyns, "Maya Lin Made Her Mark on Williamstown," *Williams Record*, May 10, 2005.

7. Herbert Muschamp, "Crossing Cultural Boundaries," *New York Times*, February 12, 1993.

8. Thomas de Monchaux, Review of Museum of Chinese in the Americas, http://www.archpaper.com/e-board_rev.asp?News_ID=3836.

9. "Art: 21—Art in the Twenty-First Century" (2003), http://www.pbs.org/art21/artists/lin/clip1.html.

10. Jim Sexton, "Making Art That Heals," *USA Weekend*, November 1–3, 1996.

11. Mendelsohn, "Maya Lin."

12. William Zimmer, "'Culture Bites,' Slices of Modern Life, in New London," *New York Times*, February 23, 1992; the show later moved to Sonoma State University, California.

13. Patricia Leigh Brown, "Maya Lin: Making History on a Human Scale," *New York Times*, May 21, 1998.

14. Mariana Cook, *Couples* (San Francisco: Chronicle Books, 2000), 130.

15. According to one source and *only* one (*People* 14 [August 4, 1980], 60)—he was born in China.

16. Jan Garden Castro, "One Who Sees Space," *Sculpture* 21 (September 2002): 38.

17. Thomas Holmes and Richard Rahe, "The Social Readjustment Rating Scale," *Journal of Psychosomatic Research* 11 (1967): 213–18.

18. Brown, "Maya Lin."

19. Steven Litt, "Lin Won't Let Her Vietnam Memorial Hem Her In," *Plain Dealer* (Cleveland), May 27, 1998.

20. Brown, "Maya Lin."

21. Details can be found in the timeline at the beginning of this book.

22. Steven Litt, "Vietnam Memorial's Designer Unveils Her Plans for Library's Reading Garden," *Plain Dealer* (Cleveland), November 22, 1996.

23. Regina Hackett, "Maya Lin Emerges from the Shadows," *Seattle Post-Intelligencer,* October 19, 2000.

24. Maya Lin, *Boundaries* (New York, Simon & Schuster, 2000).

25. Ibid., 10:16.

26. "Commemorating Carson," http://www.chatham.edu/rci/rci_leadership.html.

27. Litt, "Lin Won't Let Her Vietnam Memorial Hem Her In."

28. Fred Bernstein, "The Mild West: Davy Crockett Meets Armani," *New York Times*, April 1, 1999.

Chapter 13

A NEW MILLENNIUM

Much to the chagrin of would-be biographers, Maya Lin has assiduously partitioned her private life from her professional career. Glimpses afforded by interviews make it clear that her family comes first. There is no better demonstration of that than her cancellation, with less than a week's notice, of the 2002 Presidential Lecture in the Humanities and Arts at the prestigious Stanford Humanities Center because she preferred to be with her mother, who was facing surgery. And, when "on tour," she insists on being away from her husband and daughters for no more than a week. Daily life revolves around them. It starts with "feeding them breakfast. Either I'll take them to school or my husband takes them.... I often get up before the kids get up so I can get some work done in the house. I find that's probably the easiest time to do some writing or drawing, even before I head down to my studio." When asked how raising a family affects the level of her creative thinking, she speaks of "balancing like crazy," reflecting, "I don't think I work late hours, but then creativity you...bring to wherever you are. Certain ideas I might have might take longer to get to. I don't think I'm taking on anything I don't want to do. My problem is that I might take on too much." Her answer (she claims) is to "Say no. Just say no!"[1]

The extent and scope of her work in the first decade of the new millennium suggest that she did not always follow her own advice. She prophesied:

> I can imagine spending the next 10 years [in New York] and then disappearing completely after that, just going off into the middle of the woods, disappear out to Colorado every summer, ... experimenting out there. So I started very public. I'll probably end up extremely curmudgeonly. I'll be a hermit by the time it's all done.[2]

Prompted by what she saw in the Frieda Mock documentary, in 2000 Lin published *Boundaries*, which she characterized as a "visual-verbal sketchbook" in which she spoke for herself.[3] Three years in preparation, the revealing document exposed, for the first time and at length, her profound emotions about the Vietnam Veterans Memorial. Candid text and exquisite images presented 10 years of her work. She explained that the appropriately named book was about "the in-between areas," adding, "but it's as much about ... my East-West heritage, art and architecture, the fact that I use science a lot in my work. It's between science and art."[4] One reviewer wrote that it proved Lin to be "one of the most articulate, smart, and heartful artist/architects, with the great gift for ecological ... creations that grip, teach, and open and expand both emotions and mindscapes."[5] That was no faint praise.

At the start of a new century—a new millennium—Lin remained at the center of what she described as the whirlwind of the preceding four years. In the course of 2000, her work was shown in no fewer than seven group art exhibitions, two of which traveled through the United States. Another, *Illusions of Eden: Visions of the American Heartland*, moved to the Museum of Modern Art in Vienna, Austria; the Ludwig Museum in Budapest, Hungary; and several U.S. venues. In the fall, she was appointed to the Robert Gwathmey Chair in Art and Architecture at the Cooper Union School of Art, which also mounted a solo exhibition, *Between Art and Architecture*, in its Houghton Gallery. She also remained increasingly in demand across the country as a visiting lecturer at universities, art galleries, and cultural organizations.

In 2000, the Christopher Columbus Foundation presented Lin with the Frank Annunzio Award in the Arts and Humanities for "using art to focus on contemporary social and political—war, racism and gender equality." After remarking upon her passion for environmental issues, the citation read, in part, "Ms. Lin's sensitivity to aesthetic concerns, her innovative approach to site specificity, and her ability to address complex historical and social issues have afforded her a unique place in contemporary culture, and her work continues to engage and inspire viewers in a manner unprecedented in contemporary art."

Late in 2000, Lin announced that she was about to close her New York architectural practice so that she could make art. Two works that she was occupied with around that time reveal her engagement with nature, albeit in quite different ways. The first is *Timetable,* commissioned by Helen Bing for the Iris & B. Gerald Cantor Center for Visual Arts at Stanford University and dedicated in October 2000. Despite Lin's insistence that it was not a memorial, some saw it as marking "not an event or a personal sacrifice but time itself."[6] It is a working clock, designed in consultation with engineers and computer specialists and constructed with the help of clocksmiths, fountain experts, and a turntable manufacturer. Its movements are set in a black granite slab 10 feet in diameter and 21 inches high; respectively marking Pacific Standard Time, Pacific Daylight Time, and Greenwich Mean Time, their precisely calibrated mechanisms revolve once a minute, once an hour, and once each solar year. Water flows from an off-center hole in the table—another "water table"—and runs off the edges into a circular bed of pebbles. In this crisply sculptured geometric work—there is little "natural" about it in a literal sense– the link with nature lies in mathematical precision and the application of the laws of physics.

On the day before Thanksgiving, after months of repeatedly declining the commission, Lin finally yielded to requests and undertook "an extraordinary memorial," now known as the *Confluence Project.*[7] Originally proposed in May 1999 by a coalition of local Native Americans and civic organizations from Oregon and Washington, it celebrates the bicentenary of Lewis and Clark's arrival in the Pacific Northwest; it aims to encourage the preservation of the region's cultural and natural resources. Rather than reviewing the journey from the explorers'

perspective, the artworks reflect the responses of the local indigenous people. Lin's site-specific installations, at seven junctions of the Columbia River and its tributaries between the Pacific coast and Washington's eastern border, integrate natural elements, sculptures, and textual fragments. Environment restoration and enhancement complement each of the designs. There has been steady progress since work started in 2002, and four of the installations were complete by mid-2010.

Cape Disappointment is at the southwestern corner of Washington State. For that site, Lin designed a curved viewing platform extending out into the Pacific, and, next to a boat launch, she sculpted a large basalt monolith to form a fish-cleaning table inscribed with a traditional Chinook creation myth. Nearby, a "cedar circle" of driftwood trunks stands among living trees—an idea redolent of her *Aligning Reeds* of 1985. The Land Bridge in Vancouver, Washington, is an earth-covered pedestrian bridge, 40 feet wide and planted with native vegetation. It reconnects the former trading post and fort with the Columbia River waterfront and incorporates interpretive elements by Lin. For the Sandy River Delta, in Oregon, she designed a bird blind reached by a spiraling ramp, fenced with vertical slats carrying the names of the 134 flora and fauna species described by Lewis and Clark. At Sacajawea State Park, near Pasco,

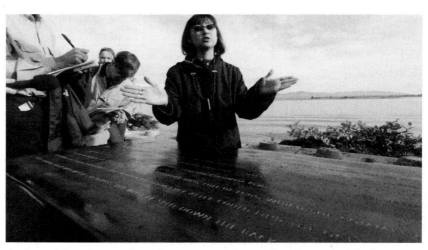

Architect Maya Lin speaks with reporters as she stands in front of a fish cleaning table made of a 16-foot-long piece of polished columnar basalt following its dedication on November 18, 2005, in Cape Disappointment, Washington. (AP Photo/ Rick Bowmer.)

Washington, seven "story circles" are formed by raised or lowered rings set into the ground and surrounded by tribal stories carved in the stone.

The three remaining elements, yet to be built, include an environmental research center and laboratory next to Ridgefield National Wildlife Refuge, a 5,000-acre nature sanctuary near the confluence of the Columbia and Lewis Rivers; Celilo Park, east of the Dalles, where a curved ramp will lead 300 feet to a point cantilevered over the Columbia River (a reference to Native Americans' traditional fishing platforms); and a stone-rimmed "listening circle" at Chief Timothy Park, an island in the Snake River near its confluence with the Clearwater. Lin has explained her vision:

> Fundamentally, it's about how we treat the land, how we see the land, how we want to own the land.... I'm reticent to make an artistic statement calling attention to itself. I want to connect you back to the landscape, make you pay a little closer attention to where you are, maybe who you are.[8]

Despite her stated intention to discontinue it, Lin's architectural practice has remained extremely busy throughout the decade. Working with various licensed practitioners, she designed several buildings that revealed her commitment to social issues and to the environment. The first and the last of them recycled disused buildings. With Hotson, she won a commission, in 2001, to convert a 1908 two-story trolley-car repair shop in Long Island City into SculptureCenter, incorporating indoor and outdoor exhibition spaces, offices, a library/reading room, and living/work spaces for visiting artists. It opened in December 2002. Completed in 2009, her Museum of Chinese in the Americas (with Bialosky) on the western edge of New York's Chinatown occupies the first floor and basement of a former industrial machine repair shop. The renovated space, part of a six-story building, consists of two separate structures surrounding a courtyard. Seeking a silver Leadership in Energy and Environmental Design (LEED) rating, Lin took a sustainable design approach. The two highly successful projects bracketed other "green" commissions undertaken in the intervening eight years.

In collaboration with New Jersey architects Cybul and Cybul, in 2003, Lin designed her first industrial building, Greyston Bakery, on a

reclaimed brownfield site in southwest Yonkers, New York. The bakery, owned by the nonprofit Buddhist Greyston Foundation, employs homeless people, and its profits support self-sufficiency programs for low-income families, HIV/AIDS patients, and the homeless. Completed in September 2003, the following year it was chosen as a Top 10 Green Project by the AIA Committee on the Environment.

In that same year, Lin designed a second building for the Children's Defense Fund (CDF) in Tennessee. The timber Riggio-Lynch chapels form evokes an ark—the CDF motto is "Dear Lord be good to me/The Sea is so wide/and my boat is so small"—set beside a pond (which it uses as an environmentally sound heat-exchanger) across from the Langston Hughes Library. A concrete-block administration building is connected to it by a covered open-air terrace. Finishes are of recycled and/or environmentally friendly materials. Bialosky was the architect of record. It is, says Lin, probably the architectural work of which she is most proud.[9]

In 2005–2006, once again in collaboration with Hotson, she designed the Sanctuary and Environmental Learning Laboratory at Manhattanville College in Purchase, New York. The project involved recycling an historic chapel as a greenhouse and building a new environmental classroom in the Ohnell Environmental Park, a teaching tool for energy-efficient building technology. The new building, of glass and renewable timber, is LEED-compliant and employs sustainable systems, building materials, and finishes. Both the classroom and the chapel achieve internal climate control through passive solar-heating devices.

There were other architectural projects, such as the Box House in Telluride, Colorado (with Bialosky, 2005) and Michael Koch's high-tech Park Avenue apartment in New York City (with Hotson), in the following year. Of about the same size and both cunningly detailed in timber, they complete yet another trilogy—this time with the New York apartment for Peter Norton (also with Hotson) that Lin completed in the late 1990s. But the other buildings mentioned have a clearly unifying quality: in one way or another expressing Lin's great respect for nature, they converge upon interpretation and conservation of the environment.

The theme that for a long time has preoccupied Lin also characterizes her sculpture. Between 2006 and 2009, *Systematic Landscapes*,

her second major exhibition in 10 years, traveled from Seattle to St. Louis, San Diego, San Francisco, and Washington, D.C. Three large works were at its focus. One, *2x4 Landscape*, is a hill, 60 by 20 by 10 feet, partly inspired by volcanic lava flows of Washington State and constructed from more than 50,000 fir and hemlock boards set on end. *Water Line* is a "line drawing in space"—made of aluminum tubes each measuring one-quarter inch in diameter —of Bouvet Island, near Antarctica. Lin collaborated with scientists at the Woods Hole Oceanographic Institute to create a computer rendering, which she and her studio assistants then reconfigured and modified in scale. *Blue Lake Pass* is a spatial model of an actual mountain range near Lin's home in Ridgway, Colorado. Its nine components are constructed from layers of particle board that have been divided into a grid and then separated so that viewers can walk between them. Among other pieces, the show also included smaller works in trilogies: *Bodies of Water* (*Caspian Sea, Red Sea, and Black Sea*) and *Sketch Tablets* (*Wanås, Kentucky, and Colorado*). A press release explained that "her work blends a typology of natural forms, from rivers to mountains to seas, with a visual language of scientific analysis represented by grids, models, and maps. Lin merges an understanding of the ideal and the real."[10]

Since 2005, besides the architectural works and those shown in *Systematic Landscapes*, the prolific Lin has produced several site-specific works. *Where the Land Meets the Sea* is a filigree of stainless steel tubing measuring 36 by 60 by 15 feet and showing the topography of San Francisco Bay, above and below water. Completed in 2008, it hangs above the West Terrace of the California Academy of Sciences building in San Francisco's Golden Gate Park. In 2007, the Indianapolis Museum of Art commissioned *Above and Below*, a 20-by-100-foot aluminum tubing sculpture that portrays part of Indiana's underground White River system. Like all of Lin's "topographic" works, both were interpretations of parts of the planet achieved through modern technology.

Lin [challenges] the means by which we perceive landscapes in the ... era of digital photos and satellite maps on the internet. "You just want to translate what you see," Lin said.... She is not actually looking at the landscape and reproducing what she sees, but using large amounts of scientific data to produce a vision of what

she might see. Part of her vision is to see what has changed in our global environment and show it to those viewing her work.[11]

In recent years, she has also worked with the Earth in a completely literal sense. The Wanås Foundation is an art organization located on an estate near Knislinge, in southern Sweden. Since 1987, its sculpture park has collected works by contemporary artists. In this century, it began to feature fewer artists in its annual shows and, in May 2003, it invited only Lin to exhibit. She chose a 23-acre cow pasture for an installation, which she wanted to relate to the prehistoric Hopewell Indian earth mounds in her native Ohio—specifically the 1,000-year-old Serpent Mound, 70 miles west of Athens. She produced models of alternative configurations in her New York studio and, in April 2004, returned to Knislinge, where she constructed her first major work outside the United States—the 1,600-foot-long by 12-foot-high "earth drawing" *11 Minute Line*. It was dismissed by *Time* as "a grass-covered earthen wall favored by grazing cows." Lin agreed that "the cows love it," explaining that the project started her "on a series about what the character and quality of a line is." Although they were in a different medium, *Water Line*, *Where the Land Meets the Sea*, and *Above and Below* were later investigations of the line. Lin also created another earth line in Kentucky for a private collector.[12]

She produced another trilogy of earthworks—each larger than the preceding one and all in the United States. The first, mentioned in chapter 12, was *Wave Field*, commissioned in 1995 by the University of Michigan. While researching aerodynamics, Lin encountered an image of the Stokes wave, which inspired her to sculpt a 100-foot-square plot of lawn in front of the Aerospace Engineering Building into 8 rows of grassy waves—50 in all—three to six feet high. She also found precedents (she said) in the large earthworks of Robert Smithson, Michael Heizer, and James Turrell. Ten years later, she created *Flutter*—two 15,000-square-foot rectangular lawns outside the Wilkie D. Ferguson Jr. Federal Courthouse in Miami. She formed gentle mounds, on average three feet high, and planted them with Bermuda grass to evoke the sand formations left by waves on a beach.

By then, the idea for the third "wave" work—at 240,000 square feet, by far the largest—was already forming. Around 2000, Lin had been invited to think about making a piece for the Storm King Art Center, a 500-acre sculpture park in Mountainville, New York. She chose as a site a disused gravel pit on the park's southwestern edge, the last vestige of an industry that had flourished in the 1950s, during the construction of the New York State Thruway. *Storm King Wavefield*, like its predecessors, is made of soil and grass. Its seven rows of earth berm "waves," between 10 and 15 feet high and between 305 and 368 feet long, cover about one-third of the 11-acre site. Of the project, Lin said, "I always knew that I wanted to culminate the [wave field] series with a field that literally, when you were in it, you became lost inside it, so the waves had to become much larger than you."[13] The installation is screened from the Thruway by native trees in numbers calculated to offset the carbon footprint of the construction process. Accurately describing the work as a "classic," one art critic asserted, "It has the gravity of [Lin's] commemorative sculptures and the sociability of the earlier 'wave' pieces.... And, more immediately than almost any of her other outdoor projects, it is inextricable from nature, which is where...all her art starts."[14]

Throughout the decade, Lin's minor works appeared in more than 25 smaller exhibitions, about a third of which were solo showings.

In the 14th century, the city of Florence honored the painter Giotto with the title *Magnus Magister* (Great Master) and appointed him city architect because he was "a very great man." Similarly, by the start of the 21st century, Lin had achieved such an elevated status that she was sought after by institutions—even some not directly linked with the arts. In July 2002, she became the first artist and the first Asian American woman elected to serve on the Yale Corporation, the University's highest policy-making body. Each year, the Association of Yale Alumni (AYA) elects one of its own, usually chosen from two to five aspirants, for one of the Corporation's six alumni seats. In the fall of 2001, the New Haven clergyman W. David Lee announced his candidature and submitted a petition with almost 5,000 signatures—an accepted means of nomination. Supported by prestigious endorsements and using direct mailing financed by $60,000 in donations from Yale's unions, he

promised to forge a "true partnership between Yale and New Haven." The University's relationship with the unions had always been fraught; a few years earlier, negotiations between them had ended in a 10-week strike that took more than a year to resolve. Lee was accused of being a "tool of the unions, interfering in Yale's affairs."

The AYA selection committee named Lin as its only candidate. She avoided press interviews during the campaign and, relying on her "background, accomplishments and affection for Yale rather than some new comments that might be interpreted as trying to garner votes," allowed others to politick for her. Almost three times the usual number of ballots were cast, and she received more than 83 percent of the vote. In an acceptance statement, she said,

> My only agenda is that I care deeply about Yale and I will do my best to help the University as a member of the governing board.... I am very concerned about Yale's relationship to its

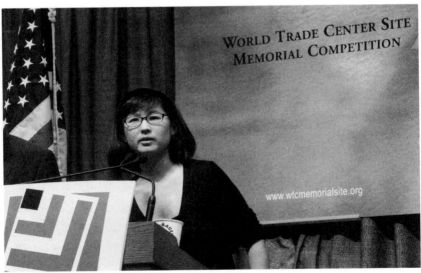

Maya Lin answers questions during a news conference near the World Trade Center site on April 28, 2003, to announce the start of an international competition to design a memorial in honor of those killed during the September 11 attacks and the 1993 World Trade Center bombing. Lin, who designed the Vietnam Veterans Memorial in Washington, D.C., was one of a group of jurors in the competition. (AP Photo/Gregory Bull.)

community and if we can learn anything about this election process it is that this town-gown relationship is a critical issue that must continue to be addressed.[15]

In summer 2002, *New York Times* architecture critic Herbert Muschamp asked Lin for a "sketchbook of thoughts" for a memorial to the 9/11 tragedy. Her response was published in the newspaper's magazine on September 8. The following April, the Lower Manhattan Development Corporation (LMDC) launched the World Trade Center Site Memorial Competition. Committees consisting of survivors, victims' families, first responders, residents, community leaders, and design professionals developed the program for a single memorial to all who were killed at the Twin Towers site, as well as the victims of the 1993 terrorist bombing of the Trade Center garage. Lin was appointed to a 13-member jury of artists, architects, and civic and cultural

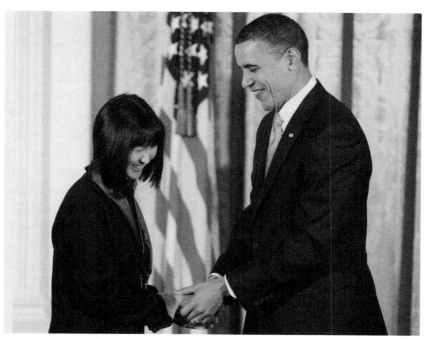

President Barack Obama congratulates architect Maya Lin after presenting her with the 2009 National Medal of Arts, February 25, 2010. (AP Photo/Charles Dharapak.)

Maya Lin and Daniel Wolf arrive at the White House in Washington, January 19, 2011, for a state dinner in honor of China's President Hu Jintao. (AP Photo/Evan Vucci.)

leaders, which, after months of assessment, chose 8 finalists from 5,200 anonymously reviewed conceptual designs. The controversial winner, *Reflecting Absence*, by New York City Housing Authority architect Michael Arad and (on the jury's recommendation) landscape architect Peter Walker, was announced on January 13, 2004.

Although Lin was a passionate advocate of Arad's design, rumors that she had stage-managed its success are unfounded. Indeed, all the short-listed entries were to some degree redolent of her Vietnam Veterans Memorial, leading Paul Goldberger of *The New Yorker* to suggest (despite the fact that the jury meetings were confidential) that she dominated its deliberations. Conspiracy theorists accused the jury of choosing Arad's proposal because it most resembled one of Lin's 2002 *New York Times* sketches. One claimed that "The circumstances of the competition and the lax manner in which the rules have been embraced indicate that it was all along the intention of the LMDC that one of the Jurors [read Maya Lin] would be the principal designer of the memorial in fact if not in name."[16]

Year by year throughout the decade, Lin received honorary doctorates and local, national, and foreign accolades.[17] During the the Clinton administration, she and Daniel Wolf moved in White House social circles. Although she has donated generously to the political campaigns of Democratic candidates, including Hillary Clinton's campaign for the Senate (and, incidentally, for the 2008 presidential nomination), Lin considers herself apolitical. But, in 2000, she "[shuddered] at the thought of George [W.] Bush as president. 'The environment can't afford him,' she [said]."[18]

In June 2009, she was among an "accomplished group" of 28 citizens appointed by President Barack Obama to the President's Commission on White House Fellowships, a group charged with recommending candidates for selection as White House Fellows.

Throughout the foregoing 10 years, besides her prodigious artistic output, she had been developing her "last memorial"—*What Is Missing?*

NOTES

1. Elisa Turner, "Her Balancing Act's a Fine Art," *Miami Herald*, February 16, 2007.

2. Robert Campbell, "Rock, Paper, Vision," *Boston Globe*, November 30, 2000), http://www.highbeam.com/doc/1P2-8625723.html

3. Maya Lin, *Boundaries* (New York: Simon & Schuster, 2000).

4. Brian Lamb, "*Boundaries* by Maya Lin," C-Span, *Booknotes*, November 19, 2000, http://www.booknotes.org/Transcript/?Program ID=1589.

5. Michael Krasny, "Thinking with Her Hands" (interview), *Whole Earth* (Winter 2000), http://www.wholeearth.com/issue/2103/article/125/thinking.with.her.hands.

6. Kenneth Baker, "Carving Out Time," *San Francisco Chronicle*, October 24, 2000.

7. Richard Lacayo, "Talking to Maya Lin," *Time*, June 15, 2009.

8. Paula Bock, "A Meeting of Minds," *Seattle Times Pacific Northwest Magazine*, June 10, 2005.

9. McGuigan, Cathleen. "Escaping from the Shadow of the 'Wall,'" *Newsweek Web*, http://www.newsweek.com/2007/01/22/escaping-from-the-shadow-of-the-wall.html.

10. Press release, Corcoran Gallery of Art, http://www.corcoran.org/exhibitions/press_results.asp?Exhib_ID=238.

11. "Maya Lin: *Systematic Landscapes*," Contemporary Art Museum, St. Louis, July 2010, http://www.contemporarystl.org/maya_lin.php.

12. McGuigan, "Escaping from the Shadow of the 'Wall.'"

13. Carol Kino, "Once Inspired by a War, Now by the Land," *New York Times*, November 9, 2008.

14. Holland Cotter, "Where the Ocean Meets the Mountains," *New York Times*, May 8, 2009.

15. "Renowned Architect Maya Lin Elected to Yale Corporation," *Yale Bulletin & Calendar*, June 7, 2002, http://www.yale.edu/opa/arc-ybc/v30.n31/story3.html.

16. Robert Campbell, "Not Everyone Agrees That WTC Design Is a Winner," *Boston Globe*, March 7, 2004.

17. These are set out in the timeline at the front of the book.

18. Regina Hackett, "Maya Lin Emerges from the Shadows," *Seattle Post-Intelligencer*, October 19, 2000, http://seattlepi.nwsource.com/visualart/maya.shtml.

FURTHER READING

WRITINGS BY MAYA LIN

Boundaries. New York: Simon & Schuster, 2000.

Ecliptic: Rosa Parks Circle, Grand Rapids, Michigan. West Michigan Visual Arts Organizations, [2003].

Foreword to Allen Hershkowitz, *Bronx Ecology: Blueprint for a New Environmentalism*. Washington DC: Island Press, 2002.

Foreword to Tina Oldknow, *Pilchuck: A Glass School*. Seattle: University of Washington Press, 1996.

Maya Lin. Milan: Electa; Rome: American Academy in Rome, 1998. Catalogue.

Maya Lin: Topologies. Winston-Salem, NC: Southeastern Center for Contemporary Art, 1998. Catalogue.

"Reading a Garden" [with Tan Lin]. *Bomb* (suppl.) (Spring 1999): 88–91.

Timetable: Maya Lin. Stanford, CA: Iris & B. Gerald Cantor Center for the Visual Arts, 2002.

BOOKS, MONOGRAPHS, AND CATALOGUES

Andrews, Richard, and John Beardsley. *Maya Lin: Systematic Landscapes*. Seattle: Henry Art Gallery, University of Washington; New Haven: Yale University Press, 2006. Catalogue.

Ashabranner, Brent. *Always to Remember: The Story of the Vietnam Veterans Memorial*. New York: Dodd, Mead, 1988.

Brenson, Michael. "Maya Lin's Time." In *Acts of Engagement: Writings on Art, Criticism, and Institutions, 1993–2002*, ed. Michael Brenson. Lanham, MD: Rowman & Littlefield, 2004.

Fairbank, Wilma. *Liang and Lin: Partners in Exploring China's Architectural Past*. Philadelphia: University of Pennsylvania Press, 2009.

Hass, Kristin Ann. *Carried to the Wall: American Memory and the Vietnam Veterans Memorial*. Berkeley: University of California Press, 1998.

Hess, Elizabeth. "Vietnam: Memorials of Misfortune." In *Unwinding the Vietnam War: From War into Peace*, ed. Reese Williams. Seattle: Real Comet Press, 1987.

Hilton, Isabel. "The Lost City." *Granta* 73 (Spring 2001). http://www.granta.com/Magazine/73/The-Lost-City/2.

McLeod, Mary. "The Battle for the Monument: The Vietnam Veterans Memorial." In *The Experimental Tradition: Essays on Competitions in Architecture*, ed. Hélène Lipstadt. New York: Architectural League of New York; Princeton Architectural Press, 1989.

Rogers, Sarah J. *Maya Lin: Public/Private*. Columbus: Wexner Center for the Arts, Ohio State University, 1994. Catalogue.

Scruggs, Jan C., and Joel L. Swerdlow. *To Heal a Nation: The Vietnam Veterans Memorial*. New York: Harper & Row, 1985.

PERIODICALS

Abramson, Daniel. "Maya Lin and the 1960s: Monuments, Time Lines, and Minimalism." *Critical Inquiry* 22 (Summer 1996): 679–709.

"Academy of Sciences Picks Maya Lin." *Artweek* 37 (February 2006): 24–25.

Albrecht, Donald. "Cross-cultural Journey." *Architecture* 82 (July 1993): 66–69.

Amelar, Sarah. "Inspired by Asian Puzzle Toys." *Architectural Record* 194 (April 2006).

Amelar, Sarah. "Within the Chaos of New York City." *Architectural Record* 187 (September 1999): 132–39.

"Apartment in New York." *Detail* 40 (March 2000): 205–9.

"Architect Maya Lin Creates Her First Line of Furniture for Knoll." *Architectural Record* 186 (June 1998): 192–93.

Beardsley, John. "'Like a Mighty Stream'—Civil Rights Memorial, Montgomery." *Landscape Architecture* 80 (January 1990): 78–79.

Bernstein, Fred A. "Architecture's Quiet Soul: Maya Lin." *Blueprint* (May 1999): 28–31.

Bernstein, Fred A. "Naturally Perfect." *Metropolitan Home* 39 (April 2007): 102–11.

Betsky, Aaron, et al. "Maya Lin Studio: Langston Hughes Library." *Architecture* 89 (July 2000).

Boettger, Suzaan. "Hybrid Field." *Art in America* 97 (October 2009): 118–21.

Brake, Alan G. "The Boat in the Woods." *Architecture* 93 (October 2004): [52]–59.

Branch, Mark Alden. "Maya Lin: After the Wall." *Progressive Architecture* 75 (August 1994): 60–63 ff.

Brown, Brenda J. "Where They Skate among Stars." *Landscape Architecture* 92 (April 2002): 76–83, 107–8.

Campbell, Robert. "An Emotive Place Apart." *AIA Journal* 72 (May 1983): 150–51.

Coleman, Jonathan. "First She Looks Inward." *Time*, November 6, 1989, 90 ff.

Deitsch, Dina. "Maya Lin's Perpetual Landscapes and Storm King Wavefield." *Woman's Art Journal* 30 (Spring–Summer 2009): 2–10.

Dugdale, Juanita. "Heart of Yale; Designer: Maya Ying Lin." *Landscape Architecture* 84 (April 1994): 22, 24.

Eckardt, Wolf von. "Storm over a Viet Nam Memorial." *Time*, November 9, 1981, 103 ff.

Everett, Deborah. "The Next Chapter: Building the Sculpture Center." *Sculpture* 22 (March 2003): 42–47.

Feldman, Karen S. "The Shape of Mourning: Reading, Aesthetic Cognition, and the Vietnam Veterans Memorial." *Word & Image* 19 (October–December 2003): 296–304.

Freeman, Allen. "An Extraordinary Competition." *AIA Journal* 70 (August 1981): 47–53.

Friedman, Daniel S. "Public Things in the Atopic City." *Art Criticism* 10 (1995): 66–104.

Griswold, Charles L. "The Vietnam Veterans Memorial and the Washington Mall: Philosophical Thoughts on Political Iconography." *Critical Inquiry* 12 (Summer 1986): 688–719.

Guilbert, Juliette. "Reversing Course." *Metropolis* 28 (November 2008): 38–44.

Hawthorne, Christopher. "Water Works: For a Park in Downtown Grand Rapids, Maya Lin Sculpts an Urban Space." *Metropolis* 21 (March 2002): 74–79, 108–9.

Hess, Elizabeth. "A Tale of Two Memorials." *Art in America* 71 (April 1983): 120–27.

Hines, Susan. "Outsider Artist." *Landscape Architecture* 97 (February 2007): 110–15.

Howett, Catherine M. "The Vietnam Veterans Memorial: Public Art and Politics." *Landscape* 28 (1985): 1–9.

Isaac, Allan Punzalan. "Tea and Empathy." *Metropolis* 17 (October 1997): 98–99.

Johnson, Jory, and Michael Leccese. "Topo, Charlotte Coliseum Basketball Stadium." *Landscape Architecture* 82 (July 1992): 34–49.

Kennicot, Philip. "Why Has Maya Lin Retreated from the Battlefield of Ideas?" *Washington Post*, October 22, 2006.

Lavin, Sylvia, et al. [Norton residence, New York]. *A+U* (August 2001): 86–91.

Lebowitz, Cathy. "Maya Lin: Building Nature." *Art in America* 96 (May 2008): 152–55, 157.

Lim, Tresna. "Making Waves: Maya Lin's 'Wave Field.'" *Dimensions* 10 (1996): 4–8.

Marling, Karal Ann, and Robert Silberman. "The Statue Near the Wall." *Smithsonian Studies in American Art* 1 (Spring 1987): 4–29.

Marling, Karal Ann, and John Wetenhall. "The Sexual Politics of Memory: The Vietnam Women's Memorial Project." *Prospects* 14 (1989): 341–72.

Parfit, Michael. "Maya Lin." *Smithsonian* 36 (November 1, 2005): 100–2.

Pedersen, Martin C. "Maya Lin: One Driving Idea." *Graphis* 54 (January–February 1998): 56–69.

Platt, Susan Noyes. "Maya Lin's Confluence Project." *Sculpture* 25 (November 2006): 54–59.

Sokol, David. "Higher Ground." *Architectural Record* 194 (September 2006): 86–92.

Stein, Judith E. "Space and Place." *Art in America* 82 (December 1994): 66–71, 117.

Sturken, Marita. "The Wall, the Screen, and the Image: The Vietnam Veterans Memorial." *Representations* (Summer 1991): 118–42.

Upton, Dell. "Commemorating the Civil Rights Movement." *Design Book Review* (Fall 1999): 22–33.

Vai, Elena. "Apartment in Manhattan." *Ottagono* (February 2008): 124–31.

Wagner-Pacifici, Robin, and Barry Schwartz. "The Vietnam Veterans Memorial: Commemorating a Difficult Past." *American Journal of Sociology* 97 (September 1991): 376–420.

Zevi, Adachiara. "Maya Lin's Verbal Sketches." *L'Architettura* 45 (March 1999): 180–82.

TRANSCRIPTS OF INTERVIEWS

American Academy of Achievement. "Maya Lin, Artist and Architect." June 16, 2000, Scottsdale, AZ, http://www.achievement. org/autodoc/page/lin0int.

Arroyo, Leah. "Between Art and Architecture: The Memory Works of Maya Lin." *Museum* 87 (July–August 2008): 42–49.

"Art in the 21st Century." PBS, http://www.pbs.org/art21/artists/lin/ clip2.html.

Brown, Patricia Leigh. "At Home with: Maya Lin: Making History on a Human Scale." *New York Times*, May 21, 1998.

Campbell, Robert. "Rock, Paper, Vision." *Boston Globe*, November 30, 2000.

Castro, Jan Garden. "One Who Sees Space: A Conversation with Maya Lin." *Sculpture* 21 (September 2002): 36–43.

Finkelpearl, Tom. "The Anti-Monumental Work of Maya Lin." *Public Art Review* 8 (Fall–Winter 1996): 5–9.

Hackett, Regina. "Maya Lin Emerges from the Shadows." *Seattle Post-Intelligencer*, October 19, 2000, http://seattlepi.nwsource.com/visualart/maya.shtml.

Hines, Susan. "Outsider Artist: *Landscape Architecture* Talks with Maya Lin." *Landscape Architecture* 97 (February 2007): 110–15.

Krasny, Michael. "Thinking with Her Hands." *Whole Earth* (Winter 2000).

Lacayo, Richard. "Talking to Maya Lin." *Time*, June 15, 2009, http://lookingaround.blogs.time.com/2009/06/15/talking-to-maya-lin/.

Lamb, Brian. "Boundaries by Maya Lin," C-Span, *Booknotes*, November 19, 2000, http://www.booknotes.org/Transcript/?ProgramID=1589.

Lynch, Kevin. "Maya Lin to Mark Anniversary." *Capital Times* (Madison, WI), April 25, 2001, http://www.highbeam.com/doc/1G1–73690182.html.

McGuigan, Cathleen. "Escaping from the Shadow of the 'Wall.'" *Newsweek*, January 23, 2007, http://www.newsweek.com/id/70211.

Mack, Linda. "Lin Heads for Minneapolis." *Star Tribune* (Minneapolis), October 23, 1996.

"Maya Lin." Natural Resources Defense Council, April 2003, http://www.nrdc.org/reference/qa/intlin.asp.

Menand, Louis. "The Reluctant Memorialist." *New Yorker*, July 8, 2002, 54–65. Reprinted in Menand, *American Studies*. New York: Farrar, Straus, & Giroux, 2002.

Moyers, Bill. "Becoming American." Interview with Maya Lin. Public Affairs Television, http://www.pbs.org/becomingamerican/ap_pjourneys_transcript5.html.

Rabinowitz, Cay Sophie. "Making Waves." *Art Papers* 24 (March–April 2000): 26–31.

Sollod, Ellen. "Maya Lin." *Arcade* 24 (Summer 2006): 34–35.

Sommer, Mimi G. "Maya Lin: Human Proportions on a Heroic Scale." *New York Times*, April 17, 1994.

Stamberg, Susan. "Interview: Maya Lin...Discusses Her Works of Art." *Weekend Edition—Saturday.* NPR. 2000. December 14, 2008, http://www.highbeam.com/doc/1P1–36529014.html.

FILMS, VIDEOTAPES, DVDs

Mock, Freida Lee (director). *Maya Lin—A Strong Clear Vision.* Ocean Releasing, United States, 1995. DVD release date 2003.

INDEX

Abe, Shinichiro, 147

Above and Below (Lin sculpture), 165

Academie Européenne "Méditerranée," 30

Ain, Noa, 121

Aligning Reeds (Lin project), 122, 162

American Council of Learned Societies, 36

American Institute of Architects (AIA), 80, 98

American Legion, 93

Andersen, Ross, 82

Andrews Air Force Base, 85, 89

Anthony G. Trisolini Gallery, 35

Anyone Can Sculpt (Zaidenberg), 98

Appalachian Ohians, 54–55

Après le Cubisme (manifesto), 126

Arad, Michael, 170

Architecture, China and, 18–19

Arnold, Henry, 139

Art in America (magazine), 112

Ashworth, Edward, 134–35

Assistens Kirkegård, 70

Athens, Ohio, 1, 34, 39–47; cultural character of, 43–44; Ohio University (OU) and, 40–43; politics in, 44; protests and riots in, 45–47; racial discrimination in, 56–57; settlement of, 39–40

Athens High School (AHS), 59

Baker, Elizabeth Evans, 131, 132–33

Baker, John Calhoun, 131–32, 133

Barensfeld, Paula, 60

Beck, Joan, 92

Beeby, Thomas H., 120

Belden, Ursula, 34

Belluschi, Pietro, 84

Benson, John Everett, 136

Berger, Richard, 126

Bergstrom, George, 69

Bernstein, Fred, 156

Between Art and Architecture (art exhibition), 160

Bialosky, William, 146

Bing, Helen, 161

Bing Xin, 123–24

Blecher, Hilary, 122

Bloch, Milton, 138–39

Bloomer, Kent, 70

Blue Lake Pass (Lin sculpture), 165

Bodies of Water (Caspian Sea, Red Sea, and Black Sea) (Lin sculpture), 165

Bond, Julian, 134

Bonifas, Paul A., 30, 125–26

Boston Globe, 91

Boullée, Étienne-Louis, 76

Boundaries (Lin), 16, 81, 83, 84, 160

Boxer Rebellion, 2

Boynton, Peter, 126–27, 150

Brewster, Kingman, 137

Brodin, Rodger, 114

Brown, J. Carter, 98, 108, 111, 114

Brown, Joseph, 85, 106

Brown, Patricia Leigh, 50, 118–19, 123, 152

Brown v. Board of Education, 136

Buchanan, Pat, 99

Buddhist Greyston Foundation, 164

Burr, Andrus, 70, 75–77, 80, 81–83

Bush, George W., 171

Callahan, Pamela, 42, 94

Campbell, Robert, 24

Cape Disappointment, 162

Carhart, Tom, 98, 99

Carter, Jimmy, 79

Chai Zemin, 9

Chang, Ming-hui (Julia), 14, 30–33, 56; Athens, Ohio, and, 42–44; translations by, 36–37

Chang Fu Xing, 56

Charlotte-Mecklenburg Art Commission, 138

Cheek, Robert, 138

Cheng Gui-lin, 17

Chiang Kai-shek, 7, 10–11, 14

Chicago Tribune, 92, 99

Childhood and youth of Lin, Maya, 49–61

Children's Defense Fund (CDF), 155–56, 164

China: architecture and, 18–19; Christianity and, 27–29; conflict defeats by, 2; history of, 2–14

Chinese ancestry of Lin, 1–14

Chinese People's Political Consultative Conference (PCC), 21
Chinese Reform Association, 4
Chronicles of Narnia (Lewis), 54
Clay, Grady, 84, 85
Clinton, Hillary, 171
Cohen, Richard, 136
Cole, Robert, 136
Commission of Fine Arts (CFA), 79
Concubine, 17
Confluence Project (Lin memorial), 161–62
Contemporary American Print Collection, 35
Controversy, The, 93–94, 117, 118
Cooke, Alistair, 85
Cooper, W. Kent, 95
Cooper-Lecky Partnership, 105
Copulos, Milton, 99, 105
Cotter, Holland, 125
Cret, Paul Philippe, 19
Cronkite, Walter, 85
Cutler, Manasseh, 40
Cybul and Cybul architects, 163–64

Dal Co, Francesco, 120
Daniel Wolf Galleries, 151
Davison, Michael, 100
Day, Russell, 33
Deer Hunter, The (movie), 78
Dees, Morris, Jr., 134, 136
Denver Art Museum, 151
Dickie, George, 115

Doubek, Robert, 78, 95
Dowager Ci Xi, Empress, 4
Druckrey, Inge, 138
Dupré, Louis, 70
Durenberger, David, 114

Earth drawings, 166
Earth Is (Not) Flat, The (Lin furniture design), 154
Eastman Reading Garden, 153
Eckbo, Garrett, 84, 99
Eclipsed Time (Lin kinetic sculpture), 141–42, 148
Edelman, Marian Wright, 155
Eisenman, Peter, 148
11 Minute Line (Lin earth drawing), 166
Environmental issues, 53, 162–63
Esman, Rosa, 146
Esman art gallery, 145–46
Essays on Contemporary Chinese Poetry (Julia Lin), 36
Eyes on the Prize (PBS TV series), 135

Fairbanks, John, 16
Fairbanks, Wilma, 15–16
Family history, 1–2; of extended Lin family, 2, 5, 7–10, 24, 123–24
Fangyin, Cai, 20
Fine Arts Commission (FAC), 94, 98, 107, 114
Finkelpearl, Tom, 101
Flowing water sculptures, 152–53
Flutter (Lin earth drawing), 166

Fujian, 2
Furniture designs, 154

Gapp, Paul, 99
Garner, David, 140
Gate of Heavenly Peace: The Chinese and their Revolution, The (Spence), 15
Gehry, Frank, 120, 121
Goldberger, Paul, 97, 170
Goodacre, Glenna, 115
Gorlin, Alexander, 119
Gormenghast (Peake), 54
Great Wall, 2
Greene, John, 140
Greene and Greene, 151
Greyston Bakery (Lin industrial building design), 163–64
Griffith, Reginald W., 115
Groundswell (Lin Wexner Center project), 148
Guangxu (emperor), 3, 4

Hammerschmidt, John Paul, 79
Han Chinese dynasty, 2
Harries, Karsten, 70
Hart, Frederick, 85, 106, 111–14, 152
Hay, Dick, 57
Heizer, Michael, 166
Henry, C. Jewett, 132
He Xue-yuan, 17
Hilton, Isabel, 22–23
Hocking Canal, 40
Hodel, Donald, 114
Holzman, Malcolm, 153
Hotson, David, 119, 147, 153

Hsi-en Chen, Theodore, 29
Hu Han-min, 10
Huiyin, Lin, 15–25; American studies by, 19; comparison to Maya Lin, 24–25; death of, 23; National Emblem of the People's Republic and, 21–22; as refugee academic, 20–21; Xu Zhimo and, 18
Hunt, Richard H., 84
Hyde, Henry, 100

Illusions of Eden: Visions of the American Heartland (Lin art exhibition), 160
Isaacs, Walter F., 30
Isley, John, 138

James, Billy, 138
Japanese architecture, 124–26
Jayne, William, 105
Jen, Gish, 58
Jinbudang (Democrat Party), 6
Johnson, Lyndon B., 45
J. Paul Getty Museum, 151
Judges for Vietnam Veterans Memorial, 84–86, 89–90
Jun, Long, 20
Juniata College chapel, 131–34
Juniata College Institute for Peace and Conflict Studies, 132

Kang Youwei, 3, 4
Keaton, Diane, 151
Kennedy, John F., 44
Kennicott, Philip, 92

King, Martin Luther, Jr., 135–37
Koch, Michael, 164
Koolhaas, Rem, 120
Krier, Rob, 120
Krosinsky, Marvin, 85
Kübler-Ross, Elisabeth, 76
Ku Klux Klan, 134
Kuomintang (KMT), 6, 10–11

Lalich, Peter, 63
Landscape Architecture Quarterly
 (magazine), 84
Leadership in Energy and
 Environmental Design (LEED)
 rating, 163, 164
Lecky, William, 95
Le Corbusier, Charles-Édouard,
 30, 126
Lee, Richard C., 64
Lee, W. David, 167–68
L'Ésprit Nouveau (art journal),
 30, 126
Letter to My Wife, A (Juemin), 5
Levin, Joseph J., Jr., 134
Lewis, Michael J., 81
Lewis Kruse Blunck, 153
*Liang and Lin: Partners in
 Exploring China's Architectural
 Past* (Fairbanks), 15
Liang Congjie, 17
Liang Qichao, 2–5, 6, 7, 19
Lin, Huan (Henry), 14, 17,
 29–30; aloofness of, 57–58;
 Athens, Ohio and, 42–44;
 ceramic pottery by, 125–26; as
 Dean of College of Fine Arts,
 34; death of, 36, 56, 133–34;

early craftsmanship of, 50;
 Northwest Designer Craftsmen
 and, 33; religion and, 27–31;
 School of Art, Ohio Univer-
 sity (OU) and, 34–35
Lin, Julia. *See* Chang, Ming-hui
 (Julia)
Lin, Maya: adolescent alienation
 of, 55–58; Aligning Reeds
 project by, 122; ancestry of,
 1–14; Appalachian Ohians
 and, 54–55; architecture major
 of, 69–70; artistic works by,
 131–42; Athens, Ohio and,
 39–47; childhood years of,
 49–61; China trip of, 122–24;
 college dormitory life of,
 66–67; *Confluence Project* and,
 161–62; conservation advo-
 cacy and, 147–48; early career
 choices of, 67–69; early design
 exercises by, 76–77; earth
 drawings of, 166; *Eclipsed Time*
 kinetic sculpture by, 141–42,
 148; environmental issues and,
 53, 162–63; Esman art gallery
 and, 145–46; extended family
 of, 7–10, 56; family home of,
 49–51; flowing water sculptures
 by, 152–53; formal education
 of, 52–53; furniture designs by,
 154; grad school and, 119–20;
 Greyston Bakery design by,
 163–64; *Groundswell* project
 of, 148; high school achieve-
 ments and honors of, 60–61;
 honors and awards for, 148–49,

154, 160–61; Japanese architecture and, 124–26; Juniata College chapel and, 131–34; overseas architectural studies programs of, 70–71; parentage explanation by, 37; parents escape from China, 31–37; racial discrimination against, 56–57, 70–71, 99; religious beliefs of, 27–31; rock collecting and, 59; sculpting and, 120–21; sibling rivalry and, 51–52; Southern Poverty Law Center (SPLC) and, 134–37; *Timetable* artwork by, 161; *Topologies* exhibition by, 154–55; *Topo* project and, 138–41; *Trio* stage set creation by, 121–22; Vietnam Veterans Memorial and, 75–86, 89–101, 105–15; Weber residence project and, 146–47; *Women's Table* sculpture of, 138, 148, 152; World Trade Center Site Memorial Competition and, 169–70; Yale University and, 63–72

Lin, Tan, 1, 33, 153

Lin Changmin, 7–10, 16–17

Lincoln Memorial, 93

Lin Juemin, 5, 123

Lin Zhen Gao, 5, 123

Little Red Book, The (Mao Zedong), 13

Long March, 12–13

Lord of the Rings (Tolkien), 54

Lower Manhattan Development Corporation (LMDC), 169

Lutyen, Edwin, 84

Mao Zedong, 12–14

Martella Associates, 155

Martin, Judith, 96

Mathias, Charles, 79

Maya Lin: A Strong Clear Vision (documentary), 149–50

Maya Lin Studios, 126–27

Mayer, George, 151

McCallum, Paula, 60

McGowan, Irene, 33

McGrath, Lee Kimche, 138–39

Memorial Quadrangle at Yale University, 65

Menand, Louis, 24, 55, 91, 101

Metropolitan Transportation Authority (MTA) Arts for Transit program, 141–42

Michener, James, 85

Mock, Frieda Lee, 149, 160

Modern Chinese Poetry: An Introduction (Julia Lin), 36

Monument to the People's Heroes, 21

Morris, Robert, 139

Mosley, Arthur, 105

Murray, Andrew, 132

Muschamp, Herbert, 169

Museum for African Art, 147

Museum of Chinese in the Americas, 163

National Capital Memorial Advisory Committee (NCMAC), 94

National Capital Planning Commission (NCPC), 79, 94

National Emblem of the People's Republic, 21–22,

National Endowment for the Arts, 80
National Mall, 79, 98, 100
Neff, Robert, 132, 133
New Haven, Connecticut, 64–65
New People's Miscellany (Liang Qichao), 4
Newton, Isaac, 76
New Yorker, The, 170
New York Times, 97, 99, 125, 152, 156, 169
Nivola, Costantino, 84
Nixon, Richard, 45
Northwest Designer Craftsmen, 33
Norton, Peter, 153, 164

Obama, Barack, 171
Odell Associates, 138
Ohio Company of Associates, 39–40
Ohio University (OU), 40–43; cancellation of school activities at, 46–47; enrollments in, 42–43; protests and riots at, 45–47
Oles, Paul Stevenson, 92–93
Olin Partnership, 153
On Death and Dying (Kübler-Ross), 76
Opium Wars, 2
Ozenfant, Amédée, 30, 125

Paley, Albert, 139
Parfit, Michael, 118
Parks, Rosa, 136
Peace chapel at Juniata College, 131–33

Pelli, Cesar, 95, 120
Pence, Coralynn, 33
Pennington, Ruth, 33
People's Liberation Army (PLA), 13–14
Perot, H. Ross, 98, 99, 101, 107
Peter Forbes and Associates, 110, 127, 134
Phillips Exeter Academy, 107
Pictorial History of Chinese Architecture, A (Sicheng), 15, 23–24
Public/Private (Lin solo exhibition), 148
Pucci, Carl, 82
Purves, Alec, 70
Putnam, Rufus, 39, 40
Putnam School, 52–53

Qing dynasty, 2, 4

Racial discrimination, 56–57, 70–71, 99
Reading a Garden (Lin sculpture), 152–53
Reagan, Ronald, 100, 113
Reflecting Absence (Arad design), 170
Reiser, David, 94
Religious beliefs of Lin, Maya, 27–31
Revive China Society, 4
Reynolds, Malvina, 50
Rock collecting, 59
Rogers, Richard, 120
Rohlfs, Charles, 151
Rosati, James, 84
Rowdies, 59

Rudoph, Paul, 119
Ryder, Amanda, 2

Sad-eyed Army nurse (Brodin
 statue), 114
Salzer, Lisel, 33
Sampley, Ted, 27
Sanders, Terry, 149
Sargeant, Winthrop, 40
Sasaki, Hideo, 84
Schaet, Donald, 91
Schlafly, Phyllis, 99
Schmidt, Benno, Jr., 137
School of Architecture at Yale
 University, 119–20
Scruggs, Jan C., 78, 85, 89,
 101, 107
Scully, Vincent, 70, 84, 113, 118
Serra, Richard, 121
Sevareid, Eric, 85
Sexton, Jim, 150
Shapiro, Joel, 138
Shepard, Raymond, 46
Shift in the Stream, A (Lin wall
 sculpture), 153
Shinohara, Kazuo, 124–25
Sicheng, Liang, 15–25; American
 studies by, 19; Communist party
 attack of, 23; Monument to the
 People's Heroes and, 21; Na-
 tional Emblem of the People's
 Republic and, 21–22; North-
 eastern University architecture
 department and, 19–20; Picto-
 rial History of Chinese Architec-
 ture, A, 15, 23–24; as refugee
 academic, 20–21; Society for

the Study of Chinese Archi-
 tecture (SSCA) and, 19, 20
Sino-Japanese War, 2
Sketch Tablets (Wanås, Kentucky,
 and Colorado) (Lin sculpture),
 165
Skowronski, Hella, 33
Skull and Bones (Yale secret
 society), 137–38
Smithson, Robert, 166
Society for the Study of Chinese
 Architecture (SSCA), 19, 20
Society for the Study of National
 Strengthening, 3
Sodergren, Evert, 33
Song Jiaoren, 6
Soong Ching-ling, 7
Sottsass, Ettore, 151
Sounding Stones (Lin sculpture),
 153
Southern Poverty Law Center
 (SPLC): civil rights move-
 ment memorial and, 134–37;
 founders of, 134; Intelligence
 Projects of, 134
Sowle, Claude, 35
Spence, Jonathan, 15
Sperry, Robert, 33
Spreiregen, Paul D., 79, 84, 85,
 89, 92, 94–95
Stones (Lin furniture design), 154
Storm King Wavefield (Lin wave
 work), 167
Sturken, Marita, 99
Sun Yat-sen, 4–5, 6, 7, 10
Systematic Landscapes (Lin
 exhibition), 164–65

Teaching Tolerance (magazine), 149

10 Degrees North (Lin project), 148

Thompson, Nadine, 155

Three People's Principles, 5, 10

Three Soldiers (Hart sculpture), 108, 113–14, 152

Time, 117

Timetable (Lin artwork), 161

Tong, James Yingpeh, 57–58

Topo (Charlotte, NC competition), 138–41

Topologies (Lin solo exhibition), 154–55

Trio (opera), 121–22

Trisolini, Anthony, 34

Trisolini Print Project, 35

Tufte, Edward, 138

Tupper, Benjamin, 39, 40

Turrell, James, 166

Twentieth-Century Chinese Women's Poetry: An Anthology (Julia Lin translation), 36–37

2x4 Landscape (Lin sculpture), 165

Veterans of Foreign Wars (VFW), 93, 134

Vietnam Veterans Memorial: accolades for, 117–18; accusations directed at, 27; Assistens Kirkegård influence on, 70; building of, 89–101; Constitution Gardens influence on, 81; dedication of, 108–9; design competition for, 79–80; funding for, 78, 79; idea for, 78; inscriptions on, 94; judges remarks on, 89–90; judging for, 84–86; Lin 850 word rationale for, 90–91; Lin design for, 80–84; resistance to, 92–101; Scruggs, Jan C. and, 78; Washington conflicts with, 105–15; Woolsey Hall influence on, 66

Vietnam Veterans Memorial Fund (VVMF), 78–80, 84–86, 89, 91, 92–93, 98, 100–101

Vietnam War, 45

Vietnam Women's Memorial Project (VWMP), 114

Von Eckardt, Wolf, 85, 97

Von Rydingsvard, Ursula, 121

Walker, Peter, 170

Wall Street Journal, 100

Wanås Foundation, 166

Wangh Ching-wei, 10

Warm Spirit, Lin logo design for, 155

Warner, John, 100

Washington Monument, 93

Washington Post, 92, 96, 99

Water Line (Lin sculpture), 165

Watt, James, 79, 94, 100–101, 103

Wave Field (Lin project), 148, 166

Webb, James, 100, 105

Weber, Lawrence and Judith, 146–47

Weeks, Linton, 109

Weese, Harry, 84, 93, 107

Wexner Center for the Arts, Ohio State University, 147

What Is Missing? (Lin memorial), 171

Whealey, Richard, 61

Wheeler, John, 78–79

Where the Land Meets the Sea (Lin sculpture), 165

Who Do You Think You Are? (television series), 1

Wijdeveld, H. Th., 30

Williams, Juan, 135

Wolf, Daniel, 28, 150–52, 171

Wolf, Erving and Joyce, 151

Wolf, India, 153

Wolf, Rachel, 154

Wolfe, Tom, 99

Wolf's Head (Yale secret society), 137–38

Women of the Red Plain (Julia Lin translation), 36

Women's Table (Lin sculpture), 138, 148, 152

Woods Hole Oceanographic Institute, 165

Woolsey Rotunda at Yale University, 66

Wouk, Herman, 85

Wright, Frank Lloyd, 147, 151

Xu Zhimo, 18

Yale Herald, 138

Yale University, 66; admissions process of, 63–64; architecture classes taught at, 69–70; Lin and, 63–72, 118–20, 127–28; Memorial Quadrangle at, 65; School of Architecture at, 119–20; women students at, 64, 119, 137–38; Woolsey Rotunda at, 66

Yüan Shikai, General, 4, 6–7

Zaidenberg, Arthur, 98

Zhi, Chen, 20

Zhou Dynasty, 2

Zhou Wu Wang, 2

About the Author

DONALD LANGMEAD, PhD, was adjunct professor at the University of South Australia, Adelaide, Australia. He held doctoral and master's degrees in the history of architecture and a postgraduate qualification in city planning. His published works include 11 books in Australia and the United States, such as Greenwood's *Icons of American Architecture: From the Alamo to the World Trade Center*; Greenwood's *The Artists of De Stijl: A Guide to the Literature*; Praeger's *Frank Lloyd Wright: A Bio-Bibliography*; and many articles in Australian and overseas journals.